D0479557

Expanded Edition

Lettering

Lettering

CHARLES R. ANDERSON
WITH ILLUSTRATIONS BY THE AUTHOR AND ANITA L. ANDERSON

EXPANDED EDITION

VNR **VAN NOSTRAND REINHOLD COMPANY**
New York Cincinnati London Toronto Melbourne

To My Son
Erik Jon

Expanded edition first published in 1982
Copyright © 1969, 1982 by Van Nostrand Reinhold Inc.
Library of Congress Catalog Card Number 69-15894
ISBN 0-442-20871-5

All rights reserved. No part of this work covered by the copyright
hereon may be reproduced or used in any form or by any means—
graphic, electronic, or mechanical, including photocopying, recording,
taping, or information storage and retrieval systems—without written
permission of the publisher.
Printed in the United States of America

Designed by Myron Hall III

Van Nostrand Reinhold Company Inc.
135 West 50th Street, New York, NY 10020

Van Nostrand Reinhold Publishing
1410 Birchmount Road, Scarborough, Ontario M1P 2E7

Van Nostrand Reinhold Australia Pty. Ltd.
17 Queen Street, Mitcham, Victoria 3132

Van Nostrand Reinhold Company Ltd.
Molly Millars Lane, Wokingham, Berkshire, England RG11 2PY

First edition published 1969 by Van Nostrand Reinhold Company

16 15 14 13 12 11 10 9 8 7 6 5 4 3 2 1

PREFACE

The letterer of today is no longer concerned primarily with production of books and documents as were his predecessors. His role has been extended to new and more challenging areas, as well as to those areas always in the domain of the letterer. At a time when the skills and talents of this individual are being denigrated by those who erroneously believe that the totality of modern technology can replace him, he finds his talents in more constant demand than ever before. This demand is apparent in almost every major industry in the world. He is indispensable to the advertising field; he is vital to the furtherance of the type-founding and phototype industries; he is essential to the thousands of corporations and business houses that depend on his skill to create a favorable and lasting image before the consumer, in the form of trade-marks, corporate images, and a host of other originally lettered items.

He is essential to architecture as a practicing artisan or as a consultant for the development of all forms of graphic communication and inscriptional matter; his disappearance would be a very serious loss to the packaging and industrial design organizations; he exercises the ancient art of sign-writing and designs communicative symbols; he designs new letters and symbols to fit the needs of each technological advance; he creates and executes fine manuscripts and documents for private and governmental purposes; and he is the teacher of others, a function that will increase to vast proportions as man progresses in his current struggles to regain a beautiful and legible writing hand.

The letterer seems destined to achieve greater prominence than at any other period in history. The renaissance of writing, now in its infant stages, is a major step in man's attempt to retain (or perhaps regain) a sense of individual identity within his vast technological world. The making of good letters is a completely personal and individual act, the results of which remain as a distinctive and lasting testimonial to the personality of man.

Through the medium of this book, which represents a tangible outgrowth of my stated convictions, I seek to provide the individual with an effective knowledge of the major historical stages in the development of letters; of the intricacies of letter design and construction, and of their function as elements of communication and design. To satisfy these intentions in the most flexible manner, the book has been divided into two parts. Each part could be considered separately, but the two parts have been planned to work together to create a more effective approach to the problem.

Part I, an outline of the history of Western writing, explains the basic stages through which all writing systems have passed, and traces the development of the Roman alphabet, the evolution of the minuscule letter form, and the changes wrought through the advent of a practical method of printing. A comprehensive history of writing is well beyond the scope of this book, but those who wish to undertake more profound scholarly research and study into specific areas will have a firm background to aid them in their pursuits.

Part II, a comprehensive course of instruction in the study and formation of letters, places strong emphasis upon correct beginnings and upon the development of the necessary disciplines and visual sensitivities. Emphasis is also placed on the study and execution of the beautiful and subtle forms of the Trajan Roman capitals, as well as on the development of a "controlled freedom" for the production of good, true, pen-written letters. The comparison charts, alphabets, and contemporary examples, as well as the historical illustrations in Part I, should provide the individual with a useful reference source.

This book is a contribution in support of a renaissance of writing. I will be amply rewarded if but a few persons are influenced, through these pages, to direct their creative energies toward a wider dissemination of beautiful and legible writing by taking their places as fine letterers, writing masters, and teachers of others in their turn.

C. R. A.

December 29, 1967

ACKNOWLEDGMENTS

I am indebted to many individuals who have assisted and encouraged me during the years required for the completion of this book. I wish to take this opportunity to offer them my sincere thanks and gratitude.

To the late Mr. John Howard Benson, master calligrapher and stonecutter, for kindling my interest and furnishing inspiration; to my wife, Anita, a woman of letters, for supplying unflagging assistance, devotion, and patience; to Professor Richard M. Schlemmer and his wife, Virginia, for valuable advice and assistance; to Professor Thomas D. Greenley, for contributing both his work and his valuable discussions and ideas; to Dr. Lawrence N. Jensen, for his encouragement and help in promoting the idea; to Dr. June Sherline and Joann Ditmar, for valuable suggestions and encouragement; to Dr. Warren L. Cook, for his assistance in scholarly research; to Mr. Graham Carey and Father Edward Catich, for their encouragement and advice; and to Mr. Thomas Slayton, for his efforts, both publicly and photographically, in my behalf.

I am equally indebted to the Library Staffs of the Castleton State College and the State University of New York, College at Farmingdale, for their research assistance; to the Staff of The British Museum, notably Mr. R. H. Parker, Mr. T. W. Webb, Mr. D. B. Alsford, and Mr. C. B. F. Walker; to Mr. Ronald Hall, M.A., Librarian, The John Rylands Library; to Dr. Frederick B. Adams, Director, and Mr. Herbert Cahoon, Chief, Reference Library, The Pierpont Morgan Library; to Mrs. Helen B. Jones, The American Museum of Natural History; and to the Staff of the Victoria and Albert Museum, for their generous assistance in supplying the fine photographic material for this book.

Among the contributors of examples of work that enrich this book, I wish to thank Mr. Ramon Folta, Folta and Schaffer Advertising; Mr. Malcolm Grear, Head, Department of Graphic Design, Rhode Island School of Design; Mr. Robert C. Niece, Evening Registrar, Los Angeles Art Center, College of Design; Miss Claudia Heidt and Mr. Harry Ford, Atheneum Publishers; Miss Elizabeth Crawford, Doubleday & Company, Inc.; Miss Betty Anderson, Alfred A. Knopf; Dover Publications, Inc., for so generously allowing me to reproduce examples from among their publications; and those students who so generously contributed of their work.

CONTENTS

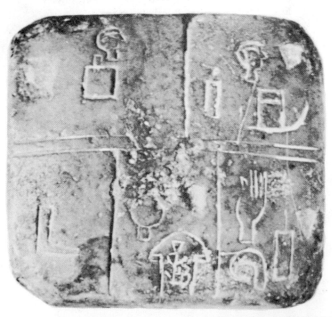

The earliest known example of true writing, from the ancient city of Kish, in what is now Iraq. The limestone tablet shows several well-developed pictographs. From about 3500 B.C. (Courtesy of the Directorate-General of Antiquities, The Bagdad Museum, Bagdad, Iraq.)

LIST OF ILLUSTRATIONS

PART I

AN HISTORICAL OUTLINE OF WESTERN WRITING

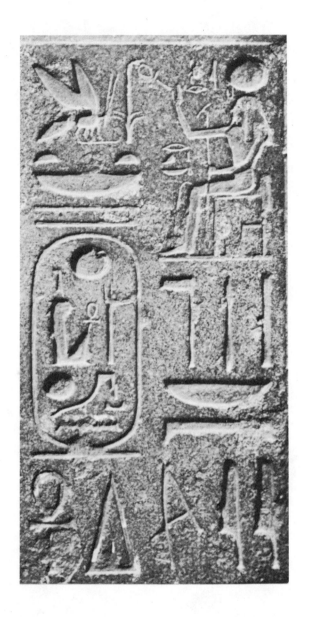

AN INTRODUCTION 1

Fifty thousand years ago, by scratching a simple picture on the wall of a cave, man began the evolutionary process which resulted in the most spectacular and decisive achievement ever to affect mankind — the art of writing and the development of a phonetic alphabet. Relative to the length of time man has existed on earth, writing can be considered a very recent development, having evolved slowly over the millennia in direct proportion to man's need for communication. The principal factors that have enabled him to develop civilizations were the ability to write and the ability to understand what was written. Without a means of written communication for the transmission of ideas, man would not have risen above the cultural level of the most primitive people.

Early man did not need a written system of communication. Members of his society did not mingle or travel outside their immediate environment, and legends and records were handed down orally within a family or group. However, as more and more people ventured forth from their groups in search of new and better hunting areas and living quarters, people from distant places with different customs soon became acquainted with one another, causing language barriers to manifest themselves. The existing system of oral communication was no longer sufficient. A better method had to be evolved to enable people of different backgrounds and language to communicate and understand each other's customs.

The Hand Sign

Faced with the problem of "speaking" to people of different languages, man turned to the logical solution of the use of hand signs (gestures) to convey ideas and needs from one to another. The hand sign was a natural movement or series of movements that, in their simplest forms, corresponded closely to the kinaesthetic motions required to perform a desired act. Figure 1(A) illustrates the word "catch." The right arm is extended straight out from the shoulder, the index finger pointing forward with the other fingers and thumb closed. The hand is then brought toward the shoulder, at the same time that the index finger is closed. Note that the first movement may also be used for "direction," by omitting the drawing-in of the hand. Figure 1(B) depicts "drink." The right hand is cupped in front of the face and the hand is then brought down to touch the lower lip. Figure 1(C) represents "sleep." The movement is suggestive of a man sleeping on the ground with his head resting on the right hand and his left hand placed across his chest.

Fig. 1 (A) The sign for the word "catch"; (B) The sign for the word "drink"; (C) The sign for the word "sleep."

There were a great many movements, some quite complex and dependent upon the use of a series of related signs. In time, the signs were used to relate more abstract meanings relative to the primary use of the given sign. For example: (1) the sign for "hide" meant "secret"; (2) the sign for "cold" meant "winter" and "year"; (3) the sign for "tired" meant "weak"; (4) the sign for "fast" meant "quick"; and (5) the sign for "catch" meant "take." A sample sentence conveyed through sign language might evolve as follows: To ask the question — "Will you go for a walk with me?" — the signs for "walk," "you," and "me" would be made, followed by the sign for "question." Obviously there was a great economy of words, so that communication by this system, while reasonably fast, was not particularly effective in every case. It had, however, at least in its simplest, most direct forms, the advantage of being fairly universally understood.

Theories have been advanced in the past to suggest that the hand sign was actually "writing in air," but no evidence exists to support the use of the word "writing" in this connection. Sign language was a "visual" language, conveying thoughts or acts, but by means of the ancient art of pantomime, which antedates even oral language. The use of hand signs stems from dancing and movement — the very first means by which man was able to communicate.

Sign language is still very much in use today. American Indians used it well into the 19th century to communicate with Western settlers and it is still used on ceremonial occasions. Some primitive groups in South America, Africa, and the Pacific still use modified forms of the hand sign for communication. Throughout the world, people afflicted with speech and hearing losses utilize an advanced form of sign language in place of oral communication. The signs in this case are alphabetic signs, each representing a letter of the alphabet that corresponds to a vocal sound of the oral language. A skilled individual will develop incredible speed in the use of this visual language and communicate almost as rapidly as persons using the spoken word. Yet another example of the current use of hand signs, often accompanied by verbal communication, is evident in everyday life. When a person is asked for directions, he may invariably supplement his verbal description with a finger pointing in the general direction of the goal. A person will hold his nose closed with his fingers if something has a bad odor, or he may make a circling motion at his right ear with his index finger to indicate that someone or something is crazy or puzzling. The natural inclination to the use of these signs as short-cuts of speech has its beginnings with young children who, in order to be understood by others, often resort to hand motions to communicate their desires and stories. It is only natural that this tendency should continue, in some form, to adulthood.

Sign language, though not a form of writing, can certainly be considered a precursor to actual writing. An examination of early, primitive pictographs reveals some remarkable similarities between the written picture-sign and the visual hand sign. Pictures of an extended arm and hand for directional signs, pictures of running legs to represent a man running, pictures of a figure with hand cupped to mouth used to depict drinking, all bear traces of the earlier hand signs used to express these ideas. When man discovered that he could draw and carve, his conversion of the visual image into a sign-picture must have been a relatively logical step. Naturally, the ability to draw brought with it great degrees of invention, so that most of the hand signs capable of ready conversion to pictures were soon discarded in favor of more expressive pictures.

The Stages of Writing

Writing's long history has gone through four distinct stages. These stages follow a logical pattern of evolution, though no clear-cut divisions can be established between them. There is much overlap, as each successive stage was an outgrowth of a former stage, and, in some cases, particularly mnemonic and ideographic, they are in use along with earlier stages. Almost all written languages have passed through these successive stages, and, although the adoption of an advanced one has generally caused the former to lapse into disuse, vestiges of all the previous stages may be found incorporated within a people's language.

These stages can be classified for convenience of explanation as follows: (1) The "mnemonic" (memory-writing) stage, in which a tangible object was utilized as a memory-aiding device to recall messages or records. Such objects as wooden sticks, shell beads, or knotted cords served in this capacity. This stage anticipated both the pictorial and symbolic stages of writing with the introduction of carved or woven signs; (2) The "pictographic" (picture-writing) stage, in which a picture was used to represent the "thing" or "object"; (3) The "ideographic" (idea-writing) stage, in which a picture was representative of the "name" of an object, thus becoming symbolic and capable of expressing abstract qualities and meanings of the thing so represented; (4) The "phonetic" (sound-writing) stage, in which a picture was representative of the "sound." The phonetic stage can be divided into three sub-stages as follows: (A) Verbal, in which a sound-sign represents a word; (B) Syllabic, in which a sound-sign represents a syllable; and (C) Alphabetic, in which a sound-sign represents a letter.

The Mnemonic Stage

Many cultures utilized various devices to aid the memory in the recall and interpretation of records, transactions, etc. These devices are called "mnemonic" (aiding the memory), and have been used throughout history both independently and in conjunction with other recording systems. The most predominant of these devices are notched sticks of wood, knotted cords and thongs, and shell beads strung on cords.

Notched Sticks

Figure 2 illustrates a typical example of a notched stick. Herdsmen kept records of the number and type of animals which they tended by cutting notches into a wooden stick that measured approximately two feet in length and one to two inches in thickness. This device had four equal sides, each of which represented a different type of animal. Notches were cut into the edge of one side to correspond to the number of animals of a particular type herded; for example, 29 cows required 29 notches in the edge designated for cows; five oxen required five notches in the edge designated for oxen. The edges used to represent the various animals were consistent throughout a community; therefore, a fairly accurate record could be kept and generally understood.

Records of sales, purchases, debts, and other matters could be maintained — in addition to livestock records. During a later period in history, signs were often carved on the flat surfaces of these sticks to indicate special days and unusual occurrences. There are accounts of recent (19th-century) usage of these devices for the recording of sales of bread, milk, grain, and other commodities, as well as for the recording of monetary debts in England, Europe, and the United States. Most likely they were in use in other parts of the world as well. The usage of this device for the recording of money debts is quite interesting, particularly since it occurred as relatively recently as the 19th century. The amount of the money loan was carved into one side of a squared stick of well-seasoned wood, the notches used being of different dimensions according to the various monetary divisions. On two opposite sides of this stick, the amount was recorded in Roman numerals, together with the date and the name of the lender. The stick was then split in half, one part being kept by the lender, the other by the borrower. When the debt fell due, the pieces were presented and fitted together. If the notches matched up as they should, the debt was paid to the lender.

Knotted Cords

Figure 3 illustrates a Peruvian *quipu,* a combination of knotted cords or thongs which is one of the most interesting forms of the mnemonic device. Although the *quipu* has a long history as a recording device among many peoples, its use among the Inca Indians of Peru represented perhaps the most elaborate usage. These knotted cords were very complex in design. A vast variety of ideas and things was designated by separate cords and colors. A primary cord was utilized to represent a general item; from this cord was hung a number of secondary cords, each a different color and each depicting a separate breakdown of the general category. If it became necessary for a more detailed breakdown, additional cords were appended to the secondary cord. For example, consider a *quipu* made for a census of the population of an Inca community. The main cord represented the general category of "census-population." The secondary cords hung from this might represent the following items: (1) single men, (2) single women, (3) married men, (4) married women, (5) widowers, (6) widows, (7) male children, (8) female children. Each cord was then knotted according to the numbers present within each category, the knots having the following values: one knot — 10; two single knots, side by side — 20; one double knot — 100; two double knots — 200; etc. A great variety of complex records could be kept in this manner. This system was perfected to a surprisingly high degree, and was used not only for reckoning and recording livestock and purchases, but also for keeping the annals of the Inca Empire, for the transmission of orders and messages, for military records, and even for preserving records of the number of deceased.

The major drawback to the use of the *quipu* was its inability to be translated readily and easily in other communities. Each town or community had its own "knot-officer," whose duty it was to tie the knots and translate them properly when necessary. Few others could interpret them in the community.

Fig. 2 A typical notched stick used as a mnemonic recording device.

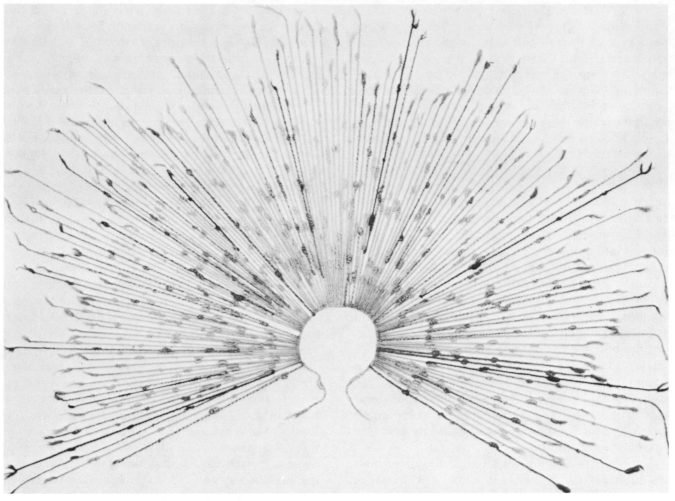

Fig. 3 An excellent example of a Peruvian Indian *quipu*. (Courtesy of the American Museum of Natural History, New York.)

If anything befell these individuals through war, pestilence, or old age, the entire set of records was endangered and was often rendered worthless.

The knotted cord has been used in many cultures for the purpose of record-keeping. Evidences of these mnemonic devices have been found in the ancient Mexican Indian cultures, the North American Indian cultures, various tribal cultures of West Africa, the Hawaiian Island and other Pacific Island cultures, and even in the ancient cultures of Persia and China.

Wampum

Figure 4 illustrates an American Indian wampum belt that belonged to the Algonkin Indians. Wampum belts, originally the medium of exchange in trading and bartering, and the Indians' most cherished and valuable possessions, were composed of a series of cords or thongs on which beads of shell had been strung. The number of strands denoted the value or importance of the belt. It was only natural that they

Fig. 4 American Indian wampum belts originally belonging to the Algonkin Indian tribe. (Courtesy of the American Museum of Natural History, New York.)

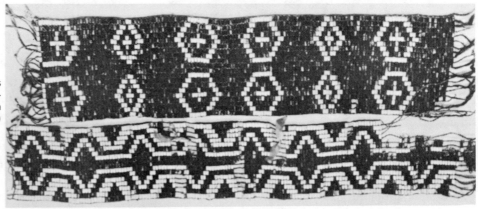

should have used them to seal and solemnize their most important negotiations. Wampum belts were used to commemorate treaties, to seal and act as deeds for land and real estate transactions, and to prove title to other valuable possessions. In this manner, wampum became a mnemonic device of unusual design. The signs which adorned the majority of these belts were "woven" in with the beads and were both pictographic and ideographic.

One of the most famous wampum belts is that given to William Penn in 1682 by the chiefs of the Leni-Lenape Indians to cement a treaty of friendship and peace between them. This belt, housed in the collection of the Pennsylvania Historical Society, is exceptionally large and is composed of 18 strings of wampum. Represented on the belt are two figures — one dressed in what appears to be European costume — holding hands in a gesture of friendship. Another good specimen is one made by the Onondaga Indians of New York, and which, according to tradition, commemorated a treaty between these Indians and the Government of the United States. This belt is composed of 15 strings of wampum and is quite decorative. At the center is a picture of what is thought to be the Capitol building in Washington, D.C., flanked on both sides by a number of figures holding hands in the manner of friendship and protection. In addition to their use for treaties and alliances, some wampum belts, like the famous "Huron Missionary Belt," were made to commemorate the acceptance of the Christian religion by the Indians. The use of wampum was an interesting and unique contribution to the systems of written communication and adds much to the heritage and tradition of the Indian Nations.

The Pictographic Stage

The picture-writing stage represented a great advance over the former means of communication. Sign language was a personal means of expression with the disadvantage of being "of the moment," having no degree of permanence. Mnemonic devices had a relatively good degree of permanence, as attested to by the numbers of these devices that have been preserved; the disadvantage of these, however, was the necessity of interpretation, of which but a few individuals were capable. The pictograph surpassed these devices by providing a permanent record that could be understood by many without prior interpretation — the picture represented the thing or object and thus told its own story.

The earliest pictographic inscriptions were composed of disconnected pictures, but gradually the pictures became connected and related, recording stories, epics, and songs. These pictographs were the beginnings of recorded history, telling scholars

much concerning the life and manners of these primitive people. Pictographic records were incised in or drawn upon a number of natural materials, among them rock, clay, bone, ivory, parchment, and the bark of certain trees, principally birch bark.

The earliest known examples of pictorial records are the drawings and paintings discovered in caves in parts of southwestern and southeastern Europe, North and southern Africa, Australia, and the Scandinavian countries. Many of these cave records date to almost 50,000 B.C. and primarily depict animal life, hunting parties, warriors in battle, and ritualistic dancing. The artists belonged to groups now referred to as the Advanced Hunter Culture and their signs dealt primarily with events and ideas relative to a hunting society. Figures 5 and 6 illustrate a selection of drawings from these cave-dwellers, and

Fig. 5 A freely drawn facsimile of an eland buck engraved in the rock wall of a cave in western Transvaal, South Africa.

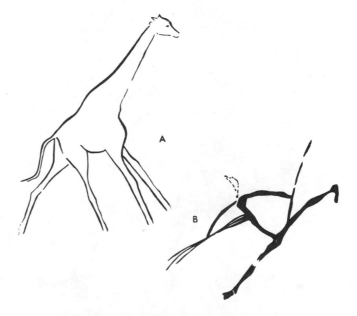

Fig. 6 (A) A freely drawn facsimile of a giraffe painted on a rock wall of a cave in Rhodesia. (B) A freely drawn facsimile of a running hunter, holding bow and arrows, painted on a cave wall in Spain.

reveal the highly developed skill and imagination possessed by them. In many cases, a relatively complex arrangement of signs was both painted and incised; the outline and parts of the image were scratched in stone and pigments were rubbed into the depressions and over the surface to complete the work. There has always been some question as to whether these cave drawings were simply works of art or actually records of events, thus making them written records. That they are works of art is unquestionable, and since the subject matter very often pertains to the telling of some kind of story — a hunt, a chase, dancing — it would seem that these are indeed records, whether or not the artist, at the time, was aware of the act of preserving for posterity the particular subject matter portrayed.

Many fine examples exist from sources other than cave paintings and a selection of these is illustrated in Figures 7, 8, and 9. The North American Indians produced many fine examples drawn on parchment and birch bark, and incised in rock; the Eskimos produced drawings and engravings on walrus tusk and bone; and the Chinese created excellent and finely drawn signs on silk cloth. Likewise, fine examples were produced by the Babylonians, the Egyptians, and the Africans, as well as by the peoples of the ancient Maya, Aztec, and Inca civilizations.

Fig. 7 A fine example of a buffalo robe by the Oglala Dakota (Sioux) Indians. The figures depict a victorious battle scene. (Courtesy of the American Museum of Natural History, New York.)

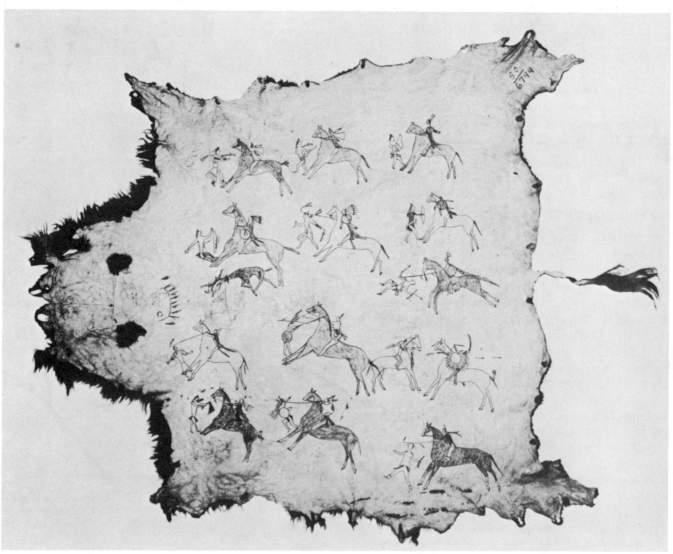

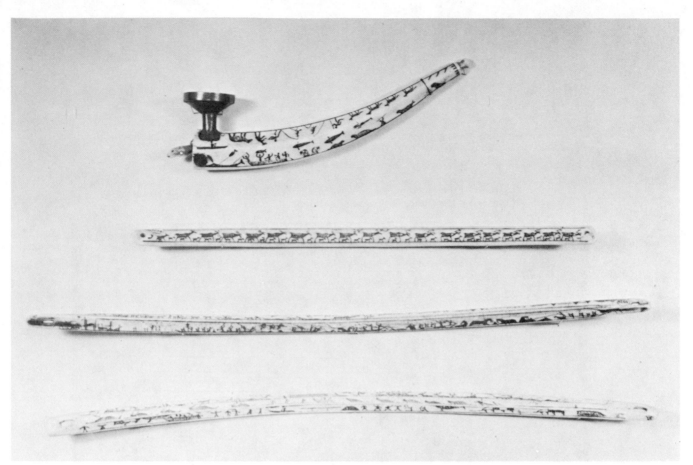

Fig. 8 Western Eskimo implements of ivory with incised designs depicting hunting scenes for whale, walrus, caribou, and birds. (A) A pipe; (B,C,D) Bow drill handles. (Courtesy of the Trustees of the British Museum.)

Fig. 9 A Western Eskimo arrow shaft straightener depicting caribou hunting scenes. (Courtesy of the Trustees of the British Museum.)

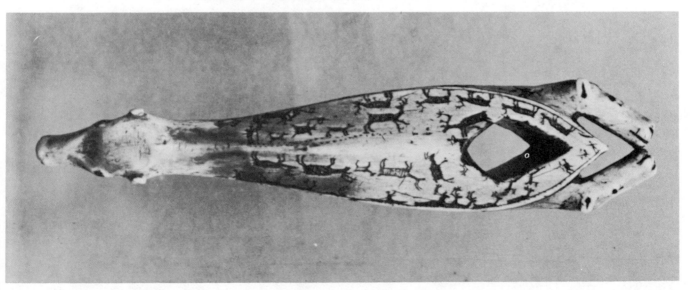

IDEOGRAMS

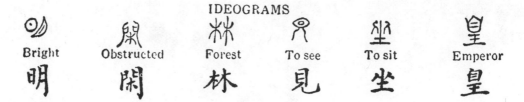

Bright	Obstructed	Forest	To see	To sit	Emperor

Fig. 10 Examples of ancient Chinese ideographs and their modern counterparts. (Courtesy of the American Museum of Natural History, New York.)

Fig. 11 A portion of the limestone stele of *TJETJI*, Thebes, 2100 B.C. with Egyptian ideographic symbols. (Courtesy of the Trustees of the British Museum.)

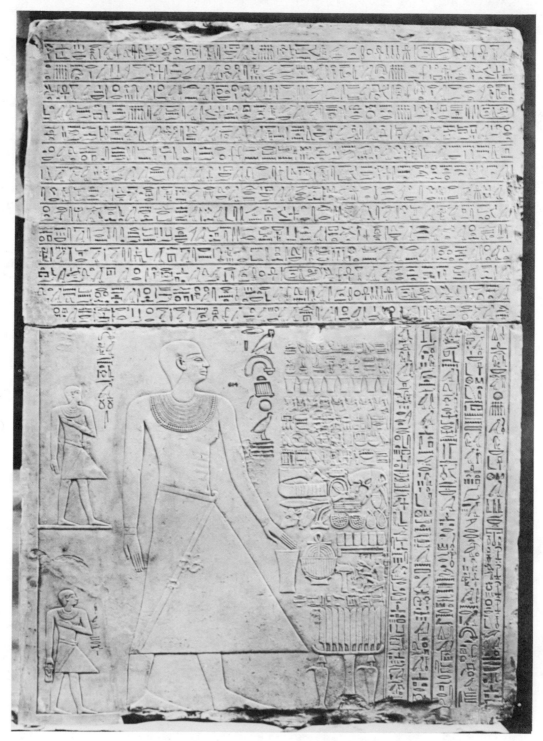

The Ideographic Stage

The ideograph was an outgrowth of the pictographic stage, but the picture-sign was representative of the "name" of the thing or object. An important advantage of the ideograph over the pictograph was that it replaced a great variety of signs, which were employed through the artistic whims of the individual scribes, by a fixed and conventional picture. By a process of selection and custom, a single sign became identified with the name of the object that it represented. Once these signs had become accepted, they could represent abstract ideas and qualities that were associated with the primary object. For example: (1) The "hand" might be used to express "power," "authority," or "force"; (2) The "eye" might be used to express "seeing," "sight," or "perception"; and (3) The sign for "water" might be used to express "rain," "sea," or perhaps even the statement, "good fishing."

Ideographic writing sometimes took the form of a "rebus" (things or objects used to represent the word-sound). For example: the sentence, "I saw a man pick a raspberry," would read ideographically as follows:

The objects used are simple and readily understandable, since the name of the object or objects creates the word-sound. The word "belief" can be expressed by a picture of a "bee" and a "leaf," while a combination of ideographic and phonetic signs could create the word "caterpillar" as follows:

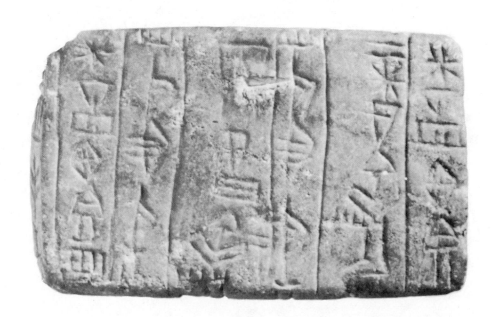

Present-day usage of the rebus utilizes both of these writing stages for such things as teaching aids for children, advertising promotions, and word games, to name a few.

Ideographic signs have been present in almost all writing systems, some of which retained these signs to be used in conjunction with the more practical phonetic signs. The Chinese retained variants of their primitive forms, combining them with the phonetic signs of their written language. These signs were used solely for the purpose of catching the eye, to better convey the phonetic meaning. The hieroglyphs of the Egyptian civilization present a similar case. Often an ideograph will follow a phonetically spelled word. Its functions are to act as an eye-picture, interpreting the phonetic meaning, and to distinguish between the great number of homophones (any of two or more signs having a sound in common, such as "pain" and "pane") present in the language.

Figures 10 and 11 illustrate a representative variety of ideographs that have been used throughout history. These signs are used today in many ways and are ever-present in our society. Such symbols as the dove, the olive branch, the cross, the dollar sign, the question mark, the winged foot, and many others are all unquestionably familiar. Similarly, the hallmarks and trademarks of many business houses are ideographic, as are many seals and heraldic ornaments.

Fig. 12 A stone foundation from the temple built by A-ANE-PADA, King of Ur, at al'Ubaid — 2600 B.C. Sumerian ideographic symbols. (Courtesy of the Trustees of the British Museum.)

The Phonetic Stage

This stage of writing was probably one of the most intellectual achievements attained by mankind. Through the slow, gradual development of writing, the ideographs were replaced with signs representing the phonetic values of their names. The written language at this stage became capable of expressing the fundamental, phonetic sounds of the oral language. During its initial phase, a phonetic sign was used to represent the sound of a word. In its second phase, signs represented word syllables. The final and decisive development within the phonetic stage was the use of a sign to represent the initial letter of the word, thus providing man with an alphabetic/phonetic system of writing. This system, commonly known today as the "Alphabet" (the word was created from the first two words of the Greek alphabet — Alpha and Beta), made possible the written expression of all the sounds of an oral language by means of a few fixed character-signs. The English alphabet, which has descended virtually unchanged from the Roman alphabet, contains only 26 basic letters (the minuscule variants of these basic letters are discussed in Chapter 4; numerals and punctuation are discussed and illustrated in Chapter 7). It seems miraculous that with these few, easily learned letters, everything that can be spoken can also be written.

The transformation from ideographs to an alphabetic system was a completely natural and logical outgrowth; the selection of the phonetic signs was probably made from among the more common syl-

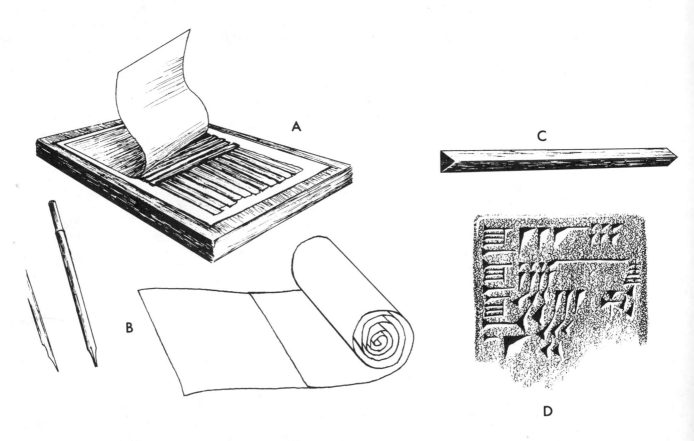

Fig. 13 Writing materials and tools. (A,B) The making of papyrus by gluing the thin strips of reed together and then pounding and polishing. The finished sheets are glued together to form a long roll. The reed pen was the usual instrument for writing on the papyrus, but a form of brush was sometimes used. (C,D) The wedge-shaped stylus made from reed was used to impress the cuneiform symbols into soft clay by Sumerians, Babylonians, and Assyrians. The clay was later baked for permanence. (E) The Romans painted their letters on the stone with a brush and then incised the inscription with a chisel and stone hammer according to the brush strokes. Often the stone-cutter corrected errors or added his own finishing ideas. (F) The Eskimos carved or painted on bone and ivory, with scenes usually relating to hunting and fishing.

labic signs having sounds that corresponded to the single alphabetic sounds for which signs were necessary. An example of this changeover can be observed in ancient Mexican sources. The name of an Aztec king was "Itzcoatl," which was pictographically represented by a serpent (coatl) with stone knives (itzli) upon its back. The phonetic version of the same word is pictured in a rebus as follows: A weapon armed with blades represents the first syllable (itz). The remainder of the word, coatl, meaning "snake," and previously represented by a serpent, is now expressed by two objects, an earthen pot (co), and the sign for water (atl). These signs were not meant to be read "knife-pot-water," as would be the case in a pictograph, but rather as the sound of the Aztec words, "itz-co-atl."

Writing Materials and Tools

The attainment of a written language assumes a knowledge of writing materials and tools. The final form and appearance of the writing style is very much dependent upon the type of writing surface used and the writing tool employed. The oldest writing material appears to have been stone, usually slate or limestone, upon which the message was carved or drawn. Both of these materials are relatively soft and can be incised easily with a harder instrument, such as a pointed stone or piece of metal. In addition, both exist with smooth surfaces. Slate, in particular, is highly compatible to drawing or painting. Many examples exist of rock carvings, or petroglyphs, which exhibit a high degree of skill and workmanship; in general, however, they were fairly

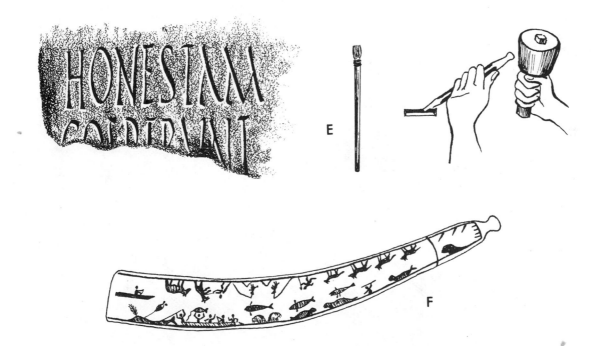

E

F

crude productions. As in any society, the skill of the workman is very important to the excellence of the finished product, and considering the primitive tools available, even some of the crudest inscriptions must be considered as representing a respectable achievement for primitive man.

One of the more famous writing materials was papyrus, made from a water plant that flourished in great abundance along the lower Nile River. The Egyptians discovered that papyrus fibers made an excellent writing surface when properly prepared. Two layers of soaked fibers were used, the first layer laid vertically and the second horizontally, both being bonded together with an adhesive. The resultant material was then pressed and dried, and the horizontal side was polished to create a smooth writing surface. The individual sheets were then fastened together, end to end, and made into huge rolls. The writing instrument was a reed pen, used with an ink composed of gum, lampblack, and water. The number of documents that has been preserved attests to the durability of both the papyrus and the ink. Manuscripts have been found that verify the use of these materials almost 3,000 years before Christianity.

Another important writing material was clay. Though several cultures used this medium, the Babylonians appear to have used it most extensively. The wet clay was formed into a rectangular tablet and signs were indented into it by means of a wedge-shaped stylus. The tablets were then baked hard in an oven, producing a reasonably durable and permanent record. The methods employed by the Babylonians produced a singularly unusual style of writing called cuneiform, which will be discussed in Chapter 2.

The Chinese, in addition to using clay, utilized silk cloth in much the same manner as Egyptians used papyrus. The fibers provided an excellent surface, and the writing instrument most used was the brush, though reed pens were also utilized. The Chinese, too, are responsible for the first use of the brush (fifth century B.C.) and for one of the greatest advances in writing — the invention of paper during the first century A.D. The invention of paper was to be of immense importance much later in the development of printing.

Other writing materials similarly used throughout history include the parchments and barks of the North American Indians, the bone and ivory of the Eskimos, and wood, used extensively in many cultures. All of these materials have made their important contributions in preserving man's recorded history. Archaeologists, anthropologists, philologists, and other scholars have attempted to piece together the paths along which writing has developed, and at the same time they have discovered much concerning the lives and customs of ancient peoples.

THE LEGACY OF SUMER

Throughout the course of history, the collapse and disappearance of great civilizations have been caused by invasion, conquest, pillage, fire, social upheaval, religious fervor, and the ravages of time, resulting in a great loss of records and lack of knowledge concerning the written languages and social structures of ancient peoples. Those monuments, documents, and artifacts that survived have remained lost or unintelligible to succeeding cultures for many centuries. Only recently have scholars been able to unravel many of the mysteries which shrouded the ancient civilizations of Sumer, Babylonia, Assyria, Persia, and Egypt. Only recently has it been possible to decipher their written languages and reconstruct the social and political structures by which these people lived. The knowledge gained in the past 150 years has been considerable and of great importance, but the realization of what lies as yet undiscovered and undeciphered remains a constant and obsessive challenge to those concerned with man's historical past. The decades to come hopefully will provide new discoveries and fresh research, opening the developmental stages of written history and language to greater clarity and understanding.

The Beginning of Civilization

Mesopotamia — the name given to the land area watered by the great Tigris and Euphrates Rivers — was the site of the oldest civilization known to man, Sumer. The racial and linguistic origins of the Sumerians is unknown, but in accordance with the best information available from archaeological research, it is generally agreed that they were the first people to establish and develop a civilized society. Agriculture was being practiced by 7000 B.C., and there is evidence to support the fact that sheep, goats, cattle, horses, and dogs had been domesticated. The valley supplied an abundance of fish and fowl, as well as building materials in the form of mud, clay,

and reeds. Under those conditions, with the newly developed skill of farming, man was no longer forced to be nomadic in search of new and bountiful land. He could remain in the same place for generations, raising a family and secure in the knowledge that food would be plentiful and shelter adequate. For the first time, permanent settlements were established which would grow into villages, towns, and cities. As populations multiplied, people became organized to produce and supply the necessities of such a society. Craftsmen banded together to supply clothing, housing, boats, tools, and implements; granaries and storehouses were built to hold surplus foods; tradesmen brought raw materials and goods from distant places into the community; and overseers and officials came into power to organize the labor force, supervise the distribution of foods and goods, and administer the community according to religion, laws, and government. To document their complex transactions they achieved one of the greatest and most important of man's feats, the invention of writing, which heralds the beginning of written history.

The Invention of Writing

The development of the Sumerian towns and cities brought with it the necessity for establishing permanent visual records. The urban society had become too complex to be serviced entirely by memory and memory-aiding devices. Commercial transactions were no longer conducted by the simple expedient of barter and short-term debts, but rather had become impersonal and were handled on large-scale, long-term conditions. In a society with sharp recognition of public and private property, a means of writing became a logical necessity. It is probable that man first used seals to identify his personal property. Sumerian cylinder seals attained great heights of design and were used to register and

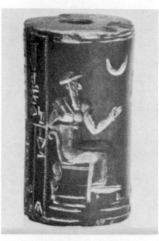

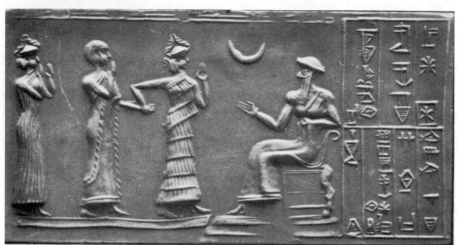

Fig. 14 Sumerian cylinder seals, shown with impressions. (Courtesy of the Trustees of the British Museum.)

26

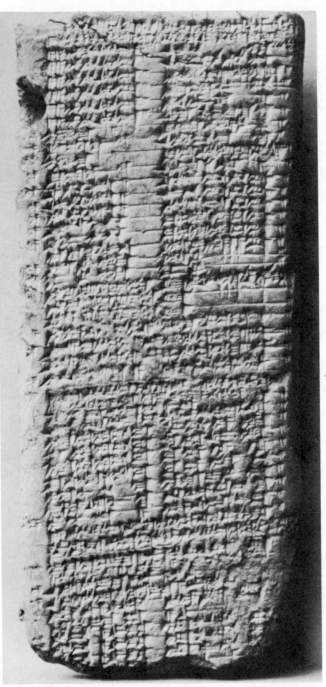

identify important documents even after the art of writing had long been established. They are the precursors of the seals used today by institutions, organizations, governments, and law to attest to the validity of their documents. It must have been an easy step for the artisans engaged in the making of seals to practice the art of writing, but it is more significant that the art of painting may have played a major role in the invention and development of writing. The Sumerians had long been familiar with the disciplines of painting and used this knowledge with great skill, particularly in the decoration of pots and bowls. Evidence tending to support the painter's significance can be found by comparison of the writing of early scribes with the production of designed pottery. At first, when pottery decorations were executed in a vertical manner, scribes similarly favored vertical writing. When these decorations became primarily geometric and were created in a horizontal manner around the circumference of the pottery, writing showed a similar change: it became horizontal and read from right to left.

Fig. 15 Sumerian cuneiform writing. (A) The second tablet of *A-AB-BA-HU-LUH-HA*, a hymn addressed to the god Mullil and written in the Eme-Sal dialect of Sumerian. (B) An official note concerning barley receipts in the 44th year of Shulgi, King of Ur, 2050 B.C. (Courtesy of the Trustees of the British Museum.)

B

27

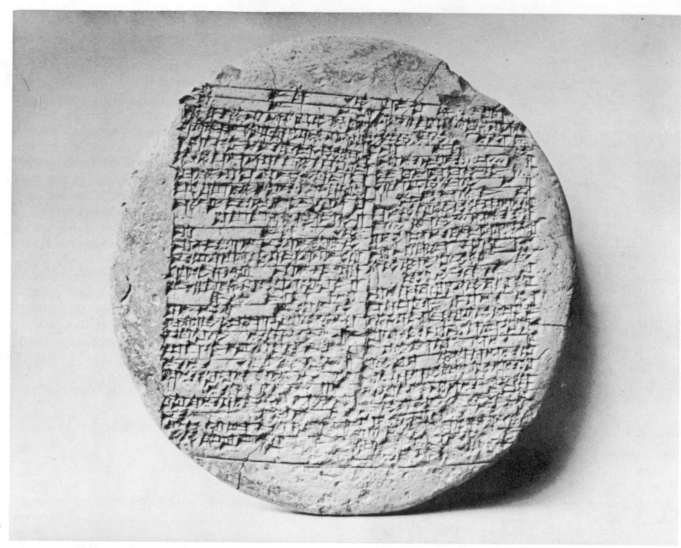

A

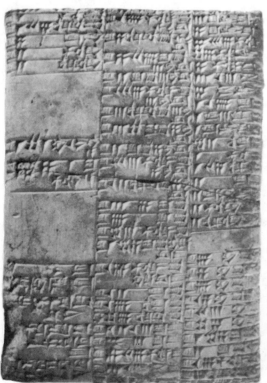

B

Fig. 16 Sumerian cuneiform writing. (A) A foundation-cone from the Giparu building at Ur, with an inscription of EN-AN-E-DU, priestess of the moon-god Nanna at Ur (1830 B.C.). (B) A list of a herd of oxen, sheep, and goats in the charge of a herdsman in the 11th year of Shu-Su'en, King of Ur, 2025 B.C. (Courtesy of the Trustees of the British Museum.)

Towns and cities were firmly established in ancient Sumer by 4000 B.C., and populations in some must have exceeded several thousands of people. The earliest known example of true writing was found at the site of the ancient Sumerian city of Kish, in the northern portion of southern Mesopotamia, and dates from 3500 B.C. It is in the form of a limestone tablet upon which were drawn several pictographs. Among the recognizable symbols are signs for the head, hand, and foot, as well as a sledge and several numerals. The first evidences of written records in any appreciable number were found at the site of the city of Uruk and date from about 3000 B.C., during the Uruk-Jemdet-Nasr period of Sumerian culture. These documents are mostly lists of inventories kept as evidence of a bartered trade, debts, temple receipts, and other commercial activities.

Cuneiform Writing

The first signs employed for the purpose of writing were pictographs of objects that played an important part in the life of the community, such as animals, oil vessels, agricultural implements, or temples, as well as numerals and ancient signs for water, month, year, and earth. These signs were later developed into more conventional and more easily written forms, no longer recalling only the name of the objects depicted, but representing sounds of speech. With the use of clay as a writing surface came another formidable problem. It was not easy to write pictographically upon wet clay, due to the nature of the material, but it was easy to make impressions that would retain their original character upon baking. Probably by experimentation, the Sumerians found that wedgelike impressions, made with a suitably formed stylus, were best retained in the clay. To give a permanence to these records, they were baked hard in ovens and then enclosed in clay envelopes for protection. The name given by scholars to these signs was "cuneiform," a term that has its origins in the 18th century; it is derived from the Latin word *cuneus*, meaning "wedge." Inscriptions in stone or metal were done by means of a chisel. Great amounts of information could be written in a small space because of the small and compact size of cuneiform signs. The use of the cuneiform system of writing soon spread to other cultures and became the written system for the Babylonians, Assyrians, Hittites, and Persians.

The development of this system required further adaptation and modification, since the wedge-shaped sign was quite different in appearance from earlier pictographic forms. The earlier signs had to be converted into simpler, more geometric forms that could be produced by a combination of one or more of the few wedge shapes possible. It became necessary to invent many new cuneiform signs to express pho-netic sounds, because many of the earlier pictographs could not be readily reinterpreted in the new form. In addition, because Sumerian words were not alterable by inflection, it was necessary to add determinative signs or phonetic complements, as in the Chinese language. Although relatively few determinatives were available, Sumerians managed to give their signs abstract qualities. The use of the eight-pointed star (AN, meaning "heaven or sky") to represent DINGIR ("god"); and the sign of the leg (DU) to represent GUB ("to stand"), GIN ("to go"), and TUM ("to carry off") are examples of these abstractions. The Sumerians also expressed intended meanings by the use of association of ideas, such as the use of the combination of the sign for "man" (LU) and the sign for "great" (GAL) to make the word LUGAL ("great man"), meaning "king."

The art of writing spread fast from Sumer because of its strategic location at the center of the main trade routes that linked the continents of Africa, Asia, and Europe. The written system of Sumer was thus disseminated throughout the ancient East by the agencies of trade and travel. Those people who adopted Sumerian cuneiform for their written language perpetuated much of the myth and lore of the literature of Sumer. At the same time, they added the stamp of their own individuality and ingenuity to the art of writing.

Persian Cuneiform

Throughout the various civilizations that employed cuneiform writing, a great variety of syllabaries was in use, some of which employed hundreds of different signs in their writing. The Persians, however, had managed to refine their system to a near-alphabetic state, employing only 41 signs. Of these signs, 36 closely corresponded to alphabetic characters, four were ideographic, and the final one acted as a word divider.

This important reduction in the number of cuneiform signs appears to have been a by-product of the establishment of the Persian Empire by Cyrus the Great at the close of the sixth century B.C. The Near East was originally populated by a variety of tribal kingdoms and subkingdoms using varying languages and syllabaries. The Persians had settled the southern portion of the Iranian Plateau, which later was invaded by the Medians, a powerful tribe from the northern part. The Medians, allied with the Babylonians, launched an assault on the Assyrians — rulers at that time of most of Western Asia — defeated them, and established the Median Empire. The Persians thus became a subkingdom, within this Empire, under the leadership of Cyrus, who was not content to remain in a subordinate role for long. Within the span of a few years, he managed to subdue not only the Medians, but the Babylonians and

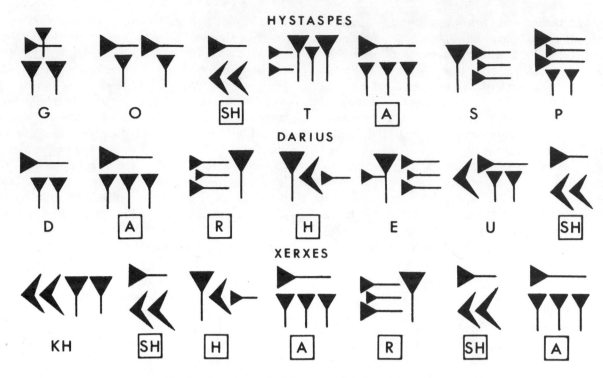

HYSTASPES

G O SH T A S P

DARIUS

D A R H E U SH

XERXES

KH SH H A R SH A

Fig. 17 Grotefend's decipherment of the name *DARIUS*.

Lydians as well, thus founding the great Persian Empire. Following a series of royal murders and intrigues, Darius succeeded to the throne of the Empire. He soon realized that due to the weakness of the kingdom, many provinces were rebelling in the hope of securing the Empire for themselves. Darius was forced to fight many battles before consolidating his power as supreme ruler.

In order to commemorate his triumphs, and to issue a warning to any future aspirants for his power, Darius caused a detailed account of his exploits to be inscribed in the face of the rock cliff at Behistun, in modern-day Iran. This record consists of a number of panels containing hundreds of lines of cuneiform text in the languages of the Persians, the Babylonians, and the Medians. This trilingual inscription was later to provide the key to cuneiform decipherment in much the same manner as the Rosetta Stone did toward the decipherment of Egyptian hieroglyphics.

The Inscriptions at Persepolis

All knowledge of cuneiform writing seems to have disappeared by the time of the Arab conquests in the seventh century A.D. It was not until the latter part of the 15th century that the first European travelers to the area were to speculate that the strange signs could be some form of writing, though certainly in no language of their knowledge. For nearly three centuries, scholars from Italy, France,

Germany, and England viewed the various inscriptions with the hope of determining the origin of this unfamiliar mode of writing. Many made copies of parts of the inscriptions in order to study them more closely, but aside from correctly determining the direction of reading and the manner in which they were executed (Engelbert Kampfer was the first to recognize the use of a wedge as the writing tool, and so gave the writing style its name), very little progress was made. In 1765, Carsten Niebuhr made almost complete and remarkably accurate copies of the inscriptions at the ancient Persian capital of Persepolis. It was he who discovered that these inscriptions occurred in groups of three. The groups always appeared in the same order, although the signs employed in each were not the same. Niebuhr reasoned correctly that the inscriptions were in three different languages and he was able to compile a list of 42 signs that he believed were alphabetic. As it later turned out, all but nine of his original signs were indeed alphabetic.

Niebuhr's copies and observations sparked a lively interest in cuneiform writing, and for the next few years and on into the 19th century, scholars worked diligently at the task of unraveling the meanings of these inscriptions. One such scholar was G. F. Grotefend, who worked on two of the inscriptional copies that Niebuhr had identified simply as *B* and *G*. Grotefend noted that the names of three members of the royal family seemed to be inscribed. An ear-

lier work that concerned the Pehlevi inscriptions, by Sylvestre de Sacy, had shown that when an inscription appeared above the figure of a king, it made references to that king and his father, and the words "King of Kings" were always present. Relying upon de Sacy's work, Grotefend determined that these names had to be related to each other and he pored over the known list of rulers to find three who would have the proper relatonship. Through a process of elimination, he arrived at the names of Darius and Xerxes, the son of Darius. He recalled that Darius was the son of Hystaspes, who was *not* a king according to Greek records. This set tallied with the known words of the inscription, which indicated that only two of the persons named were kings. Learning the Persian spelling of the name of Hystaspes, Grotefend proceeded to assign these letters to seven signs that he assumed composed the name of this individual. He then compared these with the set of signs that he concluded spelled the name of Darius, and found that two of these signs were identical to two in the previous set. The letters occupied what seemed to be their correct position and appeared to confirm both the first spelling and the identity of his second set of signs. Assigning the remaining five letters, Grotefend concluded that the spelling for Darius' name was *DARHEUSH,* but actually three of his letter assignments were incorrect.

It turned out later that the correct spelling should have been *DARYAVUSH*. This mistake resulted in the incorrect spelling of the name Xerxes, since the first two names had provided all but one phonetic value in the third name. From Greek transliterations of Old Persian, he decided that the phonetic value for the first sign of this last set was expressed by the letters *KH*. Thus, the spelling assigned to the name of Xerxes was *KHSHHARSHA,* though it should have been *KHSHYARSHA* had not Grotefend incorrectly determined the previous signs. By 1815, he had determined 12 letters correctly, to make a total of 14 signs for which correct phonetic values were known.

The Behistun Inscriptions

Figure 18 illustrates the famous monument erected by Darius to commemorate his triumphs. Cut into the sheer cliff wall several hundred feet above the land level, the inscriptions cover an area about 150 feet in length and 100 feet in height. The lower half of the inscription contains the Persian text in five columns and the Median text in three more columns. The upper half contains bas-reliefs of the king, his attendants, and political prisoners, while above the texts on the lower left is the Babylonian version. The upper right side of the monument contains four columns of supplementary text.

In 1835, a young British officer, Henry Rawlinson,

Fig. 18 The Persian inscriptions at Behistun. (Courtesy of the Trustees of the British Museum.)

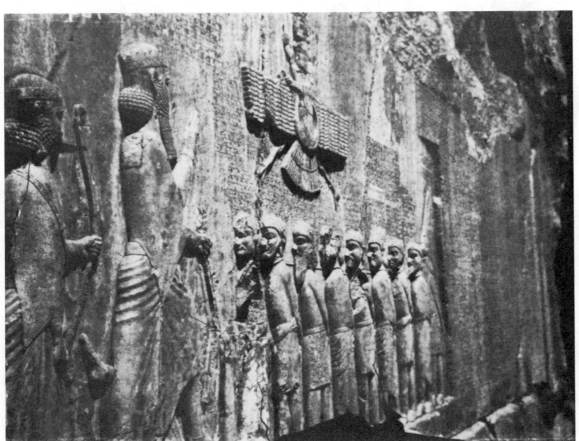

began a tour of duty in Persia. Rawlinson was an avid student of Near Eastern cultures and had studied Hindustani, Arabic, and Persian. En route to his new post, he made copies of the famous inscriptions at Persepolis that had provided Grotefend with his discoveries. Unaware of this man's work, Rawlinson independently arrived at similar conclusions, pro-

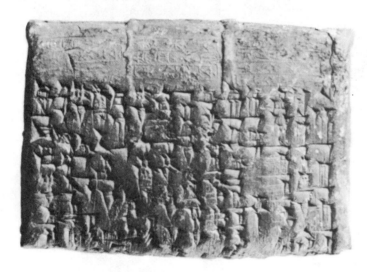

Fig. 19 Babylonian cuneiform writing. A contract for the sale of a plot of land for 2/3 shekel of silver. From Tell Sifr, reign of Samsailuna, King of Babylon, 1730 B.C. (Courtesy of the Trustees of the British Museum.)

viding himself with 13 phonetic signs. Learning of the inscriptions at Behistun, he reasoned that similar messages might be recorded there. The task of copying the Persian text required months of his free time, with the added danger of standing in a very precarious position because of the near inaccessibility of the monument. The publication of Rawlinson's trans-

lation of the Persian text was delayed until 1846 because of his service in the Afghan War. In 1847, Rawlinson returned to Behistun to obtain copies of the Babylonian text and to attempt to translate it with the help of the Persian text. By 1850, he had succeeded in identifying 150 signs and had translated about 500 words of the inscription. The cuneiform code had been broken, opening the way for the translation of the numerous Babylonian and Assyrian tablets which had already been discovered. The work of Henry Rawlinson and those before him had cleared the way for the historical reconstruction of great ancient civilizations.

Egyptian Hieroglyphics

The hieroglyphic writing of the ancient Egyptians ranks foremost among writing symbols, due both to the artistic excellence of the symbols, and to the variety and ingenuity of their designs. The word hieroglyph means "sacred writing," and is derived from the Greek *hieros* ("holy or sacred") and *glyphein* ("to carve"). It was generally believed in the Greek world that hieroglyphics were used exclusively by the Egyptian priests.

The age of hieroglyphics has long been a question of much dispute, but recent research and better methods of dating artifacts indicate that they existed in perfected form not much earlier than 3000 B.C., the earliest date now attributed to the beginning of the first royal dynasty. Egyptian dynastic history is loosely categorized as a series of eras, beginning with the Old Kingdom (3rd-6th Dynasties), the Middle Kingdom (11th and 12th Dynasties), and the New Kingdom (18th-20th Dynasties). Following the 20th Dynasty, a series of invasions disrupted the country, causing the beginning of this ancient civilization's collapse. This unsettled period came to an end with the conquest of Egypt by Alexander the Great in 332 B.C. At his death several years later, the empire he established was divided among his generals and the province of Egypt was taken over by Ptolemy, who eventually assumed the royal title of the Pharaohs and established the Ptolemaic Dynasties. At the death of Cleopatra in 30 B.C., this period came to an end and Egypt became a Roman province.

Hieroglyphics were in use throughout this time, together with the cursive forms, the hieratic and the later demotic script. By about 400 A.D., all knowledge of these signs seems to have disappeared. Although hieroglyphics were used at first for general purposes, it is unlikely that the average Egyptian citizen was capable of understanding them. There was no system of general education and the knowledge of these signs became reserved to the priesthood. Schools were established in the temple for the instruction of scribes who were needed to produce the sacred inscriptions and documents, but

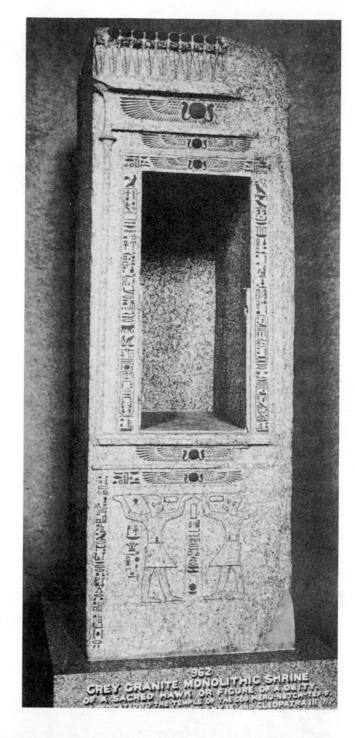

Above:
Fig. 20 Egyptian hieroglyphic writing. A limestone statue of Rameses II inscribed with his royal cartouche. From the 19th Egyptian Dynasty, 1300 B.C. (Courtesy of the Trustees of the British Museum.)

Right:
Fig. 21 Egyptian hieroglyphic writing. A granite monolithic shrine inscribed with hieroglyphic symbols from the Ptolemaic Period, 150 B.C. (Courtesy of the Trustees of the British Museum.)

Below:
Fig. 22 Egyptian hieroglyphic writing. Hieroglyphic symbols carved on the sarcophagus of Princess Ankhnesneferibre. From the 26th Dynasty, Thebes, 525 B.C. (Courtesy of the Trustees of the British Museum.)

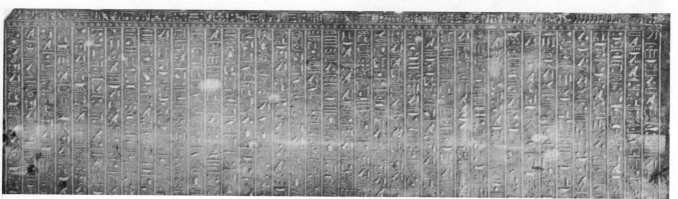

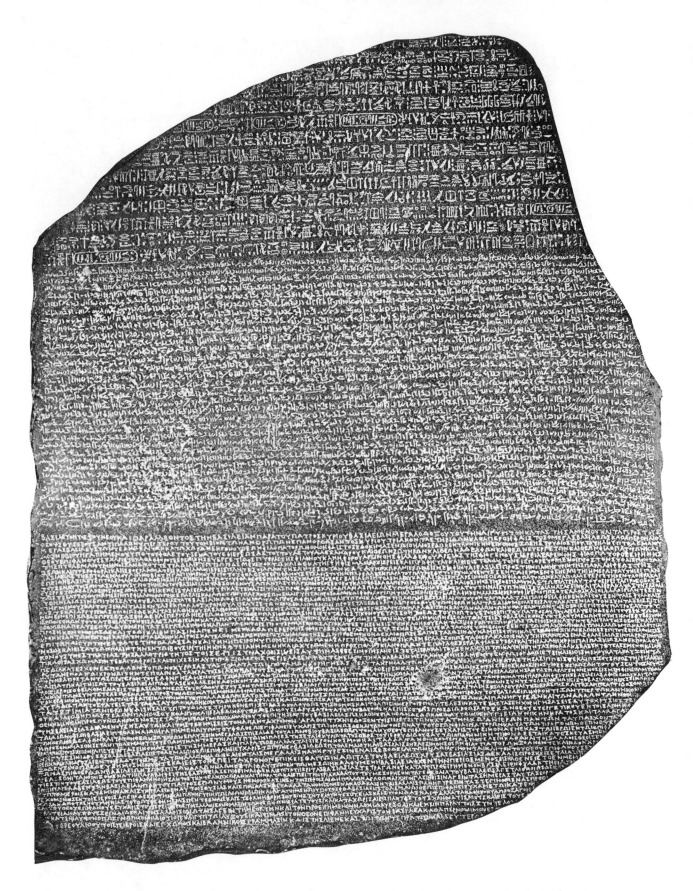

Fig. 23 The Rosetta Stone (basalt, 3 ft. 9 in. high), from Fort Julien, Rosetta, during the Ptolemaic Period, 196 B.C. The inscription is a decree of the priests of Memphis conferring divine honors upon Ptolemy V, Epiphanes, King of Egypt. This stone enabled Champollion to break the hieroglyphic code. The upper inscription is in hieroglyphs, the middle inscription is in Egyptian Demotic, and the lower and original inscription is in Greek. (Courtesy of the Trustees of the British Museum.)

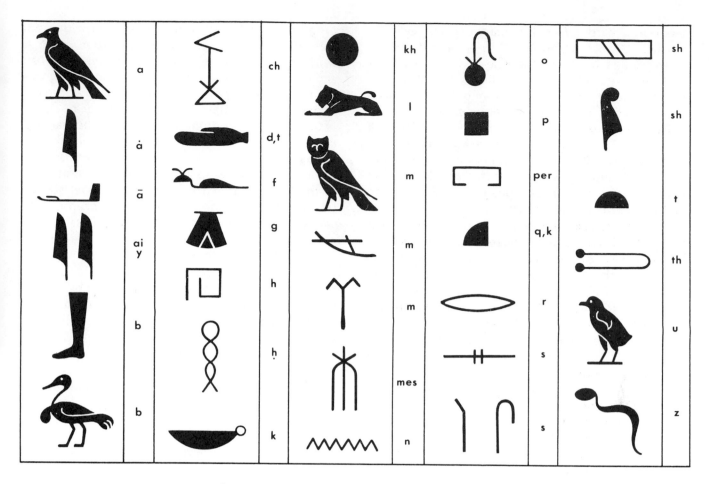

Fig. 24 The more common symbols comprising the Egyptian "Alphabet."

this program embraced a very small number of the total population. The introduction of Greek during the sixth century B.C. was perhaps the beginning of a decline in the use of hieroglyphics as the predominant written language form. By the time of Ptolemy, Greek had become the Egyptian court language and all important inscriptions were written in Greek, hieroglyphics, and demotic. Following the advent of Christianity, the decline of hieroglyphics and their other forms was rapid. By the fourth century A.D., the Christians were powerful enough to cause the closing of the ancient temples and the schools that they supported. There were few left who could write and understand hieroglyphics, and the removal of the source of instruction in this ancient mode of writing doomed it to obscurity. All knowledge of the language system vanished, remaining hidden until the early years of the 19th century — over 1,400 years.

The Rosetta Stone

Interest in the strange hieroglyphic signs appears to have been revived toward the end of the 16th century, gaining impetus during the following two cen-

turies. The work of a 17th-century Jesuit priest and mathematician named Kircher, whose attempts at decipherment were both misleading and nonsensical, was exciting enough to focus the attention and interest of the scientists of the day on finding a solution to the riddle posed by these ancient signs. Although the labors of these respected individuals were to provide some insight for succeeding investigators, the net results of these endeavors added little to that already known or surmised. Toward the end of the 18th century, two opinions had been ventured that would soon thereafter be of great significance. First, it was suggested that some of these signs might be determinative signs rather than alphabetical ones; and, second, it was thought that the oval rings (later known as *cartouches*), found as prominent devices in hieroglyphic inscriptions, might contain a message or word of more than ordinary importance — a magical word or a royal name.

During the summer of 1799, a chance find at excavations near the Rosetta mouth of the Nile was to change discouragement and frustration to ultimate triumph, by providing the key to decipherment of Egyptian hieroglyphics. Under the direction of

Pierre Bouchard, a French military engineer, soldiers unearthed a basalt slab 3 ft. 9 in. long, 2 ft. 4½ in. wide, and 11 in. thick, one side of which was covered by three different inscriptions. The stone was damaged and the upper and middle inscriptions were unfamiliar, but the lower one proved to be written in Greek, which could readily be interpreted. Fortunately, the value of this find was quickly realized and brought to the attention of European scholars. Shortly afterward, the French were defeated in Egypt and the British took possession of the stone and housed it in the British Museum.

After the Greek inscription was translated, it was found that it concerned a decree issued in 196 B.C. by the priests of Memphis in honor of Ptolemy V, Epiphanes, the King of Egypt. This decree extolled the virtues of Ptolemy toward his people, but, more important, it stated that copies (one of which was the Rosetta Stone) of the decree were to be made, written in hieroglyphic, demotic, and Greek signs, and were to be placed in every first-, second-, and third-class temple. This established that the two forms of the Egyptian writing, the "sacred writing of the gods" and the "writing of the people," were translations of the Greek.

Early attempts at decipherment, using the Greek version as a key, were generally unsuccessful because of the assumption that the demotic signs were entirely alphabetic, which was not the case. Investigation centered on the demotic text because it was the most complete of the three and offered the most immediate hope of translation. After a great many theories had been advanced, the Rosetta Stone gained the attention of the famous scientist and scholar, Dr. Thomas Young, who was able to confirm the earlier opinions that the cartouches contained royal names, and to determine the direction in which they should be read. He also suggested the partial alphabetic nature of the signs and theorized as to the use of determinative signs to distinguish homophones. Although Dr. Young never continued his investigations to the point of decipherment, his discoveries and theories were an important step toward unlocking the mysteries of hieroglyphics.

Champollion

The man who eventually reaped the honor and acclaim accompanying the successful decipherment of hieroglyphics was Jean François Champollion, a French scholar who had developed, early in life, an abiding interest in Egyptology. Through exhaustive research and study, he correctly determined the phonetic sounds for the signs within the royal cartouches to be those for Ptolemy V, Cleopatra, Rameses, Tutmosis, and many others, thus providing the key for a correct system of decipherment. The translations of the names *Ptolemy* and *Cleopatra* provided him with 12 alphabetic signs as a base from which to work, while the translations of *Rameses, Tutmosis*, and others demonstrated correctly that hieroglyphics were pictographic and ideographic, as well as phonetic, often within the same word or phrase.

Champollion was long familiar with the name of Ptolemy through his own research and that of others. Dr. Young had earlier translated this king's name from its royal cartouche, but, being unaware of the Egyptian practice of omitting vowel sounds, he came to an incorrect conclusion regarding the spelling. When he attempted to apply the same phonetic sounds in the translation of other hieroglyphic words, the results were unsuccessful. Following Dr. Young's reasoning that this name could be read phonetically, Champollion constructed it by sounds, working from the Greek into demotic, from demotic to hieratic, and finally into hieroglyphics. The identity of this first name did not constitute sufficent proof of the validity of his discovery; he needed a second name containing some of the identical signs which composed the name of Ptolemy to assure him of his success.

A fortunate circumstance occurred in the discovery of a stele from the island of Philae that was inscribed both in hieroglyphics and in Greek. Within the hieroglyphic portion of the inscription were a number of cartouches identified as belonging to Ptolemy and Cleopatra. Champollion received a copy of this inscription and realized that he was confronted with the opportunity he had sought so patiently. He had many times composed the name *Cleopatra* into hieroglyphs from a demotic papyrus source, though he had never seen her cartouche to verify his version. To his happy amazement, the cartouche of Cleopatra was constructed exactly as he had envisioned it would be. Three of the signs were identical to three in Ptolemy's name and they were in their proper positions in the word according to the spelling of Cleopatra's name as furnished by Greek and demotic records. The others corresponded correctly to his earlier deductions. Champollion was thus in possession of 12 alphabetic signs which he proceeded to put to a further test. Selecting a third cartouche, he proceeded to compare these new signs with those already established. Of the nine signs contained in the third cartouche, he already knew the phonetic values of six: *AL SE TR*. The only Greek name which could be identified with these letters was *Alexander*, which supplied him with three more signs. In a very short time, Champollion had deciphered over 80 more cartouches with complete success, verifying the authenticity of his discoveries with absolute certainty.

For some time, Champollion had only been able to test his alphabetic signs on the names of royalty

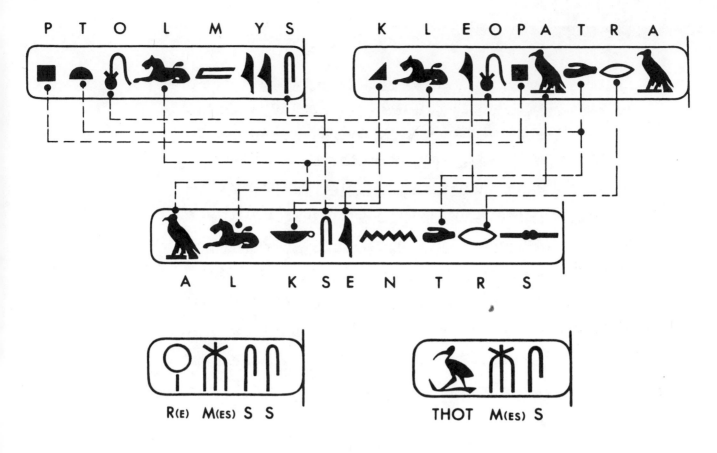

Fig. 25 Champollion's decipherment of the words "Ptolemy," "Cleopatra," "Alexander," Rameses," and "Thutmosis."

who had existed after the advent of Greek influence in Egypt. Dr. Young had earlier ventured the opinion that the phonetic signs of the hieroglyphic system were developed under Greek influence, thus inferring that the hieroglyphs of earlier dynasties had not been developed to the phonetic stage. Champollion was eager to test his new knowledge on groupings of older signs, but it was not untill 1822, when he received copies of bas-reliefs from an Egyptian temple, that he was able to do so. These reliefs predated the Graeco-Roman period and contained cartouches which he hoped would represent royal names of an earlier period. One of these contained in duplicate the sign for the letter S, as used in the cartouche of Ptolemy. Using his knowledge of Coptic (the language of the Christian Egyptians of the Upper Nile, known as Copts) Champollion reasoned the the first sign, which represented the sun, was RA. With the help of Greek and Coptic, he decided that the middle sign appeared to mean "birth" or "be born," which was expressed by the letters MS. When he placed these letters in order (RA MS SS), they spelled the name of Rameses and interpreted

the meaning of his name as the "child of Ra." Excited by the translation of his first truly Egyptian name, Champollion applied the same process to another cartouche, which was composed of three signs. Two of these signs were found in the previous cartouche (MS S) and the third sign (first in the group) was a representation of the god Thoth. These letters together created THOTMSS, which had to mean the Pharaoh Thutmosis or Tutmosis of the 18th Dynasty. These translations proved that alphabetic signs were in use prior to the introduction of Greek influences and that the hieroglyphics were not entirely phonetic.

Champollion announced his discoveries to the world in a paper in 1822 and again in 1824 through his paper, Précis du Système Hieroglyphique. He continued to expand his work until his death in 1832, and it was not until 1836, four years after this untimely event, that his Grammaire Egyptienne was published. Champollion had accomplished an astounding and remarkable feat by solving one of man's most perplexing riddles, and had brought great honor and fame unto himself and France.

Above:
Fig. 26 Egyptian hieratic writing. A sheet from the great Hamt Papyrus, 1 ft. 4½ in. high (sheet #79) written in hieratic symbols, from the 20th Dynasty, 1166 B.C. (Courtesy of the Trustees of the British Museum.)

Right:
Fig. 27 Egyptian demotic writing. The upper part of a document written in demotic symbols on papyrus in 270 B.C. (Courtesy of the Trustees of the British Museum.)

The Hieratic and Demotic Scripts

The Egyptian written language is found in three different variations: hieroglyphics — "the writing of the gods," hieratic — "the writing of the priests," and demotic — "the writing of the people." The last two are evolved from hieroglyphics. Hieratic writing is a cursive, conventionalized form of hieroglyphics, retaining much of the character of the earlier signs. It appears to have come into use not long after hieroglyphics and corresponds roughly to the handwriting of today. Hieratic was written with a reed pen and ink upon papyrus, rather than incised into stone, and was used by the priests for literary compositions, secretarial items, religious tracts and the like. The name *hieratic* comes from the Greek word *hieratikos,* meaning "sacerdotal, or priestly" (Fig. 26). The demotic script was the running hand used by the populace and came into being during the 25th or 26th Dynasty. Its name is derived from the Greek word *demotikos,* meaning "of the people." This script is derived from hieroglyphics through the hieratic script and therefore bears little resemblance to the sacred signs. The demotic was a rapid and abbreviated hand, and could be compared to today's shorthand. The demotic was one of the two Egyptian written forms used on all important documents and monuments and was in use until the fifth century A.D. (Fig. 27).

THE EVOLUTION OF THE ROMAN ALPHABET

A growing influence of the Semitic people inhabiting the Levantine coast of the Mediterranean Sea, now known as Lebanon, was contemporaneous with the rise of the Egyptian Old Kingdom in 2700 B.C. These Semites are loosely divided into two groups: the Amorites in the North, influenced by Sumerian culture; and the Canaanites in the South, influenced by Egyptian culture. Among the latter group were the Phoenicians, who inhabited a narrow strip of fertile coastland that they called Phoenicia. This ancient country was composed of a group of politically autonomous city-states, among which were the great cities of Byblos, Tyre, Sidon, and Beirut. In each city a different dialect of the Phoenician language was spoken. It was from these communities that the first great merchant fleets sailed to every major port in the known world.

The Phoenicians

The Phoenicians were a highly skilled, intelligent, and energetic people who developed a vigorous economy based on manufacturing, as well as a mercantile trade. Some of the finest examples of glass, metalwork, and pottery are attributable to the skills of these people. They were master craftsmen in the carving of ivory and the production of fine jewelry and furniture. They excelled in the production of dyestuffs — the purple dye produced from the murex shellfish was highly favored by royal and wealthy families of many lands for making purple cloth. The Phoenicians did not excel in architecture, sculpture, or other monumental works, preferring to put their efforts into the production of mobile pieces which could easily be exported. They were not a particularly creative people, but they could adopt, modify, or imitate from the cultures of others so skillfully that their products were in great demand. They assimilated the culture and arts of other lands with ease, incorporating into their own that which was most practical and likely to be useful.

The Phoenicians were the first to ply the seas with a great merchant fleet; they traded with many lands and conducted business with people of differing languages and customs. Their many contacts with the peoples of the Mediterranean contributed much to the growth of civilization in the area, since they disseminated culture in addition to commercial and industrial knowledge. To facilitate the growth of their trade, they established numerous trading outposts, many of which grew in time to become important and powerful cities. One of the best known of these was Carthage, situated on the African coast across from the Italian peninsula — for a time it rivalled even the influence of Rome. The Phoenician traders sailed as far as the Azores and Britain in search of new markets and new sources of raw materials. Although they are remembered for their great achievements as traders of the sea, the Phoenician people are usually associated with a far greater feat: the origination and dissemination of the first alphabetic system of writing.

The Phoenician Alphabet

Exactly how the Phoenicians first developed the alphabet is unknown, but the oldest known alphabetic inscription has been dated from the tenth century B.C., and was found on the tomb of Ahiram, a king of Byblos. A number of theories have been advanced as to the origin of this written system, but none of these is entirely satisfactory or convincing. It is now the general belief that the development of the alphabet was influenced by outside cultural sources and was not a completely internal development of Phoenician culture. There is much in support of this conviction, though virtually nothing exists in the way of conclusive proof that might favor one contributing culture over another as the leading influential source.

Since the Phoenicians were for the most part eclectic, it would seem that they would have taken

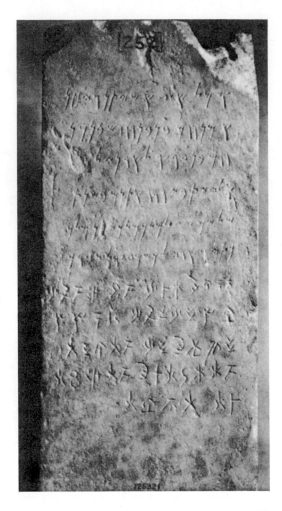

Fig. 28 Phoenician writing. A stone monument with bilingual inscriptions in Phoenician and Greek Cypriot script. For the dedication of a statue to Reshef Eliyath by Menahom, son of Ben-Hodesh, from Tamassos, Cyprus, 363 B.C. (Courtesy of the Trustees of the British Museum.)

Fig. 29 Phoenician writing. A bilingual inscription, Phoenician on the left, and Namidian on the right. From the Mausoleum of 'Atban at Dhugga, Tunisia. (Courtesy of the Trustees of the British Museum.)

an approach to their written language development consistent with their national character. Logically, the written system would have developed along composite lines, influenced by and adapted from a number of cultural sources and merged with internal influences and ideals. As merchants on an unprecedented scale, requiring the simplest and most efficient form of communication that they could devise to ensure the speed and accuracy of their transactions, an alphabet composed of a limited number of phonetic signs would be extremely beneficial.

The "invention" of an alphabet must have required centuries of modification and development of earlier non-alphabetic forms. Historically, the development of a written system progresses through several well-defined stages. This represents a long process of evolution and there is no reason to assume that the Phoenician alphabet developed otherwise. The people of Phoenicia are believed to have emigrated originally from the Sumerian valley, thus providing them with ancestral links to early Sumerian pictography as well as to the old Linear Babylonian, and Sumerian and Babylonian cuneiform signs. The influence exerted by the Egyptian civilization was great, though curiously there seems to have been little relationship between the Phoenician linear symbols and the Egyptian hieroglyphic and hieratic signs. The Egyptians were in control of Phoenicia from 1600-1200 B.C., and there is evidence that establishes that about 2000 B.C., Semitic workers in Egyptian mines were influenced by a near-alphabet developed from hieroglyphs.

In 1859, a theory was advanced by the Frenchman Emanuel de Rouge that credits the Egyptian hieratic signs with being the basic origin of the alphabet. His work was based upon an early hieratic papyrus and a Phoenician tomb inscription, written 2,000 years apart, by which he established a relationship be-

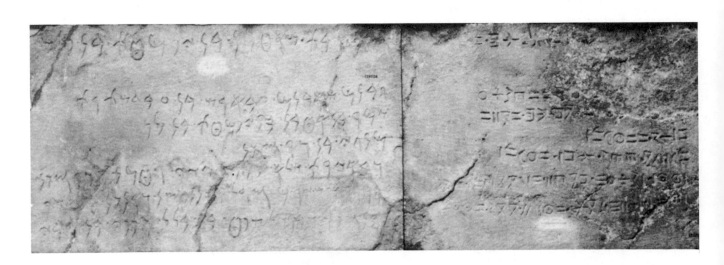

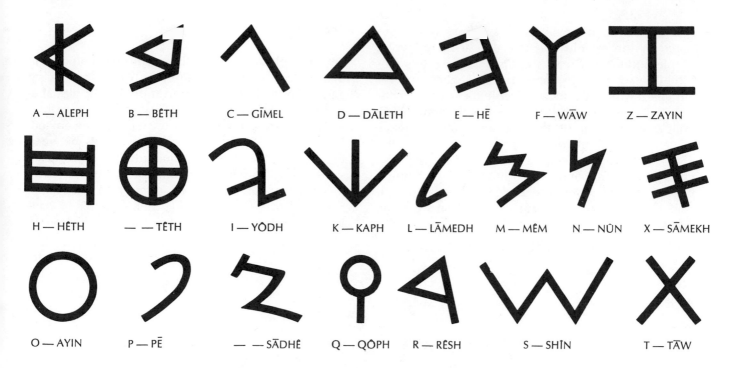

| A — ALEPH | B — BÊTH | C — GÎMEL | D — DĀLETH | E — HĒ | F — WĀW | Z — ZAYIN |

| H — HÊTH | — TÊTH | I — YŌDH | K — KAPH | L — LĀMEDH | M — MÊM | N — NŪN | X — SĀMEKH |

| O — AYIN | P — PĒ | — SĀDHĒ | Q — QŌPH | R — RÊSH | S — SHĪN | T — TĀW |

Fig. 30 The Phoenician alphabet.

tween the hieratic and Phoenician signs. Scholars who dispute this theory point out that De Rouge greatly modified both sign groups in creating his relationships; that the time interval existing between the two sets of writing was too great for reliable conclusions; and that the amount of individual freedom given the early scribes in formulating the hieratic signs makes these documents unreliable for comparison. Many scholars favored De Rouge's theory and others took a "middle of the road" stand, professing a belief that it was likely that some Egyptian signs were assimilated into Phoenician writing development, but that the process of modification altered their original forms to such an extent that tracing them back to Egyptian sources was scientifically impossible without corroborative documents. Unless documents can be found that will provide evidence of such stages of transformation, it is unlikely that the question of Egyptian origin will ever be answered.

The Greeks

The Greeks are descended from the tribes that settled in the northern part of Greece sometime before 3000 B.C. These people are believed to have emigrated from the Near East, and their economy was based primarily on agriculture. They were familiar with the use of stone for the fashioning of implements and traded with other tribes by land and by sea. Their nautical skill was developed early, and it was probably through their trade activities that they learned the use of bronze by 2500 B.C. The early

Greeks eventually gained control of most of the Aegean Islands, and established the beginnings of the expansive civilization centered on the island of Crete soon after 2500 B.C. The great Mycenaean culture, which was established on the Greek mainland around 1700 B.C., was a product of the strong influence of the Cretan civilization.

Greek history begins with the Mythical Period, which saw the movement of the numerous Greek tribes from the upper portion of the Balkan peninsula into the southern Peloponnesus, the Aegean coast, the Aegean Islands, the coast of Asia Minor, and the islands of Crete and Rhodes. It was during this period, lasting from 2000 to 1000 B.C., that the seige of Troy took place — the year is said to have been 1184 B.C. The next stage witnessed the rise of numerous autonomous city-states, ruled by the great landowners in a manner comparable to the feudal system of the European Middle Ages. The rival city-states of Sparta and Athens were to rise to power as a result of the ensuing struggle and turmoil among these states. Sparta's regime was essentially a military one while Athens developed from a tyranny to a democracy. This period, lasting from 1000 to 499 B.C., heralded the supremacy of Greece upon the seas — a time when Greece established colonies and increased its level of trade.

The next historical period was brief, from 499 to 338 B.C., and was highlighted by the Persian Wars and the "Golden Age of Pericles" (461-429 B.C.), when Greek culture, under the leadership of Athens, reached its zenith in almost every field of endeavor.

The last period of ancient Greek history was dominated by the establishment of the far-flung Empire of Alexander the Great; the dissolution of this empire upon his death; and the subsequent power struggles which culminated with the Roman conquests toward the end of the second century B.C. Following the fall of the Roman Empire, Greece came under the rule of the Byzantine Empire. In the 15th century, this empire was dissolved by the emergence and conquests of the Turkish Empire. Greece did not attain independent status again until 1829, at the close of its war of liberation from the Turks.

The Greek Alphabet

The Phoenicians apparently established colonies in in the Aegean area sometime between the twelfth and tenth centuries, and transmitted their alphabet to the Greeks about 1000 B.C. It is unknown from which city-state in Phoenicia the alphabet emanated, but comparisons show a marked similarity between the earliest Greek inscriptions and the Phoenician signs known to have originated in Byblos. Whether this system was introduced directly to the Greek mainland or through Crete is still a matter of conjecture, and it is possible that the introduction to

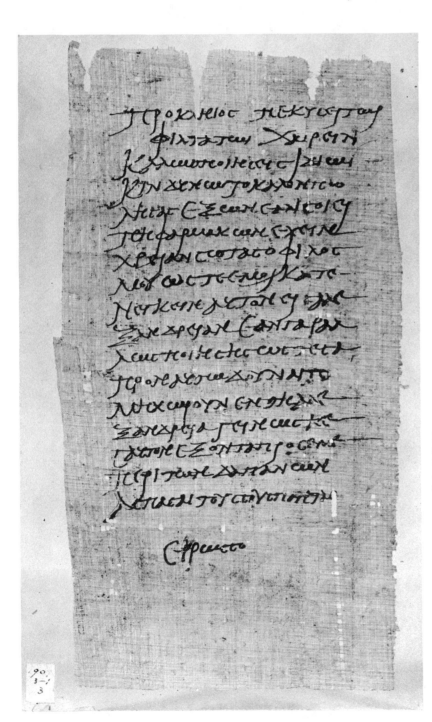

Fig. 31 An example of Greek cursive script written on papyrus with a stylus. This is a letter from Prokleios to Pekysis concerning drugs. From Alexandria, about the first century A.D. (Courtesy of the Trustees of the British Museum.)

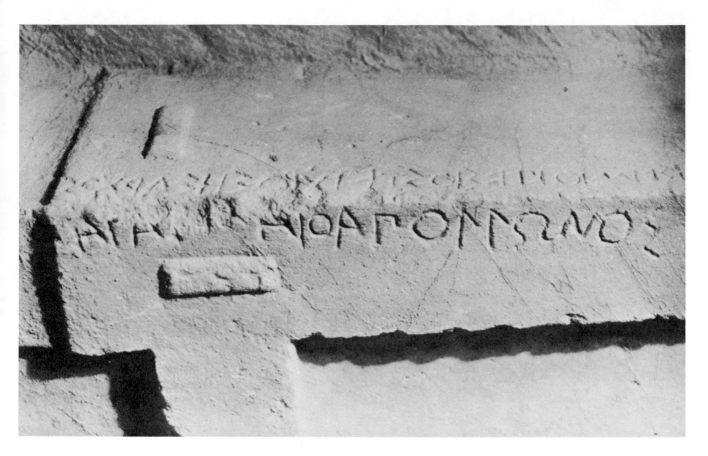

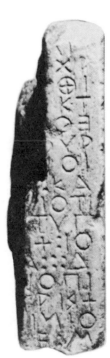

both areas may have occurred almost simultaneously, and independently. The alphabet may also have been transmitted from the city of Tyre by way of the Aegean Islands. Archaeological research being conducted in these areas may yet uncover evidence that will conclusively support one theory or another. It appears unlikely, with present knowledge, that the alphabet would have been disseminated in any manner other than those indicated.

The earliest Greek inscriptions used signs that were almost pure Phoenician, written from right to left in the Semitic manner. Sometime later, a new method was adopted — that of "boustrophedontic" writing (lines of writing running alternately left to right and right to left, as the oxen turns in plowing). Existing examples demonstrate a great degree of experimentation with this manner of writing by early scribes. Their writing variously occurs in at least the following forms: (1) The usual form of boustrophedontic writing employing the alternation of line direction; (2) the inversion of characters, usually alternating with line direction; and (3), the outward spiraling of the characters from a central point and varying in direction, sometimes spiraling outward to the right, sometimes to the left. It would seem that these were attempts to produce writing that was continuous and uninterrupted. The growing tendency toward left-to-right line direction eventually gained superiority over the others.

Fig. 32 Greek boustrophedon writing. (A) A Greek boustrophedon inscription on a marble chair. It reads: "I am Chares, son of Kleisis, ruler of Teichioussa. The statue belongs to Apollo." From the Sacred Way at Branchidae, 540 B.C. (B) A fragment of a boustrophedon inscription relating to the perquisites from sacrifices. From the middle of the sixth century B.C. (Courtesy of the Trustees of the British Museum.)

Fig. 33 Part of an inscribed Punic stele describing sacrificial rites. From the fourth or third century B.C. (Courtesy of the Trustees of the British Museum.)

Fig. 34 A statement of disbursements and loans made from the treasury of Athena in the years 415-414 B.C. From Athens, Greece. (Courtesy of the Trustees of the British Museum.)

44

Fig. 35 A metrical epitaph on the Athenians who fell at Patidaea, 432 B.C. From Athens, Greece. (Courtesy of the Trustees of the British Museum.)

The Greeks do not appear to have continued the use of pure Phoenician signs for very long as they soon adapted and modified them to suit the particular requirements of their language. Early inscriptions found at Thera, dating from the middle of the seventh century, provide evidence that this process of modification had already begun. Each of the city-states utilized its own form of the alphabet; variations appeared in the style of characters as well as in size and proportion. These local alphabets may be classed into two groups: (1) the Eastern variant, which later was the basis for the Ionian alphabet adopted as the standard at Athens in 403 B.C.; and (2) the Western variant, which included those alphabets used in Northern Greece and the Peloponnesus, as well as the one that was introduced to the Italian peninsula by the Chalcidian colonists who dominated Thrace and Italy sometime after the tenth century B.C. This latter alphabet had a direct influence on the development of the Roman alphabet.

The Greek alphabet is composed of 24 letter-signs, as compared with the 22 Phoenician signs. The Greeks contributed to the alphabet the true vowel sounds (A-E-I-O-U) by modifying the Phoenician sounds *aleph, he, yod,* and *ayin* into *alpha, epsilon, iota,* and *omicron,* and by developing a new letter-sign, *upsilon,* from the Phoenician sign, *vau.* The Greeks dropped two Phoenician signs and added, in addition to *upsilon,* four more signs, *phi, chi, psi,* and *omega.*

Fig. 36 The dedication of the temple to Athena Polias, by Alexander the Great. From the Temple of Athena Polias at Priene, about 334 B.C. (Courtesy of the Trustees of the British Museum.)

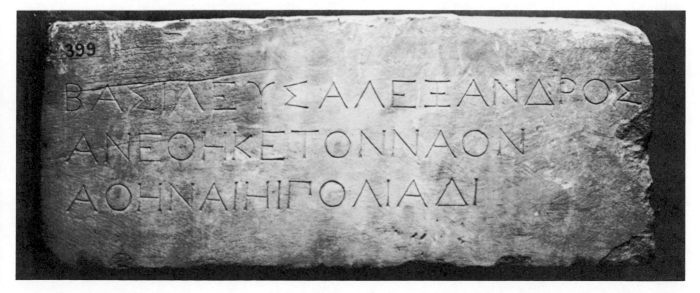

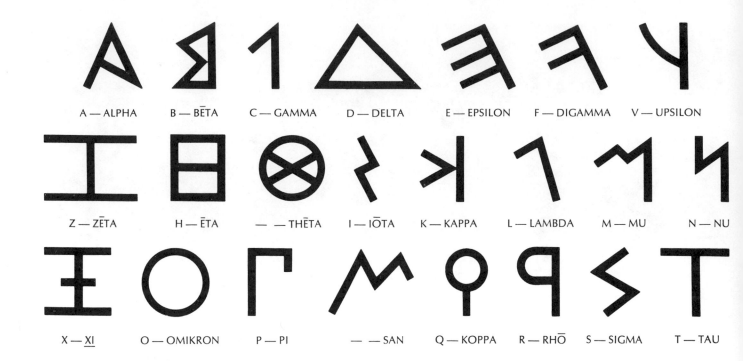

Fig. 37 The Greek alphabet.

The Greeks also modified some of the forms of the original Phoenician signs, bringing them closer to the forms that they would later assume in the Roman alphabet. The Phoenician aspirate, *cheth*, lost its upper and lower bars and became the *H* of the Greek and Roman syllabaries. One bar of the sign *mem* was discarded, and the horizontal bars of the sign *he* were elevated to a position parallel with the writing line, although the vertical bar continued to drop below the lower horizontal bar until very late in the development of *epsilon*. *Daleth*, the sign for *D*, represented by the Greek delta, lost its tail and assumed a horizontal position on its base.

The sign for *S*, represented in Phoenician by *shin* and in Greek by *sigma*, shows an interesting development of form. It is represented in a number of ways in both the Eastern and Western variants of the Greek alphabet. One of the Western forms (ϟ), used by the Chalcidians, is identical to an inverted Roman *S*. In both the Greek and Phoenician alphabets, the signs for *M* and *S* were inconveniently close in appearance, and it was necessary to modify one of them. The Phoenicians solved the problem by lengthening the first bar of the *M*, while the Greeks tilted the sign for *S* on its side in a vertical position.

The Etruscans

A number of conflicting theories have been presented concerning the origin of the people called the Etruscans. Herodotus wrote that a great famine, sometime before the tenth century B.C., in the coun-try of Lydia, caused a vast number of the population to emigrate under the leadership of their King's son, Tyrrhenius. Reaching the northern shores of Italy, they settled and prospered, calling themselves Tyrrhenians, in honor of the prince who had led them to this new land. The Romans called these people Etrusci, and the land that they dominated was known as Etruria. Other theories favor the idea that they were descendants of an ancient Oriental race who settled in the northern part of the Italian peninsula about 1000 B.C. The fact that many Etruscan artifacts evoke an Oriental feeling may give rise to this theory, but Etruscan art is not Oriental in origin. Etruscan architecture, particularly its tomb structure, is extremely similar to that found in Anatolia (modern Turkey). This fact would tend to support the theory of Lydian origin, as would the known facts relating to their religion, language, and special respect for women, all of which are characteristics of older Eastern civilizations centered in Asia Minor. Another theory credits them with being a people indigenous to Italy, but there seems to be no evidence to support it adequately. It would seem, therefore, that Herodotus was correct, and that it was neither Greek nor indigenous cultures that influenced the Etruscan development.

It is now fairly certain that no form of civilization existed in Italy or Western Europe prior to 1000 B.C. Shortly thereafter, however, there is evidence of a people called Villanovians (after the name of the town that provided the best archaeological finds on these people), who occupied the area of Etruria

Fig. 38 Etruscan writing. The bronze rim of a large mixing bowl said to have come from Bolsena about the third century B.C. (Courtesy of the Trustees of the British Museum.)

Fig. 39 Etruscan writing. An Etruscan sarcophagus for Toscanella, about 200 B.C. (Courtesy of the Trustees of the British Museum.)

Fig. 40 Etruscan writing. A fragment of a stemmed dish with a painted Etruscan inscription. (Courtesy of the Trustees of the British Museum.)

and were skilled in the use of iron. These people are thought to have emigrated from what is now Yugoslavia, around 900 B.C., and were either overrun or absorbed by the Etruscans. The Pelasgians, one of the earliest Greek tribes, had occupied Etruria prior to the Etruscan domination, and their eventual absorption imparted Greek culture and disseminated Greek writing throughout the Etruscan civilization. Greek colonization by the Chalcidians during the eighth century B.C. brought with it the Western variant of the Greek alphabet. Although previously they were relatively unaffected by outside influences, the Etruscans eagerly adopted the Greek culture.

Ancient Etruria occupied the area of northern Italy from the Arno River to the Tiber River, and from the Apennine Mountains to the Tyrrhenian Sea. Many famous Italian cities are of Etruscan foundation, among them Pisa, Florence, Rome, Assisi, and Perugia. The Etruscans developed politically autonomous city-states that were loosely consolidated under a central chieftain who occupied the position of priest-king. Their mineral resources were of prime importance to the Etruscan economy, especially during the period when Greece and Phoenicia were struggling for control of the supply sources of raw materials. There is ample evidence to show that the trade of these minerals supplied the gold, silver, ivory, and other precious commodities that the Etruscans favored for the decoration of their persons, artifacts, homes, and tombs. These people, though aggressive and warlike, were also endowed with those qualities that enabled them to respect and desire the finer and more culturally enlightened aspects of a civilization. These qualities were of immense significance because they influenced the Romans, whose empire was to become the highly influential vehicle for the spread of culture and knowledge. The rising influence of the Roman tribes to the south soon challenged the authority of the Etruscans. One Etruscan city after another fell to the Romans until Etruria was absorbed into the Roman Republic in 250 B.C.

The Etruscan Alphabet

Little remains of Etruscan writing, and there was virtually no literature, so the decipherment of Etruscan script and an understanding of the language has become a long and uncompleted task. Though their alphabet is known and the documents and monuments containing writing can be read, their language remains as yet unknown. Over 9,000 Etruscan inscriptions have been uncovered, but most of them are very short, since they are primarily tomb inscriptions containing only names and family data. In addition, a mummy bandage discovered in Egypt was found to be inscribed with a text containing about 5,000 Etruscan words, but this text is mono-lingual and there is no known cognate that could supply a means of decipherment by language comparison. Our knowledge of Etruscan culture has come principally from the study of their artifacts and from Roman and Greek writings.

The Etruscan alphabet was borrowed from the Greeks in the eighth century and modified according to their language requirements. The alphabet contains 21 basic letter-signs, although a great variety of variant signs is evident. Notable are the late forms of the M and N, which are remarkably similar in form to those of the English minuscule m and n, developed centuries later. Another peculiarity is the use of the figure 8 sign to represent the letter F. Unless a bilingual text of sufficient length can be found, its is uncertain how much more progress will be made toward an understanding of the Etruscan language.

The Romans

The Romans, an early Latin tribe, occupied the land area around the lower reaches of the Tiber River sometime after 1000 B.C. These people founded a hamlet, situated at a ford in the Tiber, which was to become the powerful city of Rome. The development of Rome was slow; in fact, it was little more than a village at the time the Etruscans occupied it in the seventh century B.C. It rapidly grew into a fortified city under the pressures of the aggressive Etruscans and, by 500 B.C., the conquerors were expelled and a republic was established. After a century of regression, the Roman people were to achieve a lasting unity and strength that would enable them to establish the Roman Empire. The Etruscans were totally defeated by the third century B.C., and Rome had annexed the whole of the Italian peninsula to its republic by 218 B.C.

Roman history can be categorized into three general periods: (1) the Regal Period (735-509 B.C.), during which the rule was by a monarchy under the influence of the Etruscan hierarchy; (2) the Republican Period (509-27 B.C.), during which the Romans achieved power and influence, defeating the Etruscans and others to gain control of the peninsula, parts of Western Europe, much of the western Mediterranean, Greece, Egypt, and Asia Minor. The Roman Empire was firmly and incontestably established; and (3) the Imperial Period (27 B.C.-476 A.D.), inaugurated by Augustus Caesar and distinguished as a period of intense internal strife and civil war; the advent of Christianity; and the final dissolution of the Empire, resulting from a split into two parts that occurred in 395 A.D. The eastern half became the Byzantine Empire, which lasted into the 15th century, while the western half was beseiged by barbarian invasions and brought to an end in 476 A.D.

The Romans were a unified people having a nat-

Fig. 41 A page from the Gospels, written on parchment in Roman uncial script. From about the third or fourth century A.D. (Courtesy of the Trustees of the British Museum.)

ural aptitude for organization and government. From the Etruscan influences they had inherited spirited and aggressive natures, while from Greek influences they had developed a taste for elegant design and the finer offerings of a civilization. They developed a strong literature and excelled in the art of oratory. As a result of the permanence of their empire, with its widespread influence, the Roman alphabet was introduced to many lands. Roman culture, and those other cultures that it perpetuated through its art and literature, were transmitted to most of the known world.

The Roman Alphabet

The Roman alphabet was composed of 23 letters and, almost without modification, was the model for the later English alphabet. The alphabet of the Romans was developed through the influences of both the Pelasgian Greek alphabet and the written system of the Etruscans, the Pelasgian being a prototype for both Etruscan and Latin alphabets. Like the Greeks and Etruscans before them, the Romans rejected certain letter-signs because of different language requirements. However, they retained 20 of

49

Fig. 42 A Roman inscription in bronze from about 200 A.D. (Courtesy of the Trustees of the British Museum.)

50

the Greek symbols, restoring the *F* (*digamma*), the *Q* (*koppa*), and the *Z* (*zeta*). They borrowed the *Y* (*upsilon*) and invented the *G* to express the voiced guttural stop of *K*, formerly expressed by the *C* in Greek. The addition of the *G, Y,* and *Z* brought the final total of letters to 23. The Roman direction of writing was from left to right, in the manner of the Pelasgian and later Ionic Greek. It is interesting to note that the Etruscans, however, continued their system of right-to-left writing long into the periods of Greek and Roman influence. Roman writing is distinguished from earlier systems by its well-defined uniformity of size and appearance, exhibiting good letter alignment and word spacing, and an aesthetic design treatment. The Romans used the dot early as a means of word spacing, and were the first consistently to clarify in this way the reading of their written language. Early inscriptions offer evidence of an increasing use of abbreviations by scribes and this seems to have occurred in most Roman documents. A modern-day scholar of Latin inscriptions and manuscripts must be familiar with a vast array of abbreviations, for the Roman scribes applied extreme freedom of variation in the performance of their profession.

The number of existing Roman inscriptions and documents is vast and varied, affording a well-established record of the transitions through which their writing system developed. The foundations of the Roman alphabet were contributed by the Greeks through the Phoenician system; the structure was provided by the early cultures on the peninsula: the Chalcidian colonists, the Pelasgians, and the Etruscans; but the final perfection and aesthetic beauty of the alphabet was the product of Roman culture. The Romans created letters of grace and dignity by using subtle weight proportions, serifs, tails, spurs, and gently rounding curvilinear forms. Their sculptors, in particular, contributed a sense of freedom to the design of the hitherto strict and formal letters. So perfect were the Roman modifications that they have served ever since as model letter forms.

Fig. 43 The famous inscription in marble at the base of the Trajan Column in Rome. The letters were first painted with a broad-edge brush and then incised in the stone. From 112-113 A.D. (Courtesy of the Victoria and Albert Museum.)

The English Alphabet

The English alphabet is almost identical in form to the Latin alphabet, with the exception of three new letters added at different times to bring the total number of letters to 26. The first letter added was the *U,* which was derived from the Greek *upsilon.* The Romans used the letter *V* to represent both the consonant and vowel sounds, and it was not until the third century that a *U* form appeared in Roman uncials as a distinguishing variant in majuscule (capital) form. The minuscule *u* first appeared in the Carolingian minuscule as a calligraphic variant of the letter *v.* The actual separation of the phonetic sounds into two distinct signs did not occur until after the advent of printing; it was first used as a new letter in a book published in France in the year 1559. This separation reportedly was put into practice at the instigation of the Italian humanist, Gian Giorgio Trissino.

The *W* is a letter that has no equivalent in ancient languages and was first used by Norman scribes in Britain during the 11th century. During the Middle Ages, this phonetic sound was expressed as *UU,* and represented a semivocalic sound of the *U.* Since this was written as *VV,* these two letters became ligatured and formed a new letter, the *W.*

The letter *J* has no ancient equivalent and developed as a calligraphic distinction to separate the consonant and vowel sounds of the letter *I.* This distinction was complete with the introduction, during the 16th century, of a new letter form, the majuscule *J.*

Fig. 44 The Roman alphabet, showing its pattern of development.

PHOENICIAN	GREEK	PELASGIAN	ETRUSCAN	EARLY LATIN	ROMAN & ADDITIONS
ⱪ	A	Λ Λ	Λ Λ Λ	Λ Λ Λ	A
◁	B	B		ẞ B	B
∧	Γ	⟨C	⟩Ɔ G	⟨C G	C G
△	△	D		▷ D	D
Ǝ	E	ⅎ E	Ǝ Ǝ ∃ Ⅎ	Ǝ E ‖	E
Y		F	⅂ ⅂ ⅃	↑ F ⌐	F
⊟	H	⊟	⅄ ⊟	H	H
⊕	⊕	⊕ ⊙	⊘ ⊙ ◇		
⁊	I	I	I	I	I J
↓	K	K	Ⱶ	Ʞ K	K
⌐	∧	↳	⅃	↳ L	L
⅂	M	⋔	⋔ ⋔ ⫴	M M M	M
⅄	N	ⱴ	⅄ ⱮⱮⱵ	Ⅳ N	N
O	O	⊙		◇ O	O
⟩	∏	P⌐	↿↾	Γ P P	P
⅄		⅄M	M M		
ⴵ		Ϙ ꝗ		ϘϘO	Q
◁	• P	P	◁ ◖ P	R R R	R
W	Σ	Ɛ ξ	ζ ξ ɀ	ς S	S
X	Τ	Τ Τ	⅄ ⅄ Ⱶ Τ	Τ	T
	Y	↿ Φ	Ɣ V Ɣ ⊕ φ	Ⅴ Ⅴ	U V W Y
⼤	⚌	+ × ⊞		X	X
⊥	Z				Z
			𝟾 8		

THE DEVELOPMENT OF
THE MINUSCULE LETTER

4

By the second century B.C., the capital, or majuscule, letter forms of the Latin alphabet had achieved perfection, the end result of an evolutionary process begun centuries before in ancient Phoenicia. These Roman capitals, used principally for monumental and official inscriptions, have retained their original forms until the present time. Although they are still used by sculptors, letterers, and type-designers as both functional letters and inspirational source material, these capitals did not materially influence further alphabetic development in their imperial forms. It is to their use as pen-written letters, beginning in about the first or second century A.D., that attention must be directed in order to trace subsequent developments in writing.

The use of Roman capitals as a written hand required some modification to suit the broad-edge reed pen and to conform to the discipline of a rapidly written hand. In addition, the secular or commercial script exerted a degenerative influence on the capitals then used for official writing. The secular writing was cursive in appearance, bore little resemblance to the formal capitals, and was written in a very rapid manner. As in the past, the needs and requirements of a civilized society stimulated a further development in written communication: the evolution of the minuscule alphabet. The major stages in this development are chronologically traced in this chapter through analytical comment and graphic representation of the pertinent letter styles. Emphasis is placed on the selected illustrations to provide both a reference source for the comparison of historical styles as well as a meaningful visual account of the minuscule evolution.

Roman Square Capitals

Roman square capitals were directly descended from Roman imperial capitals and differed chiefly in the manner of their production. These capitals were written on parchment or vellum, with a broad-edged reed or quill pen, and present strong line weights having a slight thick/thin quality. The pen angle should be not more than two or three degrees, or almost straight. Square capitals were used in the production of manuscripts soon after the start of the Christian era, and, with the production of books in the fourth century, they were widely used as a bookhand. Square capitals were abandoned as a bookhand during the sixth century, but they were retained for some time afterward for titles and initial letters.

The illustrations in Figures 45 and 46 show two

Fig. 45 A bronze diploma in Roman square capitals. It is part of a discharge certificate dated July 16, 122 A.D. (Courtesy of the Trustees of the British Museum.)

QUIA ... MEDULCISSIMAE FILIAE MEAE INSPE MISERICORDIAE DI PETISTIS UT UOBIS
DIUER SOS PSALMOS PERORDINEM SEQUESTRATIM QUIUBI PSALLI DEBEANT
UOSQUOQUE EGOPETII UTPROME DEPRECARETIS DNM DM NOSTRUM UT DONOSUO
MIHI CONCEDERE DIGNARETUR QUOPOSSIM SCAM PETITIONEM UESTRAM ARRIPERE
UELIPSO DONANTE COMPLERE INCUIUS MISERICORDIA SPERANS PROUT DOMINUS
CONCEDERE DIGNATUS EST INTELLECTUM HUMILITATE MEAE NECESSE HABUITAM
SCAE PETITIONI UESTRAE PROMEFECIT DI OBOEDIRE PROQUO OPUS SIUOBIS GRATUM
UISUM FUERIT AUT INTEGRAE ASIGNATA FUERINT QUAE QUE DICTASUNT IPSI DNO DO
NOSTRO SCO OMNIPOTENTI PROHUMILITATE MEA ORANTES GRATIAS REFERTE QUIETIAM
ASINAM LOQUI PRECEPIT QUAE IPSE DNS UOLUIT LICET ENIM INUNIUERSIS PSALMIS
QUID REQUISITUM FUERIT LEGIS DIUINAE PROPE MODUM OMNIA HABENT ATTAMEN
DONANTE DO SCO ET XPO DNO LCU ET SCO SPU TRINITATIS QUI PSALMI PROPRIE ADSIN
GULOS DIES FERIATOS DNI SALUATORIS NOSTRI FILII DI PERTINEANT SEQUESTRATIM
EXPOSUIMUS QUIAD NATALEM DNI UEL QUIAD SCAM EPIPHANIAM IDEST BAPTISSIMI
DOMINICI SEU APPARITIONIS STELLAE ETQUIIN QUINTA FERIA ANTE PASSIONE QUI
ETIAM INIPSA PASSIONE DOMINICA QUIIN ... RESURRECTIONIS EIUS DNI NOSTRI
REDEMPTORIS ETQUIIN ASCENSA EIUS INCAELIS QUIETIAM INADUENTU IPSIUS
ETIUDICIO FUTURO ET QUIDE QUILITATE UITAE AETERNAE INQUA NP DNS SUOS ...
APRINCIPIO MUNDI USQ IN FINEM HUIUS SECULI SIBI CONGREGAT SECUM REGNA
TUROS INAETERNO IN REGNO CAELESTI SCS DNS TRINUS DS AETERNUS QUIETIAM
ADDNM DM DEPRECANDUM LAETANIA UEL QUIAD PENITENTIB PSALLI DEBENT
QUIETIAM INNATALES SCORUM DICI DEBENT CETEROS UERO PSALMOS INUENIES
QUIAQUODIE APTE LEGENDUS EST ORANTES TAMEN PSALMI COTIDIE INTOTO ANNO
PERORDINE PSALLI POSSUNT SECUNDUM CONSUETUDINEM ECCLESIARUM ET MONA
STERIORUM SANE QUI LEGIS CONSIDERA QUIATNUS PSALMUS ADMULTOS DIES SCOS
PERTINET PSALLI EADEO MULTIPLICITER ITERANTUR PERSINGULOS DIES NAMEST
PSALMUS QUIUBIQ PSALLI POTEST ALII ITERUM SUNT QUIADUNIUS DIEI FIGURAM
PERTINENT ADPAUSANTES UERO QUALES PERSONAE FUERINT UTRUM RELIGIOSE
ANIMICAE DEPSALMOS QUIINQUINTA FERIA ANTE PASSIONEM AUTQUI INPASSIONE
DNI DICUNTUR AUTQUI INNATALIB SCORUM EXINDE ELIGENDI SUNT PSALLI
ITAETIAM DECANTICIS PROFETARUM FECIMUS UTNONINDIEB SUPRADICTIS CONFUSN

Fig. 46 A page from a Psalter of St. Augustine, Canterbury, England, written in Roman square capitals on parchment about 700 A.D. (Courtesy of the Trustees of the British Museum.)

examples of the Roman square capital. The example in Figure 45 was incised in metal and dates from the second century A.D., during the reign of Hadrian, while the example in Figure 46 is an excerpt from a manuscript written with a reed pen on parchment, and dates from 700 A.D. The writing of the manuscript is much more regularized than that of the inscription, exhibiting excellent line-up and letters that are consistent in size, form, and weight. Word spacing is infrequently used in the inscription, while the manuscript evidences a well-developed use of word separation. Of particular interest is the *U* form, instead of the usual *V* form, which was used consistently throughout the manuscript but is not at all evident in the earlier inscription. This document exhibits the growing influence of the Roman uncial and shows traces of the trend toward a minuscule letter, through the occasional use of the small *h* and the extreme extension of the *L* above the cap, or top, line. The elongation of some of the letter strokes into "tails" descending below the base line appears to be more for a decorative purpose than a functional one.

Fig. 47 A sectional enlargement of Fig. 46.

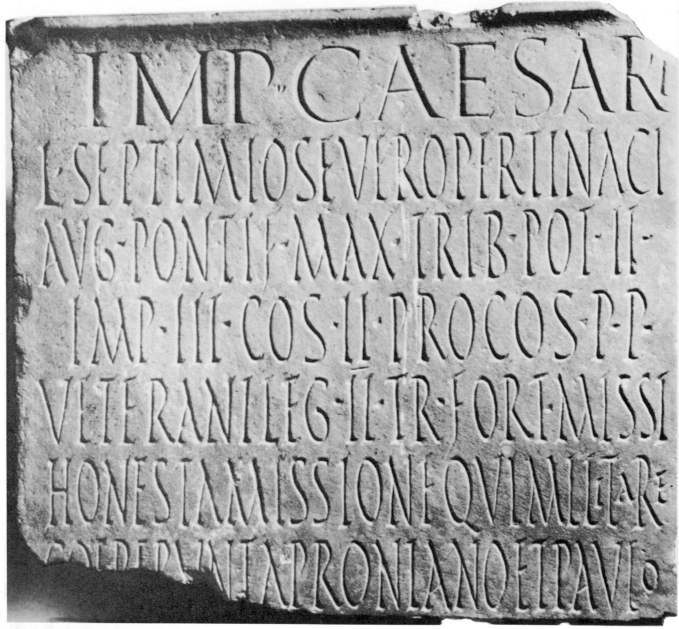

Fig. 48 A Roman inscription in rustic capitals dedicated to Septimius Severa by veterans of the Second Legion, from Nicopolis, near Alexandria. (Courtesy of the Trustees of the British Museum.)

Rustic Capitals

Rustic capitals represent a variation of square capitals and were used, during the same time period, for the production of manuscripts and books. Although freer and more rapidly written than square capitals, they are still considered to be a formal writing hand. Rustic capitals probably evolved because scribes allowed their pens to assume a more acute angle in their efforts to write faster, influenced in part by the faster, cursive writing of the commercial hands. These capitals were written with a pen angle of nearly 60 degrees, while the vertical strokes were produced with an angle exceeding 70 degrees. This change of angle resulted in a considerable lateral compression of the letters, producing a strong contrast of thick/thin strokes and emphasizing the obliques and horizontals rather than the verticals.

Word spacing in Figure 48 was achieved by the placement of a dot centered between words. Ascending letters are more prominent in this hand than in square capitals; the total effect is one of extreme verticality. Rustic capitals represented a further step in the development of the small letter and, like square capitals, continued to be used for titles and initials long after falling to disuse as a bookhand.

The Roman Uncial

The Roman uncial, a new letter form, evolved as a further development toward the minuscule letter. Though still a majuscule alphabet, uncials provide unmistakable evidence of the evolution of minuscule letters. The early examples, which first appeared toward the end of the fourth century, were written approximately one inch high and derived their name from the Latin word for inch, *uncia*. The name has persisted as a style identification, though the size of the letters varies considerably in later examples. Early uncials were written with a wide pen held at a pen position of approximately 45 degrees, but in later examples the pen has been shifted to a straight position, thus giving the letter forms a very different character. The vertical strokes are produced by slanting the pen position to one side.

The principal characteristic of the uncial letter is the extreme tendency toward the rounding of forms.

The result is a wide letter that exhibits excellent line-up and legibility, and balanced line weights. Roman uncials could be written fairly rapidly and, because they were highly readable letter forms, they were favored until the eighth century as a book-hand. The immense popularity of these letters for the production of books eventually caused the square and rustic capitals to be completely abandoned except for their use as initials. It is of interest to note that the combined use of initial letters with an uncial text was probably the first evidence forecasting the use of the combined majuscule and minuscule alphabets as elements of communication.

The manuscript illustrated in Figure 49 clearly shows the extent of minuscule development found with this letter form. The letters *E, M, U, D, H, P,* and *F* are already minuscule in form, while the *A, L,* and *G* are transitional in form. The last two letters in the ninth line of the right-hand column show a development of the letters *n* and *e* that is not evi-

Fig. 49 An example of the Roman uncial. A page of evangelia, from the Codex Beneventanus, eighth century A.D. (Courtesy of the Trustees of the British Museum.)

57

ABIAAUTEMGENUIT

ASAAUTEMGENUIT

IOSAPHAT

JOSAPHATAUTEM

Fig. 50 A sectional enlargement of Fig. 49.

dent anywhere else in the manuscript. The *n* is almost completely minuscule, very similar to that found in the much later Caroline minuscule, and the *e* is a perfect example of that letter found in documents of the 12th and 15th centuries. Another interesting discovery in this manuscript is the appearance of a calligraphic variant for the *I*. The elongated *I* anticipated the eventual separation of the phonetic values of *I* with the use of the letter *J*.

The Roman Semi-Uncial

The semi-uncials were written in the same manner as the later uncials, with a broad pen held in a straight position. These letters exhibit the same orderly writing as the uncial, but with some marked differences in skeletal form. The Roman semi-uncial was the first true minuscule-like letter form, one that made use of ascenders and descenders. The *S* shows a transitional form of the later "long s"; the *Q* and *G* have been transformed into true minuscules with descending strokes; and the *B*, *D*, and *R* are minuscule in form. The *A* has made an extreme transition from the slanting capital form of the uncial to a rounding, closed minuscule. The rounding forms adapted from the uncial provided for rapid writing and excellent legibility.

Fig. 51. An example of the Roman semi-uncial. A papyrus fragment from the *Epitome of Livy*, third or fourth century A.D. (Courtesy of the Trustees of the British Museum.)

Fig. 52 A sectional enlargement of Fig. 51.

tertio commendans
extensione manuum
significat ei quod crucis
morte fore martyrio
coronandus

Dic simoni
petro ihs simon
iohannis
diligis me plus his
usq: ad locum ubi dicit
significans qua morte
clarificaturus esset dm
cum vero innatale sci
iohannis euangelistae tu
choartda est aloco quo
ait dicit ei hoc est dns
simoni petro sequere me
usq: ubi dicit eademus
quia uerum est
testimonium eius

Sci iohannis
apostoli et
euangelista
post epiphania
dnica prima
post ephipania dnica
secunda
Inuelanda
Indedicatione sce mariae
Onica ii xlgsima paschae
post octabas dni in ihu xpi
post iii dnicas deephipania
demuliere samaritanae
Oexlgsima feria iiii
Iisci angeli & indedicatione
fontas
Conichana
Innatale sci andreae
Conichana
post iii dnicas xlgsima
feria iiii
post iii dnica xlgsima feria
iiii

Fig. 53 An example of the Irish half-uncial. A page from the Lindisfarne Gospels, folio 208, about 700 A.D.
(Courtesy of the Trustees of the British Museum.)

60

The Irish Half-Uncial

The Romans carried their form of writing to England and Ireland early in the Christian era. Reliable sources maintain that the Irish developed their half-uncial from the Roman semi-uncial, which was introduced there during the fifth or sixth century. Since the Irish monks were geographically removed from Europe, they were able to develop their writing art without the interference of the turmoil that continually engulfed the Continent. The letter forms that they devised were quite different from their Roman counterparts; the initial letters, particularly, were extremely beautiful forms composed of Celtic tracery and lacings. The high degree of development attained by the Irish can be seen in the famous *Book of Kells,* an account of the Latin Gospels that was produced by Celtic monks in the seventh century. The Irish half-uncial was fully developed by the sixth century and found favor as a writing hand until the ninth century, when the emergence of the Caroline minuscule caused its disuse.

Figure 53 shows a portion of a manuscript, written in Irish half-uncials, which probably dates from the seventh or eighth century. The lines of writing are very orderly, with a pronounced horizontal appearance due to the very slight difference in height between the body of the text and the ascenders and descenders. These letters were written with the pen in a straight position and were finished off with very noticeable ending strokes and serifs, except in the case of the descending strokes. Two other practices added to the flattened, horizontal look that these letters affect: (1) the repeated use of a number of ligatures such as the joining of *tc, ce, ft,* etc., and (2) the extreme extension of the crossbar of the *t.* There were two types of the letter *n* in use, (Ᵽ) and (ᴎ), as well as both the standard minuscule *s* and the "long s" (ſ). In addition, the words are spaced, capital letters are used at the beginning of a sentence, and in some cases those portions of a sentence that required a second line have been indented. The decorative initials are of great beauty and merit close study.

Fig. 54 A sectional enlargement of Fig. 53.

lilia agri quomodo crescunt non la
borant neque nent. Dico autem uobis q
nec salemon in omni gloria sua coopt;
sicut unum ex istis. Si autem foenum
agri quod cras hodie. et cras in clibanum
mittitur. deus sic uestit. quanto magis
uos modicae fidei. Nolite ergo solliciti
ee dicentes quid manducabimur
aut quid bibemur. aut quo operiamur. haec
enim omnia gentes inquirunt. Scit enim
pater uester celestis quia his omnibus indi
getis. Quaerite ergo primum regnum dei
et iustitiam eius et haec omnia adicien
tur uobis. Nolite ergo solliciti ee in cras
tinum. Crastinus enim dies sollicitus
erit ipse sibi. Sufficit enim diei mali
tia sua. Nolite iudicare ut non iudi
cemini. In quo enim iudicio iudicatis
aut iudicabimini. Et in qua mensu
ra mensuraueritis remetietur uobis. Quid
autem uides festucam in oculo fratris
tui. et trabem in oculo tuo non
uides. Aut quomodo dicis fratri tuo.
Sine eiciam festucam de oculo tuo.
Et ecce trabs est in oculo tuo hipocrita.
eice primum trabem de oculo tuo. et tunc uidebis

The Anglo-Saxon Minuscule

The Anglo-Saxon minuscule was developed from the northern English scripts that were introduced by the Irish monks following the Saxon invasions. This minuscule was in use in eighth-century England and is considered the immediate forerunner of the Caroline minuscule, as well as the transitional style that led to the development of the Gothic, or black, letter. The position of the pen was angled slightly to 20 to 30 degrees, creating letter forms more angular than the half-uncial, and more condensed in appearance. The serif endings are slanted and pointed, and the axis of the o shifted from a vertical position to an oblique position slanting to the left.

The manuscript illustrated in Figure 55 shows a well-defined sense of sentence structure, with word spacing and initial capitals at the beginning of each sentence. Punctuation is in evidence with the use of the semicolon, the question mark, and the period. The period was first used as a punctuation mark in the Anglo-Saxon minuscule. It developed from the earlier colon and was used as a sentence stop. Also found are the two versions of the s and the g forms from the half-uncial, slightly modified. The long, or archaic, s was used well into the 19th century and is still utilized by printers when they desire to give the text an "old style" appearance. The line-up of these minuscule letters is somewhat erratic, with ascenders and descenders running into succeeding lines. The closer line spacing, with the very small notations made between them, does not add to the overall legibility of the manuscript.

Below:
Fig. 56 A sectional enlargement of Fig. 55.

Opposite:
Fig. 55 An example of the Anglo-Saxon minuscule. A page from the Gospels of Maelbrigte, written in Latin about 1138 A.D. (Courtesy of the Trustees of the British Museum.)

Fig. 57 An example of the French uncial. Part of a page from the Codex Aureus. (Courtesy of the Trustees of the British Museum.)

The Caroline Minuscule

The customs and language of the Roman culture had left an indelible mark on many parts of the world. The alphabet and written styles of Rome had replaced or enhanced the former national hands as the established means of communication. Following the decline of Roman influence as a world power, the national hands began to move away from the unifying Roman tradition. Barbaric influences gradually undermined the writing hands until there was a variety of styles competing for prominence. Many of these were poorly executed and exceedingly hard to read. Scribes and writing masters adopted their own personal forms of shorthand and abbreviation, leading ultimately to a deterioration of understanding and communication throughout Western Europe.

Fortunately, in the year 771, a man who was dedicated to the dissemination of education and the arts succeeded to power. This man was Charles the Great, King of the Franks, and better known through history as Charlemagne. He realized that if he wished to establish a Roman-style unity within his kingdom, a universal writing hand was necessary. Charlemagne set up schools at all the monasteries and cathedrals, attracting to his service all the learned men of the day to teach, transcribe manuscripts, and write books. To supervise and maintain this educational organization, he induced the English scholar and writing master, Alcuin of York, to join him.

Alcuin, himself a monk and director of the York Cathedral School in England, entered Charlemagne's service in 781. In his capacity as supervisor of the empire's educational system, he was in a position of eminence in regard to the choice of a standard writing hand. Working with a team of writing scholars, he instituted a long study of the many styles of writing, selecting and retaining the best letters from these minuscule hands. From these examples, Alcuin developed the Caroline minuscule, drawing principally upon the Anglo-Saxon minuscule but with decided influences of the Italian Lombardic and French hands, probably the eighth-century French uncial.

The perfected Caroline minuscule, which came into prominence early in the ninth century, was a small, rounded letter of extreme legibility. It could be written rapidly and was widely used for the production of books and documents. The Caroline hand was used much later as the model for the fine Italian humanist minuscule. Figure 58 is an illustration of two facing manuscript pages written in the Caroline minuscule. The pen angle was about 30 degrees, following that of the Anglo-Saxon hand, and the lines of writing exhibit the color and overall orderliness of the earlier half-uncials. The g became a closed form, obviously a refinement of the Lombardic g (\mathcal{G}), and the use of the ampersand (\mathcal{R}), also a product of the Lombardic minuscule, is evident. The letters are tilted very slightly to the right (about 3.5 degrees), giving the lines of writing a cursive quality. This slight tilt not only adds to the aesthetic quality of the letters, but is one of the reasons why this minuscule was so easy to write. The rounding, compact forms were influenced by the English hand, though some letters were stabilized in size and shape and generally refined.

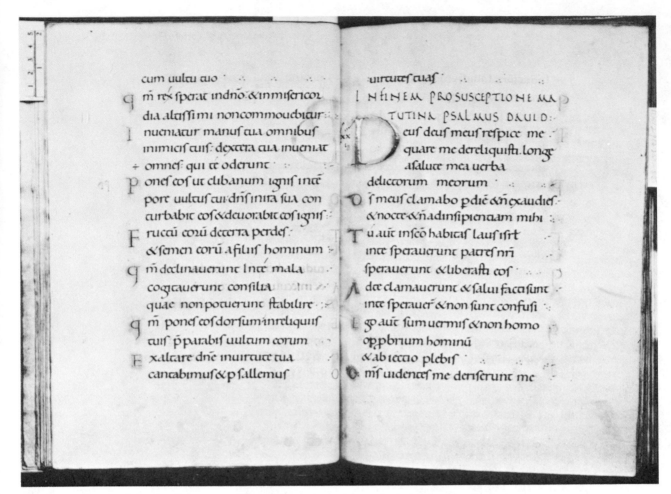

Fig. 58 An example of the Caroline minuscule. A two-page spread from the Latin Gospels, about 860 A.D. (Courtesy of the Trustees of the British Museum.)

Fig. 59 A sectional enlargement of Fig. 58.

The Gothic Black Letter

The Gothic letter was an outgrowth of the same Anglo-Saxon writing that fostered the development of the Caroline minuscule. Gradually the English minuscules shifted in form from earlier, rounding letters to angular and pointed ones. By the 12th century, these changes had resulted in the development of the black letter. This name was applied because of the extreme blackness of color that lines of this condensed style imparted to the page. The use of Gothic as a court and ecclesiastic hand lent it the dignity and formality that have continued into modern times. Almost all university degrees, legal forms, and formal government documents are printed or hand-lettered in one or more variations of this letter form. Gothic letters are classed in two distinct groups: the Northern Gothic and the Southern Gothic.

Northern Gothic

This Gothic style is characterized by extremely angular and vertical letter forms. The visual appearance of a page written in these letters is one of extreme verticality, barely relieved by hairline connectors, and compactness of elements. Though this uniform, closely spaced style was more difficult to read, it was very economical in terms of space required on a manuscript page. Northern Gothic was written with a pen position of 30 to 45 degrees and exhibits strong, pointed letter endings. To relieve the regularity of the text, the initials usually found with Northern Gothic are quite decorative and free, *so* free that in some cases the intended letter is difficult to discern. The Northern Gothic was used as a writing hand in England, Germany, northern France, and the coastal countries until the 15th century; in Germany, it enjoyed a more prolonged usage.

Fig. 60 An example of Northern Gothic text. A page from a Latin Bible, written between 1225-1252 A.D. (Courtesy of the Trustees of the British Museum.)

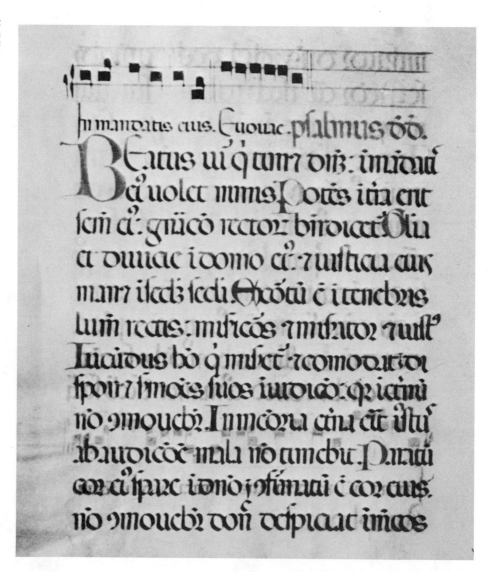

Fig. 61 A manuscript page from the 15th century A.D. A religious service referring to Psalm 66. (Collection of the Author.)

Fig. 62　A sectional enlargement of Fig. 60.

Fig. 63　A sectional enlargement of Fig. 61.

Southern Gothic

This style is characterized by the retention of the rounding forms of both the early Anglo-Saxon and Caroline minuscules. This Gothic was used in Italy, southern France, and Spain, and has a more open appearance. The color is correspondingly less black and lines of this writing are more horizontal, similar to half-uncials. The text is easier to read and more legible, due to a greater degree of contrast between strokes, counters, and weights. The pen position was about the same as that used for Northern Gothic, and both styles show deliberate word spacing, punctuation, and sentence structure. The dot over the small *i* occurs in both Gothic styles. Figures 60 and 61 are examples of Northern Gothic text, and Figure 64 is an example of Southern Gothic text.

Fig. 64 An example of Southern Gothic text. A manuscript page (enlarged section) written on parchment about 1375 A.D. The letters on this original document are written 1/16 in. in height. (Collection of the Author.)

The Decorative Initial

The use of classic capitals as initial letters began as early as the sixth century. These classic forms were used concurrently with square and rustic capital initials. At first, little or no decoration was applied to these initials, but by the seventh and eighth centuries the Irish monks were applying beautiful and complex decorative elements in accordance with a desire to design the page as a unit. The Irish transmitted their high art to England and thence to the Continent, where the influence of the Germanic culture became manifest. Throughout France and Germany, the embellishment of initials took many forms; in some cases the decoration was so ornate that the essential character of the letter was lost. Decorative initials, which were originally graphic representations of great religious spirit, encompassing the wonders of nature and God, later became page illustrations designed primarily to work with the text.

The advent of printing created a marked change in the art of the initial. At first, the printers left blank spaces so that the rubricator, or colorist, could apply the initial decorations in the same hand-drawn manner as that used on manuscripts. As the printer gradually took on the responsibility of producing the entire book, wood-block and metal-type initials, patterned after the manuscript styles, came into being and were printed along with the text. These initials were most often found within a square or oblong framework; the letter was set off against an intricate design of tracery, flowers, cherubs, and other decorative elements. Although the Gothic-style letters of the late manuscripts were used at first, they were soon replaced by the letters of the classic Roman revival, and by late uncial forms. There are so many unique and historical versions of these initials that the examples illustrated in Figures 65-79 are selections of only the most interesting or most ornamented from various periods.

Fig. 65 The letter *I* from the Bible of Charles the Bald.

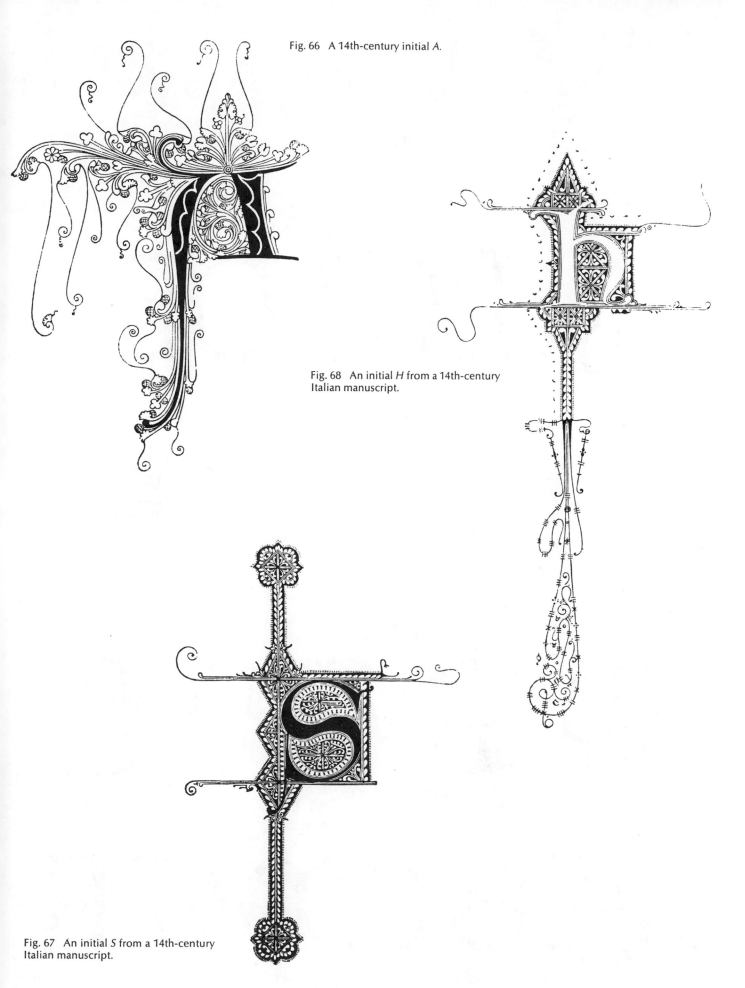

Fig. 66 A 14th-century initial *A*.

Fig. 68 An initial *H* from a 14th-century
Italian manuscript.

Fig. 67 An initial *S* from a 14th-century
Italian manuscript.

Fig. 69 Anglo-Saxon manuscript initials, ninth century.

ABCCDE

Fig. 70 Early Gothic initials, 12th century.

ABCDEF

Fig. 71 Fourteenth-century initials.

ABCDE

Fig. 72 Fourteenth-century initials.

ABCDEH

Fig. 73 The initial *A* by Erhard Ratdolt, 15th century.

Fig. 74 A ribbon-tracery initial *G*, early 16th century.

Fig. 75 An initial *B* by Geofroy Tory, 16th century.

Fig. 76 A German Gothic initial *F* used during 1600s.

Fig. 77 An initial *B* used for books in 1600.

Fig. 78 An initial *D* by Vespasiano Amphiareo, Venice, 1554.

Fig. 79 A baroque initial *B* from a 17th- century writing book.

THE EFFECTS OF
THE RENAISSANCE

5

The mid-14th century in Italy witnessed the beginnings of a great humanist movement — the Renaissance. Sparked by the desire of scholars from without the Church for more liberal teachings, this revival of classic literature, philosophy, and art signified the end of the feudal system of the Middle Ages. Universities and libraries were established to foster the emergence of enlightened thought and learning and to preserve the treasures of books and documents that fed the flames of this new spirit. The Renaissance spread rapidly from Italy to all parts of Europe and was the catalyst for many decisive cultural advancements. The growth of trade, the development of great cities, and the resulting affluence spawned a new class of citizenry that promulgated a secular culture. This period laid the foundations of modern literature through the influence of such great writers as Petrarch and Boccaccio, experienced and enjoyed the rich harvest from great land and sea explorations, and ushered in the development of the art of printing.

The Development of Printing

The slow rate of production and the high cost of books in the 14th century could not satisfy the demand. Books were copied laboriously by hand and only the nobility, the clergy, and the very wealthy could enjoy their ownership. Human needs and desires would again stimulate action toward a practical solution to the problem. Scholars knew that printing by various means had existed for centuries; the earliest examples were the Babylonian seals. Though these seals actually made impressions in wet clay and did not transfer a printed image, the process involved was similar. The Chinese invented paper in 105 A.D. They had printed from stone plates as early as 175 A.D., and from carved wooden blocks as early as 868 A.D. The invention of paper was a vital ingredient to the subsequent development of

printing, for, without it, low-cost, volume printing would have been impossible. The first paper was created from tree bark, hemp, rags, and fishnet by Ts'ai Lun in the first year of the Yuan-hsing period (105 A.D.). This early date establishes not only that the Chinese invented paper, but also that this paper was produced with rag content. This fact was confirmed by the discovery in western China of paper documents that date from the early Christian era. Figure 80 illustrates fragments of the oldest of these

Fig. 80 Two fragments considered by Edouard Chavannes to be the earliest specimens of paper in existence. They date from the Han Dynasty (206 B.C.-221 A.D.), China. (Courtesy of the Trustees of the British Museum.)

Cristofon faciem die quacunq; tueris :·
Illa nempe die morte mala non morieris

Millesimo cccc°
xx° anno :·

documents, and dates from before 137 A.D. The use of paper in Europe came much later: it was introduced in Spain in 1150, in France in 1189, and in Germany and England in 1320 and 1494, respectively. These late dates of introduction partially account for the much later development of rudimentary printing methods on the Continent.

Woodcuts and Block Books

The first uses to which printing was put in Europe seem to have been the production of playing cards and religious picture books called "block books." From carved wooden blocks, an image was rubbed or pressed onto paper. The first woodcuts were probably made as early as 1400, but the first print that can be dated with certainty is one of St. Christo-

pher, dating from 1423. It is considered that block printing was introduced to Europe from Chinese sources with playing cards, but there is no concrete evidence to definitely support this theory. Figure 82 illustrates an example of early block printing from the tenth century. Block books were a development of woodcut printing, in that several prints were combined with a text and bound together as a book. There are two forms of block books: the earlier books were printed only on one side of a paper sheet by rubbing the image from the block, and the blank pages were bound facing each other; the later books were printed on both sides of the paper by a printing press. The earliest block books were probably not printed until after 1425. The block books do not represent a stage in the development of

Opposite:
Fig. 81 The St. Christopher woodcut of 1423 A.D., one of the first woodcuts produced in Europe. (Courtesy of the John Rylands Library, Manchester, England.)

Below:
Fig. 82 Pages from a block-printed booklet containing a fragment of the Diamond Sutra (*Chin-Kang-Pan-Jo-Po-Lo-Mi-Ching*) with a colophon dated 949-950 A.D. From Tunhuang, N.W. China. (Courtesy of the Trustees of the British Museum.)

Fig. 83 The top half-page from *Canticum Canticorum*, a block-book made in the Netherlands and dated 1470. (Courtesy of the Pierpont Morgan Library, New York.)

typographic printing; they were entrants in the race to devise a method of producing inexpensive books. Both of these methods were developed independently at about the same time.

Block printing was the fastest method of printing that had hitherto been devised, but quantity book production in this manner was still not feasible. The printing of an average book required a great number of wooden blocks, the cutting of each one being a laborious process on the part of a highly skilled artisan. It must be remembered that a printing block requires an image that is reversed and indirect in order to produce a print that can be read directly. In addition, normal wear and the hazards peculiar to the nature of carved wood greatly limited the number of perfect books that could be produced from a single set of printing blocks. Though this method did not serve as a solution to the problems of economical book production, it did become a valid means of original expression as an art form. Figure 83 illustrates an example of a block book from the 15th century.

Movable Type

European printers were again indebted to China for their first knowledge of movable type. Between 1041 and 1049, Pi Sheng invented type composed of clay that had been hardened by fire. He cut his characters, about the thickness of a coin edge, into sticky clay that was afterward baked hard. To prepare them for printing, the individual type pieces were set close together within an iron frame, warmed, and the outer edges were coated evenly with a warm paste. After it cooled, the solid block of type was held together firmly. Upon the completion of printing, the type block was reheated to melt the paste, thus allowing the individual type to be separated with no damage. By working on a second form while the first was in use, Pi Sheng was able to print quite rapidly. One of the major drawbacks was that the watercolor inks had a poor affinity with the face of the clay type. It is reported that, in 1314, wooden type was used in China. A block of wood was engraved with alphabetic characters and then cut apart to

form individual pieces of type. Metal type was first cast and used in Korea in 1403 at the instigation of the ruler, T'ai Tsung. These types were made from sand castings of wooden models, and were produced there at least until 1544. Figure 84 illustrates examples of these early Korean metal types, along with the resulting printed image.

Laurens Coster of Haarlem, the Netherlands, appears to have been the first European printer to cut and use movable metal type. Books attributed to him, dating from 1440 to 1446, were printed from both wooden and metal type, the latter apparently cut by hand rather than cast from a mold. This method of type production resulted in letters of varying quality and size, creating poor line aesthetics on the page. Those type faces that had been developed hitherto were at best crude and unreliable devices. There was still too much time and skill involved in the cutting of each character for these type faces to be considered practical for the low-cost, mass production of books.

Printing by the typographic method required three essential things besides the paper: (1) A press, suitable models of which were already in use for the manufacture of paper; (2), A heavy, oil-base ink, easily obtained by adapting the oil paint used for painting; and (3) A practical cast metal type, the idea of which was known, but which was far from a perfected state. The only ingredient lacking in making typography a highly workable method was the ability to produce a durable, perfected metal type.

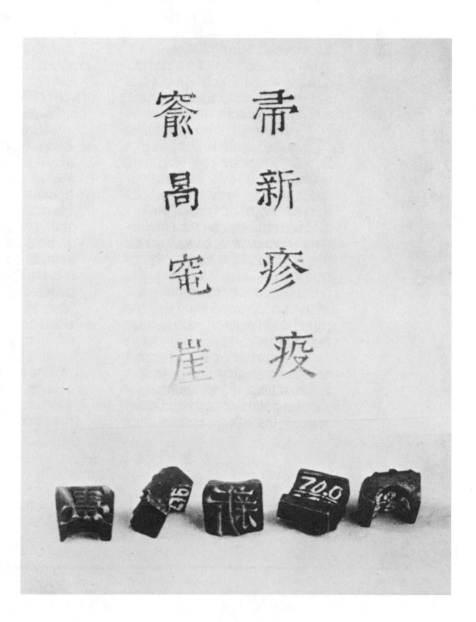

Fig. 84 Pieces of early Korean metal type, 15th century, together with imprints from the type. (Courtesy of the American Museum of Natural History, New York.)

Et ait moyses . Si non tuipse prece-
das: ne educas nos de loco isto . In
quo enim scire poterimus ego et ppls
tuus inuenisse nos gratiã in cõspectu
tuo·nisi ambulaueris nobiscũ: ut glo-
rificemur ab omnibz pplis qui habitãt
sup terram? Dixit autẽ dñs ad moy-
sen . Et verbũ istud quod locutus es
faciã. Inuenisti enim gratiam coram
me: z teipm noui ex nomine.Qui ait.
Ostende michi gloriam tuam. Rñdit.
Ego ostendam omne bonum tibi: et
uocabor in nomine dñi corã te: et mi-
serebor cui uoluero · z clemẽs ero i quẽ
michi placuerit. Rursũqz ait. Nõ pote-
ris uidere faciẽ meã. Nõ eñi uidebit me
homo et uiuet . Et iterũ. Ecce inquit ẽ
locꝰ aput me: et stabis supra petram.
Cũqz transibit gloria mea·ponam te
in foramine petre: et protegam dextera
mea donec transeã. Tollãqz manũ me-
am: z uidebis posteriora mea: faciẽ aũt
meã uidere nõ poteris.

Ac deinceps psalte ait tibi duas ta-
bulas lapideas instar priorũ: z
scribã sup eas verba q habuerũt table
quas fregisti. Esto paratus mane·ut
ascendas statim in montem synai:sta-
bisqz mecũ sup uerticẽ mõtis . Nullus
ascendat tecum: nec uideatur quispiã
per totum montem: boues quoqz et
oues non pascantur econtra . Excidit
ergo duas tabulas lapideas·quales
antea fuerant:et de nocte consurgens
ascendit in montem synai · sicut prece-
perat ei dñs: portans secum duas ta-
bulas. Cũqz descendisset dñs p nube:
stetit moyses cum eo · inuocãs nomẽ
dñi.Quo transeunte corã eo ait . Do-
minator domine deus · misericors et
clemens·patiens et mste misericordie·
et uerus : qui custodis misericordiam

in milia·qui aufers iniquitatem z sce-
lera atqz peccata · nullusqz aput te per
se innocens est : qui reddis iniqtatem
patrum filijs ac nepotibus in terciã z
quartã progeniẽ . Festinusqz moyses
curuatus est pronus in terram:z ado-
rans ait. Si inueni gratiã in cõspectu
tuo domine : obsecro ut gradiaris no-
biscum: ppls enim dure ceruicis est:
ut auferas iniquitates nostras atqz
peccata·nosqz possideas . Respondit
dñs . Ego inibo pactum uidentibus
cũctis : signa faciam · que nunqz uisa
sunt sup terram: nec i ullis gentibus:
ut cernat pplus iste in cuius es medio
opus dñi terribile quod facturus sum.
Obserua cũcta que hodie mandaui
tibi . Egoipse eiciam ante faciem tuã·
amorreum et chananeum et etheum:
pherezeum quoqz et eueum et iebuseũ.
Caue ne unquam cũ habitatoribus
terre illꝰ iungas amicitias · que tibi
sint in ruinam:sed z aras eoꝝ destrue·
et confringe statuas : lucosqz succide.
Noli adorare deũ alienũ. Dominus·
zelotes nomen eius : deus ẽ emulator.
Ne ineas pactum cũ hominibz illaꝝ
regionũ : ne cũ fornicati fuerint cũ dijs
suis · et adorauerint simulacra eoꝝ·
uocet te quispiam·ut comedas de im-
molatis. Nec uxorẽ de filiabz eoꝝ·ac-
cipies filijs tuis:ne postqz ipse fuerint
fornicate:fornicari faciant in deos su-
os filios tuos . Deos conflatiles nõ
facies tibi . Solennitatem azimorũ
custodies . Septem diebz uesceris azi-
mis:sicut precepi tibi·i tempore mensis
nouorũ. Mense enim uerni temporis
egressus es de egipto. Oñe qd aperit
uuluam generis masculini · meũ erit.
De cũctis animãtibus·tam de bobꝰ
qz de ouibus meũ erit.Primogenitũ

Fig. 85 A page from the Gutenberg 42-line *Biblia Latina*, printed in Mainz, Germany, in 1455. This was one of the first books printed with movable type. (Courtesy of the Pierpont Morgan Library, New York.)

Johann Gutenberg

The first practical movable metal type was developed by Johann Gutenberg, who was born in the city of Mainz, Germany, about the year 1400. Though this claim has been contested by some, the weight of the existing evidence is in support of Gutenberg as the true innovator. The exact date of this development and the first use of the type is not known, but the first printed document that can be attributed to him bears the date 1454. It must be presumed that the processes for producing his type were being developed prior to this date, probably between 1440 and 1450. Gutenberg's perfected use of the punch, the matrix, and the adjustable mold enabled him to produce great quantities of identical type pieces, reduce the time and skill that was required to a practical level, and provide quantity book production.

The basic principles of Gutenberg's method are still used for the mass production of modern types. His method was as follows: (1) A reversed, indirect-reading image was first hand-cut in relief on the end of a soft steel punch. This punch was then hardened for use; (2) The hardened punch was then driven into a block of softer metal, creating an impressed, direct-reading image called the matrix; and (3) The resulting matrix was then locked into an adjustable mold and a metal casting was made. The resulting piece of type was identical to the relief image on the surface of the original punch, and each piece produced was identical in height. A line of copy set in this type exhibits characters that are much more uniform in appearance, and more even in line color and line-up. A single punch was capable of making a great number of identical matrixes, from each of which quantities of identical type characters could be cast.

The development of a practical means of printing was an achievement of incalculable value to man, but it also heralded the end of further alphabetic development for general use. With the reality of typographic printing, man turned his attention away from writing development, causing a gradual decline in the evolution of new letter forms. Except for the totally new letter styles that have been designed to satisfy the particular needs of modern, 20th-century technologies, the alphabet remains almost identical in form to that of the 12th-century Caroline minuscule. There have been a number of important style changes and innovations, however, which were direct results of the advent of printing and the Industrial Revolution. These styles first evolved due to a need to produce more legible letters or to fit more lines of type upon a page. Later, the tool used to produce the letters had a profound influence on the style, as well as on the cultural attitudes and whims of the prevalent society.

The Humanist Minuscule

The influence that humanistic writing exerted upon the early type-founders was a decisive factor leading to the development of the roman styles as elements of communication rather than the Gothic texts of Germanic origin. It has been demonstrated that southern Europe, particularly Italy, had rejected early the pointed, condensed writing of the North in favor of more graceful, rounded forms, as evidenced by Lombardic and Southern Gothic writing hands. During the latter Renaissance, Italian humanist scholars, supported as they were by the Church and learned nobility, had no difficulty in supplanting the Gothic influence with a classic revival hand — the humanist minuscule. This writing hand was based primarily upon the earlier Caroline minuscule of Charlemagne, and was used exclusively for the writing of the classics, literature, poetry, and those sub-

Fig. 86 An example of humanist writing with an extremely decorative initial *V*. From a manuscript by Gianozzi Manetti, 15th century, Italian. (Courtesy of the Trustees of the British Museum.)

spicimus : ut cicero romane eloquentie prin
ceps cum de anima differeret ac quid foret
in preclaro illo tusculanarum disputationum
dialogo diligenter & accurate perscrutare -
tur. magnam quandam de eius origine loco
& qualitate dissensionem fuisse describat : &
lactantius quoque uir doctissimus atq; elegan -
tissimus cum de eisdem conditionibus in come
morato de opificio hominis opusculo inuestig -
aret inhunc modum scribens dixisse deprehen

Fig. 87 A sectional enlargement of Fig. 86.

jects relating to the greater humanities, while the more formal Gothic was retained for writings in law, theology, medicine, and similar disciplines. This development was inspired by the renewed interest in all things classical that most strongly characterized the humanist movement in Italy.

Italian scribes and writing masters modified their minuscule letters with the addition of serifs and finishing strokes that made the small letter forms more compatible with the capital forms. The humanist writing hand had been fully developed by the time printing was being practiced in Italy toward the end of the 15th century, providing the basis for the development of roman style types. Figure 86 is an example of the humanist minuscule. Noticeable in this document is the use of formal Roman capitals in the first line; the completely evolved form of the minuscule g; the greater extensions of ascending and descending letters; and the very limited usage of ligatured letters.

The Roman Minuscule

Germany maintained its status as the seat of printing for only a short period. In 1462, Mainz was virtually destroyed by invaders and the craft of printing suffered a severe decline in that city and throughout much of Germany. Unable to practice their art in their native land, many German printers traveled to Italy and established their shops in Rome and Venice where wealthy patrons were numerous and a more liberalized Church encouraged the spread of classical knowledge.

Apparently the first printers to set up for business in Italy were Conrad Sweynheym and Arnold Pannartz. They located first near Rome in the small town of Subiaco, where they published their first book in 1465. The type that they used was not a true roman, but was a transitional form between the round Gothic and the roman minuscule. The first printers to establish a print shop in Venice were Johann and Wendelin da Spira, who designed and cut the first true roman minuscule type face. Their designs first appeared in 1469, and, though more aesthetic in design than those of Sweynheym and Pannartz, they were very irregular in alignment.

Nicolas Jenson

The roman types designed by Nicolas Jenson were such a beautiful combination of aesthetics and function that they were enormously successful from their

ERVM Quoniam hoc uolumen fatis iam creuit ad duodecimum librum tranfgreffi quæ reftant ad oftédendam platonicam philofophiam ab hebræis defluxiffe cófcribemus:ut multi uideant nó nobis folū: uerum etiá Platoni iampridem fcripturam hebræorū placuiffe. *Q₂ quærere legibus non quærere ratione iuuenef debent . C . I .*

CEnfet igit fine dubitatione aliqua leges fequédas effe hoc modo fcribés in primo de legibus.Si quis recte laconum aut cretenfiū leges reprehendere poffit aliqua quæftio eft.Ego autem iudico optimá effe legé:quæ iubet ne quis iuuenū cogitari.Senex auté fi qs dubitaue rit principibus aut æqualibus referat nemine iuuenū audiente.Non ne igitur multo ante Platonem diuinæ litteræ fidem cæteris propofuere uirtutibus.Vnde apud nos quoqʒ icipiétibus ac iperfectionibus quafi fecundum animum infantibus fimplicius fcripturæ legūtur.Credédū enim omnibus eft omnia quæ in ea feruntur ficuti dei uerba ueriffima effe.Illis autem qui ad maiorem iam habitum fcripturarum puenerūt altiora petere:ac rationem fingulorum quærere conceditur:hos iudæi quafi fcripturarum expofitores fecundarios appellare folebant:poetá deinde Plato ait Theognim ex megara Siciliæ teftem habemus:qui ait fidelem uirum omni argento atqʒ auro in feditione meliorem.Nemo enī integer atqʒ fidelis fine omni uirtutis numero in feditionibus effe poteft.Quorfum hæc quia legis latorem qui a Ioue miffus é ita leges confcribere oportere céfemus ut ad maximam femp uirtutū refpiciat: quam theognim fecuti fidem quæ maxime in periculis luc& effe arbi tramur:eam non iniuria perfectam iuftitiam nominare poffumus.Ita Plato non irrationalé fidem:fed eam quæ uirtuti coniūcta é cóprobare uidetur:quod Saluator nofter breuius aptius ac diuinius pofuit.Euge inquit ferue bone atqʒ fidelis.Et rurfus:quis ergo erit fidelis & prudes paterfamilias:prudentiam enim & magnanimitatem fidei coniunxit. Præterea Plato aliquantulum progreffus. Certe inquit defunctorum animæ uirtutem quandam habent:qua uel poft mortem rebus huma nis auxiliantur. Vera enim hæc opinio eft : fed nifi prolixis rationibus probari nó poteft.Credere auté oportet huiufmodi fermoibus:quoniá a prifcis ualde uiris traditi funt.Credendum ergo eft etiam illis:qui ita hæc fe habere legibus confirmant.Sic certe de Hieremia traditum fuiffe iudæi contendunt.Et machabæorum liber rettulit uifum ipfum fuiffe **poft mortem orare pro populo.** *Q₂ conuede per fabulas adolefcenti bus maiora tradenda funt. C . I .*

Fig. 88 A page from the *Eusebius* showing the first roman type face of Nicolas Jenson, Venice, 1470. (Courtesy of the Trustees of the British Museum.)

altiora petere:ac rationem singulorum quærere
quasi scripturarum expositores secundarios ap
deinde Plato ait Theognim ex megara Siciliæ t
fidelem uirum omni argento atq; auro in sedit
enī integer atq; fidelis sine omni uirtutis num
potest.Quorsum hæc?quia legis latorem qui a
conscribere oportere césemus ut ad maximam s
quam theognim secuti fidem quæ maxime in
tramur:eam non iniuria perfectam iustitiam n

Fig. 89 A sectional enlargement of Fig. 88.

first introduction. He produced letters that were not only perfect in design, but also so well positioned on the body of the type piece that he achieved very sensitive spacing, harmonization of characters, and perfect alignment on the page. Jenson's roman type quickly become the model upon which a great many contemporary and later type-founders and printers based their roman types. His designs were so distinctive that they have set the general style upon which roman type design is still based. Jenson's roman appeared in print in 1470 and it represented a tremendous advance over all other previous roman types. The minuscule letters were modified to work perfectly with their capital counterparts and the relationship of the ascender and descender of the body of the letter was subtly adjusted to provide an excellent contrast between height/weight, and horizontal/vertical visual relationships. The letter spacing was so well adjusted that each letter receives the correct amount of white-space contrast, no matter what position it assumes in a line. A page of type set in Jenson's roman exhibits remarkably even color, due not only to the letter space, but also to the consideration of the space between lines of type.

The Italic Letter

Aldus Manutius, a printer in Venice during the latter years of the 15th century, was the originator of the type style that is called *Italic*. The design was influenced by the growing popularity of humanist cursive used for everyday needs, and it is reported that Manutius modeled the style after the handwriting of the great Italian poet, Petrarch. Italic letters were first used in 1501, and they represent a decided departure from the standard roman forms in that they exhibit a forward slant of about 8 degrees from the vertical. These letters were designed as a solution to the problem of economical printing of Latin classics for popular sale. Aldus found that italics were very economical of space and therefore used less paper per volume, which meant lower costs in mass production. Italic types were extremely popular for some time, and Manutius' designs were so successful that they were quickly copied by other printers in forged editions. After his patents lapsed in 1513, many printers copied and modified his italic type designs. It is of interest to note that roman capitals were used with the minuscule italics. Italic capitals appropriate to the minuscules were not designed until later, probably following examples used by the 16th-century writing masters, Giovanantonio Tagliente and Giovambattista Palatino. These capitals at first were slanted versions of roman capitals, but later exhibited beautiful flourishes and swirls very imitative to earlier Italian writing masters of the "chancery cursive" hand. Figure 90 is an example of the famous Aldine italic.

Fig. 90 This page from *Virgil* shows the first italic type face of Aldus Manutius, Venice, 1470 A.D. (Courtesy of the Trustees of the British Museum.)

LIB. ·II·

Rursus in arma feror, mortem'q; miserrimus opto.
Nam quod consilium, aut quæ iam fortuna dabatur?
Méne efferre pedem genitor te posse relicto
Sperasti? tantum'q; nefas patrio excidit ore?
Si nihil ex tanta superis placet urbe relinqui,
Et sedet hoc animo, perituræq; addere Troiæ
Te'q; tuos'q; iuuat, patet isti ianua leto.
Iam'q; aderit multo Priami de sanguine Pyrrhus,
Natú ante ora patris, patrem qui obtruncat ad aras.
Hocc' erat alma parens, quod me per tela, per ignes
Eripis? ut mediis hostem in penetralibus, ut'q;
Ascanium, patrem'q; meum, iuxta'q; Creusam,
Alterum in alterius mactatos sanguine cernam?
Arma uiri ferte arma, uocat lux ultima uictos.
Reddite me Danais, sinite instaurata reuisam
Prælia. nunquam omnes hodie moriemur inulti.
Hic ferro accingor rursus, clypeo'q; sinistram
Insertabam aptans, meq; extra tecta ferebam.
Ecce autem complexa pedes in limine coniunx
Hærebat, paruum'q; patri tendebat Iulum.
Si periturus abis, et nos rape in omnia tecum,
Sin aliquam expertus sumptis spem ponis in armis,
Hanc primum tutare domum. cui paruus Iulus,
Cui pater, et coniunx quondam tua dicta relinquor?
Talia uociferans gemitu tectum omne replebat,
Cum subitum, dictu'q; oritur mirabile monstrum.
Namq; manus inter, mæstorum'q; ora parentum
Ecce leuis summo de uertice uisus Iuli
Fundere lumen apex, tactu'q; innoxia molli
Lambere flamma comas, et circum tempora pasci.

D

Fig. 91 A sectional enlargement of Fig. 90.

Alterum in alterius mactatos sanguine cernam?
Arma uiri ferte arma, uocat lux ultima uictos.
Reddite me Danais, sinite instaurata reuisam
Prælia. nunquam omnes hodie moriemur inulti.
Hic ferro accingor rursus, clypeoq; sinistram
Insertabam aptans, meq; extra tecta ferebam.
Ecce autem complexa pedes in limine coniunx
Hærebat, paruumq; patri tendebat Iulum.
Si periturus abis, et nos rape in omnia tecum,
Sin aliquam expertus sumptis spem ponis in armis,
Hanc primum tutare domum. cui paruus Iulus,
Cui pater, et coniunx quondam tua dicta relinquor?
Talia uociferans gemitu tectum omne replebat,

Fig. 92 The chancery cursive of Ludovico Arrighi, 1522. The examples shown are from *Operina*, or "little writing book." (Courtesy of the Dover Publishing Company, New York.)

Ludovico Arrighi

In the early years of the 15th century, the Italian writing master, Niccolo Niccoli, established a style of writing based on the Caroline minuscule and similar in form to that of the humanist minuscule. This cursive form of writing was so well received that it was adopted as the official writing hand for all Papal briefs, thus receiving the name "Cancellaresca Corsiva," or chancery cursive. This cursive was employed by Arrighi for his writing book, *La Operina da Imparare di scriuere littera Cancellarescha,* published in 1522 from engraved wood blocks. Arrighi's chancery hand was one of the most beautiful and was not only the basis for his own italic designs, but also a strong influence on designs of many later type-founders and printers. Arrighi was primarily interested in simplicity, clarity, and speed of writing, but he obviously was not willing to sacrifice aesthetic beauty in the process. His italic types designed prior to and during 1527 are judged by many to be far superior to those of Aldus Manutius.

Fig. 93 A page from a Book of Hours showing the type of Simon de Colines, Paris, 1525. (Courtesy of the Trustees of the British Museum.)

The Modern Roman Letter

From the middle of the 16th century until the end of the 18th century, there were several continental and English type designers who made significant contributions to the advancement of typography. In France, Simon de Colines and Robert Estienne im-

proved the roman type style and followed, in a modified fashion, the Aldine patterns. Also in France, Geofroy Tory contributed typographic reforms to the French language and introduced some of the most beautiful woodcut decorative initials, as well as magnificent title pages and borders that substituted Renaissance design for the prevalent designs of the

PAVLI IOVII NOVOCOMEN-
fis in Vitas duodecim Vicecomitum Mediolani
Principum Præfatio.

ETVSTATEM nobi-
liffimæ Vicecomitum fami-
liæ qui ambitiofius à præalta
Romanorũ Cæfarum origi-
ne, Longobardífq; regibus
deducto ftemmate, repete-
re contédunt, fabulofis pe-
nè initiis inuoluere viden-
tur. Nos autem recentiora
illuftrioráque, vti ab omnibus recepta, fequemur: có-
tentíque erimus infigni memoria Heriprandi & Gal-
uanii nepotis, qui eximia cum laude rei militaris, ci-
uilífque prudentiæ, Mediolani principem locum te-
nuerunt. Incidit Galuanius in id tempus quo Medio-
lanum à Federico AEnobarbo deletũ eft, vir fumma
rerum geftarum gloria, & quod in fatis fuit, infigni
calamitate memorabilis. Captus enim, & ad trium-
phum in Germaniam ductus fuiffe traditur: fed non
multo pòft carceris catenas fregit, ingentíque animi
virtute non femel cæfis Barbaris, vltus iniurias, patriã
reftituit. Fuit hic (vt Annales ferunt) Othonis nepos,
eius qui ab infigni pietate magnitudinéque animi, ca
nente illo pernobili claffico excitus, ad facrũ bellum
in Syriam contendit, communicatis fcilicet confiliis
atque opibus cũ Guliermo Montifferrati regulo, qui
à proceritate corporis, Longa fpatha vocabatur. Vo-
luntariorum enim equitum ac peditum delectæ no-

A.iii.

Fig. 94 A printed page showing the roman type of Robert Estienne. (Courtesy of the Trustees of the British Museum.)

Geofroy Tory de Bourges, Aux
Studieux & bons Lecteurs dit &
donne humble Salut.

Enophon vous enseigne
ra cy apres trescopieuse=
mēt, & Elisee Calense tres
succinctement La manie=
re de bien regir sa Famille, & facile=
ment augmenter ses biens, mais en
cest endroit cy mes treshonorables
Seigneurs soubz vostre bonne cor=
rection, ievous en veulx escripre
Trois Motz? vous allegant seulle=
ment vne petite Parabole & Simili
tude comme il sensuit. Il fut vng
temps quil estoit vng certain Aduo
cat, qui a Chascun qui vers luy ve=
noit au Conseil, ne dōnoit que vng
seul mot de response, mais auant
toutessoys quil le dist, de prime fa=
ce tendoit la main pour auoir Ar=
gent, il tenoit son huys a demy ou=
uert / & escoutoit ce quon luy disoit
puis soubdain dōnant son seul mot
de Conseil / serroit Lhuys au visai=
ge des gens / & senfermoit en sa mai=
son. Sa renommee estoit si grande /
quō venoit a son Conseil de toutes
pars, Tellemēt que vng certain Gē
tilhomme y vient, & ayāt vng Escu

Middle Ages. His student, Claude Garamond, produced a clear, open, roman letter, based on Jenson's first type, which was received with great success throughout Italy, France, Germany, England, and the Netherlands, and was a direct influence on the final decline of the Gothic black letter.

In England, William Caslon advertised his first types in 1734 and met with almost immediate success. Caslon designed one of the finest roman types of all time for multipurpose use. His type designs were clear, legible, and aesthetically beautiful. Caslon was a genius and master craftsman who succeeded in giving his designs the right blend of function and beauty needed to create an enduring type face. He allowed himself to be influenced by only the best designs of his predecessors. Another English printer whose contributions to printing are manifold is John Baskerville, of Birmingham, England. He amassed a fortune as a successful producer of japanned ware and entered the business of printing in 1750 with the desire to produce the book as well as it could be produced. He was an admirer of William Caslon, and was certainly influenced by him, but he designed a roman type that was different from any other before it. Baskerville's type was a transitional form between the "old style" of Garamond and Caslon and the precise "modern" of Bodoni. Baskerville roman exhibited widely contrasting weights of thick and thin elements, in contrast to the old style's relatively uniform color, and introduced the pointed

Fig. 95 · A page from *Xenophon* showing the roman type of Geofroy Tory, Paris, 1531. (Courtesy of the Trustees of the British Museum.)

Fig. 96 An example of Claude Garamond's italic type with swash capitals. (Courtesy of the Trustees of the British Museum.)

serif in contrast to the rounded serifs of old-style letters. Moreover, he was the first to devise a hard-finish *wove* paper upon which to print his new types, and he greatly improved the quality of printing inks. He was the first printer to produce a beautiful book in which he controlled all the necessary factors. He produced his own type, devised the paper, created his own inks, and improved to his exact specifications the press upon which his work was printed. John Baskerville's achievements had a profound effect upon European typography.

DOUBLE PICA ROMAN. 1.

Quouſque tandem abutere Ca-
tilina, patientia noſtra? quam-
diu nos etiam furor iſte tuus e-
ludet? quem ad finem ſeſe ef-
frenata jactabit audacia? nihil-
ne te nocturnum præſidium pa

DOUBLE PICA ROMAN. 2.

Quouſque tandem abutêre, Ca-
tilina, patientia noſtra? quam-
diu nos etiam furor iſte tuus e-
ludet? quem ad finem ſeſe eff-
renata jactabit audacia? nihilne
te nocturnum præſidium palatii

Double Pica Italick.

*Quouſque tandem abutêre, Catili-
na, patientia noſtra? quamdiu
nos etiam furor iſte tuus eludet?
quem ad finem ſeſe effrenata jac-
tabit audacia? nihilne te noctur-*

D

Above:
Fig. 97 A page from William Caslon's type specimen book of 1754, showing Caslon's roman and italic faces. (Courtesy of the Trustees of the British Museum.)

Right:
Fig. 98 A page from Virgil's *Aeneidos* showing the roman type of John Baskerville, Birmingham, 1757. (Courtesy of the Trustees of the British Museum.)

P. VIRGILII MARONIS

AENEIDO,

LIBER SECUNDUS.

CONTICUERE omnes, intentique ora tenebant:
Inde toro pater Aeneas ſic orſus ab alto:
Infandum, Regina, jubes renovare dolorem;
Trojanas ut opes, et lamentabile regnum
5 Eruerint Danai: quæque ipſe miſerrima vidi,
Et quorum pars magna fui. quis talia fando,
Myrmidonum, Dolopumve, aut duri miles Ulyſſei,
Temperet a lacrymis? et jam nox humida cœlo
Præcipitat, ſuadentque cadentia ſidera ſomnos.
10 Sed, ſi tantus amor caſus cognoſcere noſtros,
Et breviter Trojæ ſupremum audire laborem;
Quanquam animus meminiſſe horret, luctuque refug
Incipiam. Fracti bello, fatiſque repulſi
Ductores Danaum, tot jam labentibus annis,
15 Inſtar montis equum, divina Palladis arte
Aedificant; ſectaque intexunt abiete coſtas.
Votum pro reditu ſimulant: ea fama vagatur.
Huc delecta virum ſortiti corpora furtim
Includunt cæco lateri; penituſque cavernas
20 Ingentes, uterumque armato milite complent.
Eſt in conſpectu Tenedos, notiſſima fama
Inſula, dives opum, Priami dum regna manebant:
Nunc tantum ſinus, et ſtatio malefida carinis.

H

90

CANTO XIII.

Non era ancor di là Nesso arrivato,
 Quando noi ci mettemmo per un bosco,
 Che da nessun sentiero era segnato:
Non fronde verdi, ma di color fosco,
 Non rami schietti, ma nodosi e'nvolti,
 Non pomi v'eran, ma stecchi con tosco.
Non han sì aspri sterpi, nè sì folti
 Quelle fiere selvagge, che'n odio hanno
 Tra Cecina e Corneto i luoghi colti.
Quivi le brutte Arpíe lor nidi fanno,
 Che cacciar delle Strofade i Trojani,
 Con tristo annunzio di futuro danno.
Ale hanno late, e colli, e visi umani,
 Piè con artigli, e pennuto'l gran ventre:
 Fanno lamenti in su gli alberi strani.
E'l buon maestro: Prima che più entre,
 Sappi, che se' nel secondo girone,
 Mi cominciò a dire, e sarai, mentre
Che tu verrai nell'orribil Sabbione.
 Però riguarda bene, e sì vedrai
 Cose, che torrien fede al mio sermone.

Fig. 99 A page from Dante's *Divina Commedia* showing the first modern roman type by Giambattista Bodoni, Parma, Italy, 1795. (Courtesy of the Trustees of the British Museum.)

Giambattista Bodoni

Giambattista Bodoni was born in Saluzzo, Italy, in 1740 and became a printer in Parma in 1768. He was directly influenced by the work of Baskerville, using the plate-finish wove paper devised by him and interpreting his typographic innovations. The influence on Bodoni's work was generally classical, with a simplification of forms in contrast to the flowering forms in vogue earlier. This formal, geometric influence was exerted by Bodoni in the creation of his new type style — the first "modern" roman type. Figure 99 is an example of this roman face. Noticeable immediately are the hairline serifs, the extreme contrast of letter weights, the formal geometric styling, the feeling of verticality, and the tendency toward characters that exhibit a condensed quality. The results of his work toward the end of the 18th century had a profound effect upon future letter design. Bodoni extended his new look to include page design as well, replacing the former decorative title-page borders of Renaissance influence with simple, geometric line treatments. His page designs presented a sophisticated formalization, reflecting the cultural tendencies of his time.

Non han sì aspri sterpi, nè sì folti

Quelle fiere selvagge, che'n odio hanno

Tra Cecina e Corneto i luoghi colti.

Quivi le brutte Arpíe lor nidi fanno,

Che cacciar delle Strofade i Trojani,

Con tristo annunzio di futuro danno.

Ale hanno late, e colli, e visi umani,

Fig. 100 A sectional enlargement of Fig. 99.

The Script Letter

The script letter forms represent the final development of calligraphy in the Western world. The height of their development occurred during the 17th and 18th centuries at the hands of the European writing masters and engravers. Ludovico Arrighi was the first to teach the mechanics of script writing, with a broad-edge pen, in his writing book published in 1522, but the French first developed the formal and informal script hands executed with a flexible, pointed pen. Under Louis XIV, France dominated much of Europe; the influence of its writing hands, as well as all its other cultural accoutrements, was extremely strong.

There were three specific styles in use during the 17th century. The first of these was *ronde,* a round, upright script that was an outgrowth of the earlier Gothic cursives. A formal script, ronde is characterized by extreme extensions of ascenders and descenders, as well as elaborately flourished capitals. This script was the model for all upright scripts used by writing masters and type-founders. The second style is called *lettre italienne,* or Italian hand, and was adapted from the Italian writing then current. It was developed from chancery cursive, but was written with a pointed pen and exhibits a forward slant of about 68 to 70 degrees from the base line.

This is a flowing, connected script that has fine rounding of letters, long ascenders and descenders, and the familiar flourishing of capitals. This script probably influenced the development of the English roundhand, which in turn had a strong effect on the development of 19th- and 20th-century script forms. The third French variety is *coulée,* which appears to be a composite of both the ronde and the Italian hand. This is a semiformal hand with rounding letters; it was written at an angle of from 65 to 68 degrees.

The Dutch writing masters followed the styles formulated by the French, writing at a greater forward slant, about 60 degrees, and developing the use of flourishes to a fantastic degree. This preoccupation with decorative flourishing resulted in the establishment of a new art, the Dutch initial, and the decorative monogram. The English roundhand, adapted from the Italian hand, exhibits the greatest writing angle of all scripts, 54 degrees from the base line, and is characterized by extreme rounding forms; hence its name. After the middle of the 17th century, there was a strong movement in England to develop a standard writing hand for the needs of commerce. Numerous writing books were produced in the late 17th century and well into the 18th. For the most part, they illustrated various types of roundhand as well as other styles in current use. One of the best and most famous of these is *The Universal Penman,*

produced by George Bickham in 1741. This book contains illustrations of the work of many contemporary writing masters and engravers, including Bickham.

English influence in later years was to spread the roundhand script to all parts of the known world; anywhere, in fact, where English trade and commercial activities were influential. For this reason, the emergence of English roundhand as the predominant script hand influenced the designs of 19th- and 20th-century type-designers and engravers. It is often considered that the 19th-century scripts added nothing to the beauty achieved in the earlier designs, and they should be regarded as

Fig. 101 Three examples of early script writing from French sources: rondé style (above); lettre italienne style (page 94); coulée style (page 95). (Courtesy of the Trustees of the British Museum.)

Lettres
du Roy Louis XJ. au
gouuerneur de la Rochelle
a ce quil ait a faire
Jouir et vser les Maire et habitans
de ladicte ville du priuilege
quilz pretendent auoir
de ne pouuoir estre conuenuz ne
mis en cause hors de la ville
en quelque matiere
ou instance que ce soit par Priui:
lege de Scholarité ou au:
trement au cas qu'Il
luy apparoisse que lesdictz
habitans en ayent iouy
au temps passé
A Sainct Jehan D'Angely
Le deuziesme de Juin
1472

Loys Par la grace de Dieu Roy De
France Au gouuerneur de la Rochelle ou a Son Lieuten
SLLVT. L'humble Supplication des Maire Escheuins
Bourgeois et habitans de nostre ville de la Rochelle auons
receüe contenant que combien que par Priuilege par noz
Predecesseurs a eux donné et octruié et par nous confirmé
Jlz ne puissent estre traich conuenuz ne mis en cause

a regression. The creation of type scripts more often tightened and distorted the freedom of flow in order to conform to the requirements of typography. In addition, because of the difficulties it presented for the layman; because of its poor legibility in the hands of the common individual; and because of the extreme license taken in its rendition, the script is often credited with a major role in the general decline of beautiful, readable handwriting. Figure 101 shows some of the script varieties that have been discussed. Figure 102, the English round-hand, is selected as the major script hand to be shown enlarged and in alphabetic form in Figure 103.

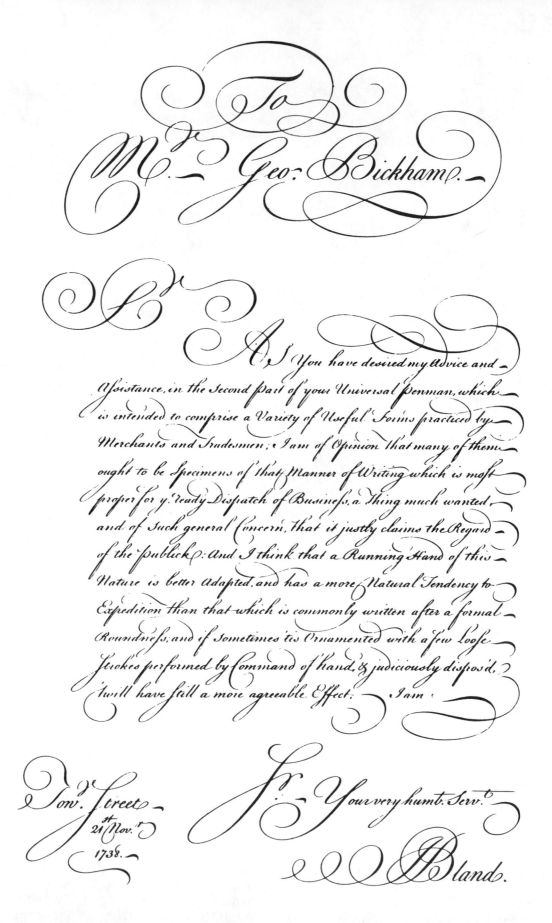

To
Mr. Geo: Bickham.

Sr

As You have desired my Advice and
Assistance, in the Second Part of your Universal Penman, which
is intended to comprise a Variety of Useful Forms practiced by
Merchants and Tradesmen; I am of Opinion that many of them
ought to be Specimens of that Manner of Writing which is most
proper for ye ready Dispatch of Business, a Thing much wanted,
and of Such general Concern, that it justly claims the Regard
of the publick: And I think that a Running Hand of this
Nature is better Adapted, and has a more Natural Tendency to
Expedition than that which is commonly written after a formal
Roundness; and if Sometimes 'tis Ornamented with a few Loose
Strokes performed by Command of hand, & judiciously dispos'd,
'twill have still a more agreeable Effect: I am

Tow. Street
21 Nov.r
1738.

Sr Your very humt. Serv.t

Bland.

Fig. 102 The English roundhand script. A letter written to George Bickham in 1738 by Joseph Bland as a sample for inclusion in Bickham's book on penmanship, *The Universal Penman*. (Courtesy of the Dover Publishing Company, New York.)

and of Such general Concern, that it justly cl

of the publick: And I think that a Runni

Nature is better Adapted, and has a more Nat

Expedition than that which is commonly writt

Roundness; and if Sometimes 'tis Ornamented a

Strokes performed by Command of hand, & jud

'twill have still a more agreeable Effect,

Fig. 103 A sectional enlargement of Fig. 102.

A B C D E F G H I K L M

N O P 2 R S T U V W X Y Z.

Aaabbccddeefffgghhijkkllmm

nnooppp grrrsfstttuvnmxxyyzzz.

The Square-Serif Letter

This style of letter is completely a typographic creation and was introduced in 1815 by Vincent Figgins. Square-serif letters are variously called "antique" or "Egyptian," the latter being the preferred designation. Types of this style are characterized by an evenness of weight, except for certain minuscule letters in which weight variation is necessary for legibility, and heavy, square, or rectangular serif structures. Square serifs were very successful during the 19th century and were designed in many variant styles, including shaded and decorative letters. Today there are many fine examples of this style in use as display copy. In 1825, the Caslon foundry cut an italic counterpart to the earlier Egyptian of Robert Thorne. The 20th century has produced a number of revivals based on the 19th-century forms, and designs recently have been produced that wed the square-serif characteristics to traditional roman forms, creating a very pleasing and bold type letter that serves well in small size as a text letter. Figure 104 illustrates 19th-century examples of the square-serif letter.

Fig. 104 Some 19th-century examples of the square-serif letter form. (Courtesy of the Dover Publishing Company, New York.)

THUNDER SHOWERS

ENCLOSURES HEAVEN'S BLESS

PRODUCTION

SHORTNESS

GRANDFATHERS' CONVENTION

Fig. 105 Some 19th-century examples of the sans-serif letter form. (Courtesy of the Dover Publishing Company, New York.)

The Sans-Serif Letter

The sans-serif ("without serifs") letter form was first designed as a display face without minuscules by the Caslon foundry in 1816, but received no real prominence until after the first quarter of the 20th century. This letter form has a total lack of serif structures and a general evenness of weight in all the letter parts. In 1925, Paul Renner designed the sans-serif type face, Futura, for general and book use, and it is characterized by clear, even weights based on geometric proportions. There are, of course, subtle weight changes to reduce heaviness at letter-part junctures and to improve the color and aesthetic appearance.

The Bauhaus movement in Germany, with its emphasis on clean, functional, and geometric lines for all design solutions, undoubtedly influenced type design just as it influenced the arts and architecture of the time. In fact, this movement was so strong and widespread that its basic influence is still felt in contemporary design. Sans-serif types are essentially modern renderings of the basic letter forms of the Roman alphabet and, with the roman faces, make up the bulk of the printed work today. Figure 105 contains 19th-century examples of the sans-serif letter.

PART II

THE DISCIPLINE AND
PRACTICE OF LETTERING

THE BASIC STRUCTURES

The classic capital letters of the Roman alphabet, the evolution of which was traced in Part I, have provided the basic form for our letter system. They have supplied not only the capital letters of our alphabet, virtually unchanged from Roman times, but also the minuscule letters, which evolved during the Middle Ages as a gradual modification of the classic forms. These capitals possess core shapes, or skeletons, upon which they were developed, just as living organisms are based upon their particular skeleton forms. The particular concern of this chapter is the observation and analysis of these structures. They are important because they formulate the relationships that exist between letter parts and between different letter forms.

The Relationship Within the Square

Every letter of the alphabet can be determined geometrically within a square: the circle forms the basis for curvilinear shapes; its central axis forms the basis for vertical and horizontal shapes; and the triangles and diagonals of the square represent the oblique shapes. The letter shapes thus formed require some modification in order to create more uniform sizes for stability and legibility when combined as communicative elements. These corrected skeleton shapes, both capital and minuscule, are illustrated in Figures 106-107, according to the area of a square that they occupy relative to each other. Groups into which the capitals fall are as follows:

(1) The *M* and *W* occupy an area greater than one full square.

(2) The *O, Q, A,* and *V* occupy one full square.

(3) The *D, H, N, T, Z, X, C,* and *G* occupy four-fifths of one square.

(4) The *U* occupies three-fourths of one square.

(5) The *Y, R,* and *K* occupy an area of more than one-half of one square.

(6) The *E, F, S, B, L,* and *P* occupy one-half of one square.

(7) The *I* and *J* are vertical strokes.

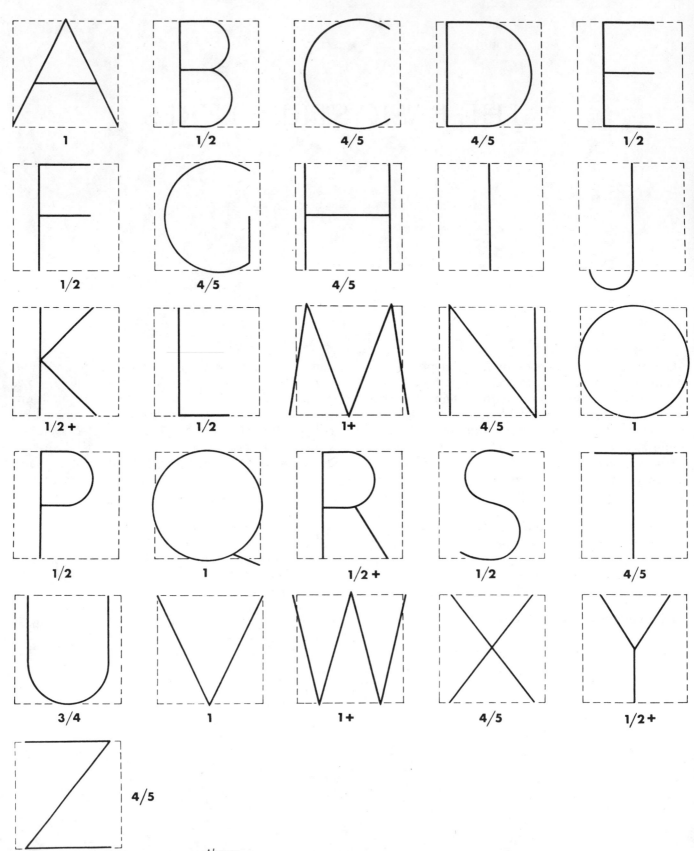

Above:
Fig. 106 The capital (majuscule) skeleton letter forms. The numbers and fractions refer to the area of a square that each letter will occupy. (The *J* in contemporary usage will generally terminate at the base line, except in the case of certain calligraphic treatments.)

Opposite:
Fig. 107 The small letter (minuscule) skeleton forms. Note that the minuscule letters do not follow a specific pattern that can be easily determined within the square format.

a b c d e f g

h i j k l m n o

p q r s t u v

w x y z

The Linear Relationships

The letter shapes also may be grouped according to the quality of the lines and angles of which they are composed. These are listed below and illustrated in Figure 108.

(1) The *E, H, F, I, L*, and *T* are composed of straight lines and right angles.

(2) The *A, K, M, N, V, W, X, Y*, and *Z* are composed of straight lines and oblique angles.

(3) The *B, D, J, P, R*, and *U* are composed of straight lines and curves.

(4) The *C, G, O, Q*, and *S* are composed of curved lines.

There are, obviously, a great number of letter styles that do not seem to bear any resemblance to

E F H I L T

A K M N V W X Y Z

B D J P R U

C G O Q S

i l t

k v w x y z

a b d e f g h j m n p q r u

c o s

a t u y

Fig. 108 The linear relationships that exist within both the capital and minuscule letter forms. These groupings point up the great linear differences beween the two major letter forms of the alphabet.

these basic skeleton shapes. However, in the majority of these cases, the basic shapes have only been bent, stretched, condensed, or pulled, so that the resulting letter form takes the desired appearance. A great deal of design, knowledge, and taste is necessary whenever deviation from the basic skeleton structure occurs, as letters are designed with two factors in mind: (1) the aesthetic quality or artistic appearance, and (2) the function or letter readability. Good letter forms are the direct result of careful consideration of both these factors. Consequently, though the skeleton structures are extremely flexible in any direction, alterations that are made must meet two conditions, if the resulting letter forms are to be good: (1) Any change effected with one letter must be proportionately effected with all other letters to maintain a uniform letter quality. (2) The change so effected must not alter the design aesthetics so radically as to diminish or destroy the design value, thus creating a bad form functionally.

Optical Illusions

Letters of the alphabet that are composed of curved strokes, and letters formed by oblique strokes merging to a point, are subject to an optical illusion when compared to a vertical letter of the same height.

These two situations are described and illustrated below.

1. Letters that are basically curvilinear should always be made slightly larger than the other letters to correct the optical illusion. If, for example, an O and an E on the same line are made equal in height, the eye will tend to compress the height of the O and visually cause it to appear shorter than the E. To correct this situation, it is necessary to make the O large enough to exceed the guide lines a slight amount. A degree of practice may be necessary to determine the proper amount of increase. (Fig. 109)

2. Letters that are fully or partially formed by the convergence of oblique lines must be made slightly larger because of optical illusion. If, for example, an A and an F on the same line are made equal in height, the eye will compress the A because of the optical difference between a horizontal and a point on the same line. To correct this, the A should be constructed so that its point exceeds the cap line slightly and visually appears equal in height to the horizontal of the F. In a letter such as the M, which has two points on the cap line and one on the base line, the point at the base must also exceed the base line slightly, or the letter will appear shortened at its middle. (Fig. 110)

Fig. 109 The effects of optical illusion graphically illustrated. The O on the right appears much shorter than the E, while the O on the left, which is physically larger, appears exactly the same height as the E.

Fig. 110 A graphic illustration of the optical illusion affecting all letters that are formed by the convergence of oblique strokes. Note that the A on the right appears much shorter than the one on the left, even though the first A is exactly the same height as the F. This problem affects the A; M; N; V; and W.

The Nomenclature of Letters

Letters are composed of parts, and each of these parts has a particular name or designation. These names form a part of the vocabulary of the letterer and should be well learned if he is to be able to understand and discuss letter forms intelligently. The essential nomenclature of letters is illustrated in Figure 111. Letters will be discussed and analyzed throughout this book using this terminology as a means of communication.

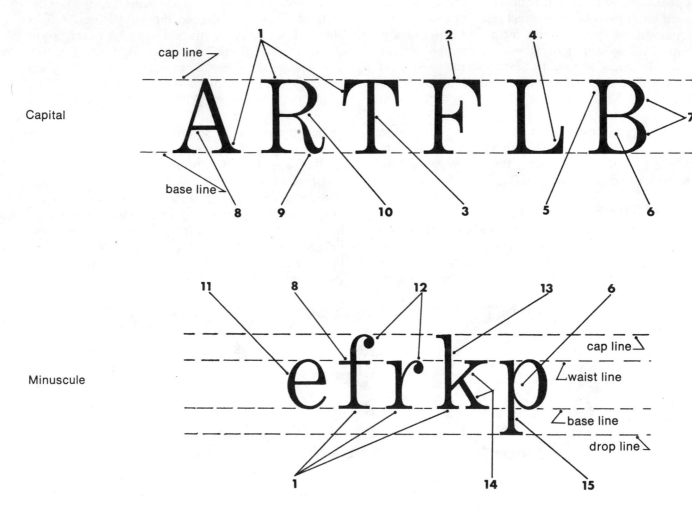

Fig. 111 The nomenclature of letter parts, capital and minuscule, and the necessary guide lines that *always* must be used when lettering. Note that while the capitals require only two guide lines for their construction, the minuscules require four to accommodate both the body letters and the descending strokes occurring with certain letters.

1. Serifs (bracketed to stem)
2. Hairline
3. Stem or Shank
4. Spur
5. Fillet
6. Counter
7. Bow
8. Crossbar
9. Tail or Swash
10. Lobe
11. Body letter
12. Kern
13. Ascender
14. Arms
15. Descender

ACQUIRING THE DISCIPLINES

Mastering the craft of lettering requires an honest and sincere endeavor. One must learn the disciplines necessary to practice this art, learn to observe the minute details of the subtle relationships inherent in letters, and apply this learning to the acquisition of the complete eye-and-hand coordination essential to the production of convincing, aesthetic letter forms. The making of letters represents a synthesis of the skills of drawing and design; thus, the ability to create and execute letters of perfection and beauty is a significant accomplishment.

Although the minuscule form of the alphabet was not created until many centuries after capitals were perfected, it seems wise, since they are used in combination, to study these two forms together and perhaps discover more concerning their overlapping relationships than if they were considered separately. A standard classic alphabet of each form has been designed and they will be used consistently throughout this chapter as models for study, tracing, and reference.

The Tools

Letters have been written with a variety of tools, principally the brush, the pen, and the pencil. The preferred tool with which to begin is the pencil, since it is the most familiar writing instrument and will, therefore, tend to accelerate the learning process and generate confidence more quickly. The brush and the pen should be considered as more advanced tools, and will be treated in some detail in Chapter 8.

Since the letters that are to be produced as exercises in this chapter are constructed of thick and thin strokes, the pencil to be used must have a wide sketching lead, 1/16 in. in thickness and ¼ in. in width; it must be capable of holding a flat chisel-edge. Two very excellent pencils that will serve this purpose are the General's Sketching pencil and the Koh-i-noor Flat Lead. A third pencil, which has a

smaller lead, ⅛ in. wide, for smaller lettering, is the Van Dyke Microtonic. All of these pencils are manufactured in the "B" ranges that are used for the exercises. A pencil of this type cannot be sharpened with a pencil sharpener. The wood must be carefully shaved off with a blade, leaving about ½ in. of lead exposed for sharpening. The sharp chisel-edge is obtained by sharpening both sides of the lead on a standard sand block, at an angle of approximately 10 degrees, as shown in Figure 112. It is generally

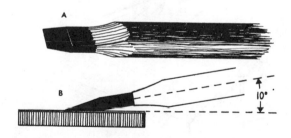

Fig. 112 (A) A correctly sharpened chisel-edged pencil; (B) The proper angle of the pencil's lead to the sand block to ensure the best sharpened edge.

desirable to allow ⅜ in. of lead to show for a long, tapering edge. The necessity of keeping this edge sharp and straight at all times cannot be emphasized too strongly, if a clean stroke is to be obtained. A dull edge will produce a ragged, uneven stroke of dubious quality. It requires only a second to restore the edge with the sand block to maintain the stroke quality.

The Material

The second consideration is the material upon which the letters will be rendered. A thin-weight layout visual paper is best because it is white, has an agreeable "toothy" surface (highly compatible to pencil), and has sufficient "see-through" quality for it to function as a tracing sheet. This latter quality is im-

portant, for much can be learned about letter construction by tracing over existing models. Should this type of paper not be available, a good quality, thin-weight tracing paper (translucent) will serve, though the pencil strokes will be of lesser quality because of the difference in paper surfaces. A good practice sheet is also obtained through the use of common graph paper, ruled in 1/4 in. or 1/8 in. grids. This type of paper will not serve as a tracing sheet because of its opacity, but guide lines and line spacing can be determined with a minimum of effort by using the blue grid lines preprinted on the paper.

Setting Up

Position a 9 in. by 12 in. sheet of paper on a flat drawing board, the surface of which has been covered with a sheet of smooth illustration or mounting board. This board acts as a cushion for the paper and should be fixed in position with staples or masking tape. The drawing board should be adjusted to a comfortable writing height and tilted forward to an angle that will allow free movement of the arm and hand. Ideally, this angle should be approximately 45 degrees, though the pencil can be manipulated

at a very shallow angle if necessary. It would be wise to become adjusted to this angle of working in preparation for lettering with the pen, which is discussed in Chapter 8. Admittedly, this angle will require time to adjust to, but the ease of working and the results obtainable are well worth the effort.

The sheet of paper should be squarely positioned toward the center of the drawing board, with the long measurement vertical. Check the horizontal level with the T square and affix the sheet with pushpins or masking tape. Establish margins on all four sides of the paper, leaving 1 in. on the top and sides and about 1 1/2 in. at the bottom. With the ruler, measure off 1 1/2 in. (the height of the model letters) from the top marginal line. Rule a parallel line from this measurement point across the paper, terminating at the side marginal lines. This establishes the first set of two guide lines within which the strokes will be rendered. Leave 1/2 in. of space before drawing the next set of guide lines. Proceed in this manner until the page is completed and five sets of lines have been prepared. These guide lines establish the height of a letter and are essential for the production of an even line of lettering.

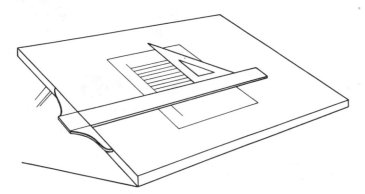

Fig. 113 The proper method of setting up the drawing board for the ruling of guide lines and for working. In order to ensure perfect horizontal and vertical lines, a T square and triangle *must* be used. It is best whenever possible to use a triangle that exceeds the length of the sheet to be lettered. Always rule guide lines very lightly and without pressing into the work surface of the sheet.

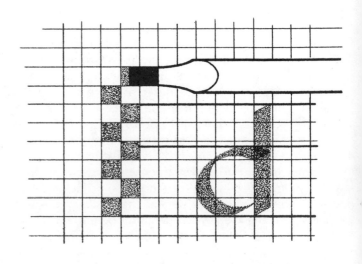

Fig. 114 The proper method for determining the correct height of the letters relative to the width of lead or nib being used. The letter shown is a somewhat squat letter and therefore has a ratio of about 4:2 in full widths. The model letters found later in this chapter have been rendered using a lead-width height of 6 1/2 strokes for capitals (cap line to base line); 4 strokes for the body letters of the minuscule (waist to base lines); and 2 1/2 strokes for the ascenders (waist line to cap line). It may be found desirable in practice to raise the ascenders 1/2 space above the capitals for aesthetic purposes. This then gives a ratio of 4:3 for ascending letters. The descending letters will carry the same proportion below the base line as the ascenders carry above the waist line. From the base line to the drop line, the number of widths should be either 2 1/2 or 3.

The Basic Strokes

The first discipline that must be acquired is the ability to render the basic strokes, the combination of which will produce all the letters of the alphabet. Some variations of these strokes will be necessary at times to produce serif constructions and certain parts of the capital and minuscule letters, but they will present no difficulty if the basics are mastered. Each of the basic strokes is shown in Figure 115.

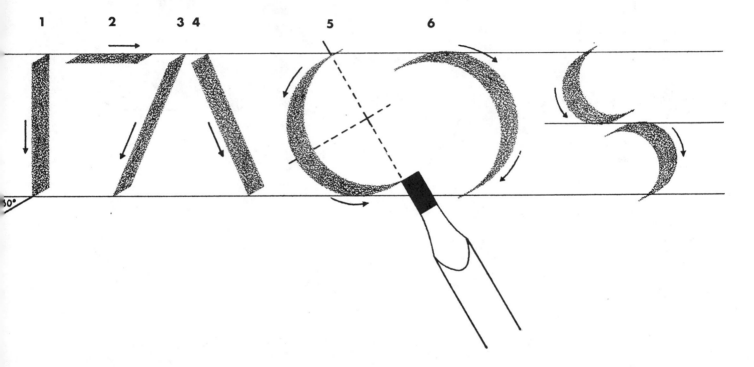

Fig. 115 The basic strokes and their proper direction of execution for right-handed letterers (left-handed individuals should refer to Figure 119 for correct directions). The strokes are: (1) the vertical stroke; (2) the horizontal stroke; (3) the left oblique stroke; (4) the right oblique stroke; (5) the left curvilinear stroke; (6) the right curvilinear stroke. The stroke angle is set at 30 degrees and this angle must be maintained *at all times* if perfect strokes are to be the result.

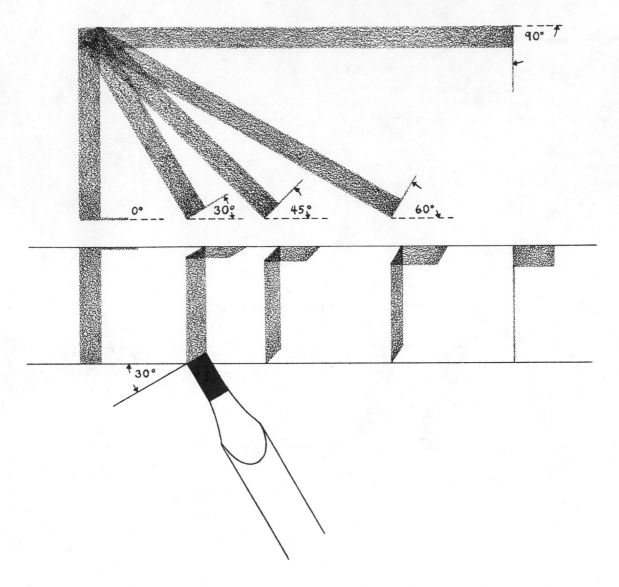

Fig. 116 The variety of strokes that may be produced by changing the angle of lead contact with the paper surface. Regardless of which angle is selected, it must be consistently maintained throughout its use.

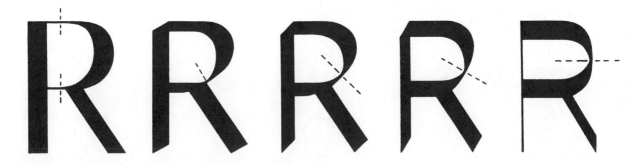

Fig. 117 Different forms of the letter *R* produced by the use of the contact angles illustrated in Figure 116. Note that not all letters are aesthetically good forms.

It is essential that one rule be particularly observed when rendering the strokes: The pencil must always be maintained at a constant angle of contact to the writing surface, regardless of the direction of the stroke. If this angle is changed while one is in the process of developing a stroke, the relationship of thick to thin will change. This will result in a letter form of awkward construction and poor aesthetic quality. The natural tendency of the chisel-edge tool is to produce thicks and thins in pleasing and correct proportion to one another, according to the angle of contact. All of the model letters used in this chapter have been rendered using a 30-degree angle of contact with the guide lines. Study the illustrations carefully before beginning the exercises. Notice that a variety of letter forms can be derived from the same skeletons by selecting a new angle of contact and maintaining it. (Fig. 117)

Position the previously prepared sheet of guide lines over the model strokes and proceed to trace them with a 6B pencil until they can be produced with relative ease and correctness. A number of practice sheets like the first will probably be necessary. The arm and hand should be "floating" on the paper in a comfortable writing position, the only point of contact being a light touch of the lower edge of the hand. The fingers should not move; all movement should originate from the shoulder. Check back after each set is rendered to determine what errors have been made, and make an effort to correct them with the next set. The amount of practice required depends upon how rapidly one acquires a "feel" for the pencil and the strokes. (Fig. 118)

When the traced strokes begin to resemble the models closely, render them in the same sequence, independent of these models. Work either on graph or layout paper, ruling guide lines, and use the models for reference only. The first attempts will, perhaps, seem awkward; however, this is usually due to tension caused by the abrupt removal of the model strokes as directional guides for the eye and pencil. If the tracing practice is diligently performed, this tension will soon disappear and the hand will continue to produce convincing strokes. Practice the basic strokes in this manner, altering the sequence in any way desired. They can be considered mastered when the same strokes can be rendered a number of times with little or no variation from the models.

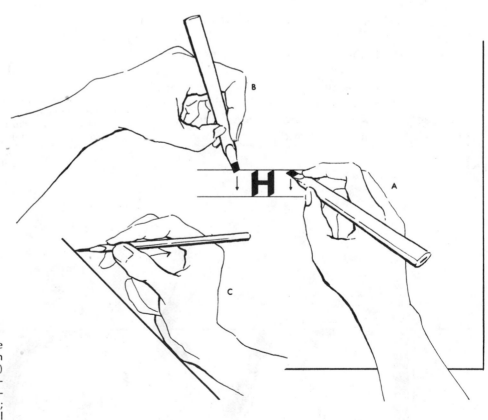

Fig. 118 (A) The correct position of the writing hand and the pencil in relation to the paper, as seen from above; (B) One of the more common positions assumed by the left-handed letterer relative to the paper, as seen from above; (C) The position of the hand and pencil relative to the board angle and position. Note that only the lower portion of the hand rests upon the writing surface to allow for a free, gliding movement.

Aids for the Left-Handed Letterer

In determining the ability to letter, it makes no difference whether or not a person is right-handed or left-handed; nature has not been discriminatory in this manner. There are differences in working procedures, however, which should be considered by the left-hander. The following information is included here to aid him and, hopefully, lessen some of the usual frustration.

(1) A left-handed person will letter with the hand upside-down or sideways. As a result, the hand is above the writing line, rather than below it. The directional angle of the writing instrument is away from the writer and above the writing line.

(2) The paper should normally have a slight cant (5 to 10 degrees) to the left; that is, in the direction of the angle of the writing arm. Some may find it easier, however, if the cant of the paper is in the opposite direction from the arm angle.

(3) The direction or method of making the strokes is different from that used by a right-handed letterer. For example:

Horizontal stroke — pull to left instead of push to right.

Vertical stroke — push down instead of pull down.

Left curvilinear stroke — pull to left instead of push to left.

Right curvilinear stroke — push to right instead of pull to right.

Left and *right oblique* strokes — push down instead of pull down.

(4) The above are not hard-and-fast rules, but only suggestions based on observation and experience. Each person should find the best and most comfortable method for himself.

Fig. 119 The basic strokes and stroke directions as executed by a left-handed letterer with the pencil in position above the writing line. The strokes are illustrated in the same positions as those for the right-handed letterer.

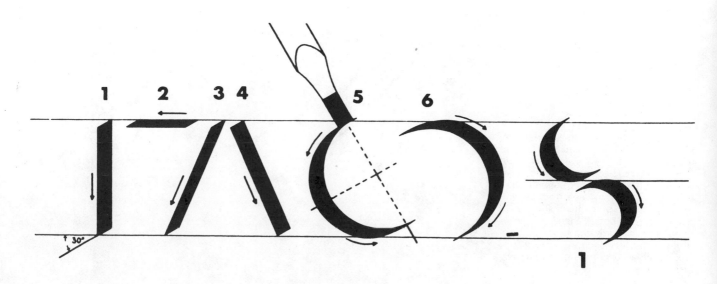

Letter Construction

The rendering of capital and minuscule letter forms is approached in the same manner as for the basic strokes. Study the model letters of each form carefully, noticing the subtleties, the sequence and direction of the strokes, and the relationships that exist from one letter to another. Place a prepared tracing sheet in position over the model capital letters and proceed to trace them carefully, noting the manner in which the various strokes interact to produce the letters. The capital form should be practiced exclusively — until good, convincing letters of this alphabet can be rendered — before the minuscule form is approached. Render the same alphabet using the models for reference only. When satisfactory proficiency has been gained, add the serif constructions (shown as dotted lines on the model letters). Refer to the section in this chapter on serif construction, and practice rendering these additions. (Fig. 120)

Minuscules

Study the models of the minuscule alphabet, observing the differences in structure that the majority of these letters present compared to the structure of the capitals. The minuscules are divided into three basic groups: (1) body letters, such as the o and e, which occupy the space between the base line and the waist line; (2) ascending letters, such as the b and d, the stems of which rise from the base line to the cap line; and (3) descending letters, such as the p and q, the stems of which descend from the waist line to the drop line. There is one letter that does not fall into any of these categories, but that may be considered as a body letter in most alphabets. This is the letter t, the stem of which rises slightly above the waist line, but does not extend to the cap line. Render these minuscule letters in the same manner as suggested for the strokes and the capital letters. Note that the minuscules occupy three spaces, compared with one space for the capitals. Four guide lines, instead of two, are needed to render these letters, so the tracing and practice sheets must be prepared accordingly. (Fig. 121)

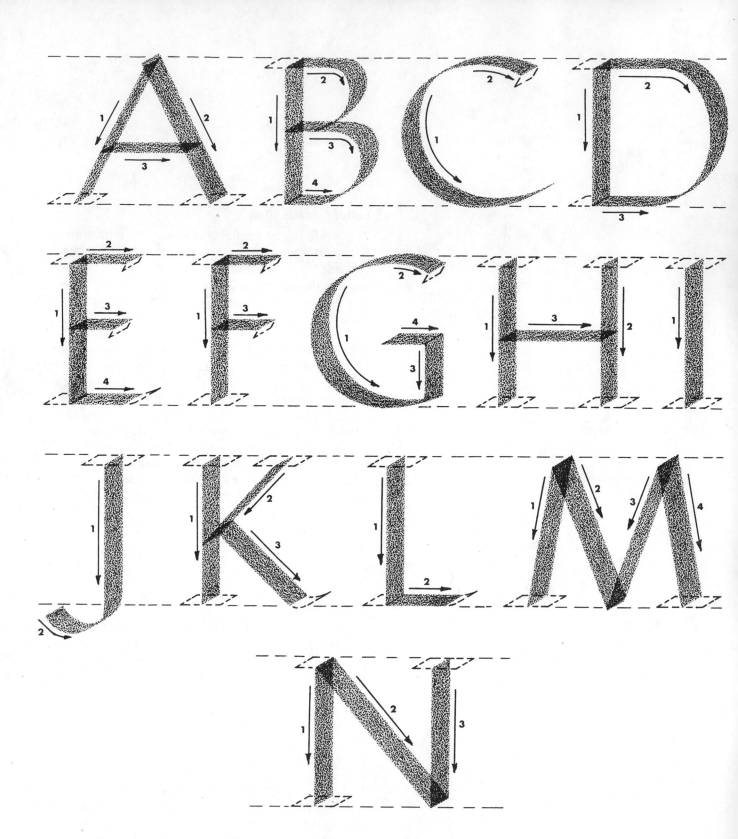

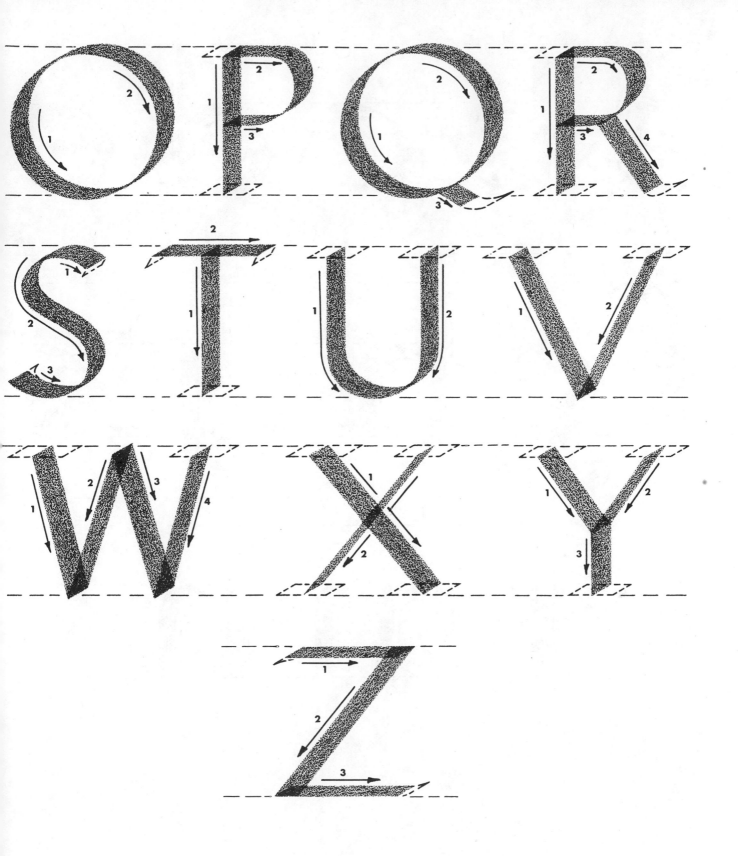

Fig. 120 A capital model alphabet. The letter forms of this alphabet have been carefully designed to remove all traces of personal style. The individual is therefore encouraged to develop his own intimate style from precise models. The letter *J* may be allowed to terminate at the base line if desired. The dotted lines indicate the position and type of serif stroke endings to be added to the basic letter. The small arrows and numerals indicate the sequence and direction of each stroke that makes up an individual letter.

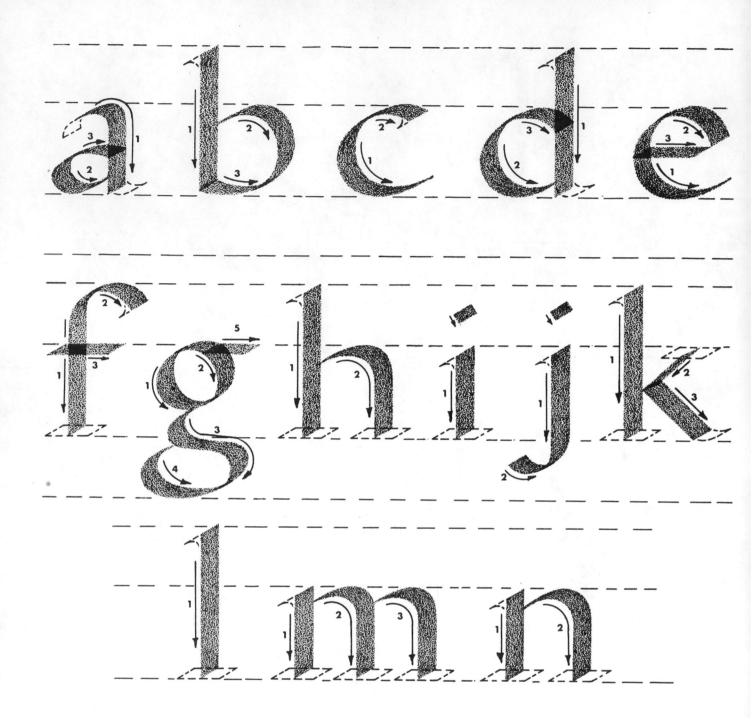

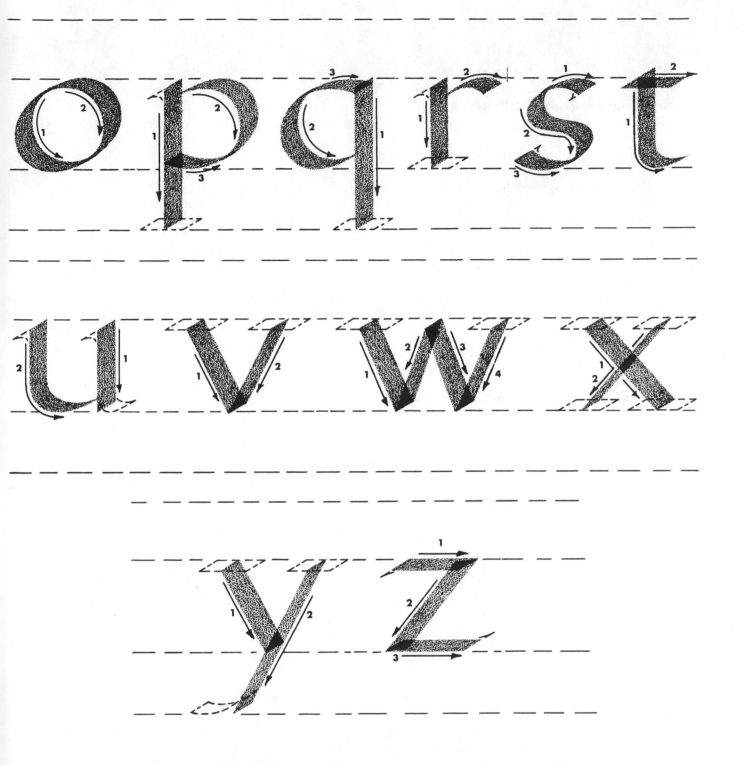

Fig. 121 A minuscule model alphabet. These letter forms are designed to accompany the capital model alphabet and are rendered in the same manner. Note the differences in form as the stroke combinations change. Four guide lines are necessary for the minuscule letters instead of two. The dotted lines indicate the correct serif endings, and the arrows and numerals indicate stroke sequence and direction. The numerals and punctuation designed for these model alphabets are found in Figures 140, 141, and 142.

Kinaesthetic and Visual Relationships

The hand will exhibit a tendency to react in a manner not totally compatible with what the eye sees. Since writing (and thus lettering) depends upon both the kinaesthetic and visual senses, it is essential to the production of good letters that the hand be trained to produce what the visual sense conveys to it.

The hand has a tendency to tilt strokes that should be vertical, to extend vertical strokes beyond their proper heights, and to compress circles. The eye, however, sees vertical strokes perpendicular to their bases, sees verticals even in height, and sees circles round and full. The only means by which the vital eye-and-hand coordination can be achieved is through the forced discipline of diligent practice and correction, until the desired reaction becomes automatic.

One further point concerning the construction of letter forms is the relationship that exists between the height of a letter and the weight of its parts. This relationship is an important factor to be considered in establishing correct letter spacing, and is valuable to the letterer in enabling him properly to vary a basic letter to fit different design situations. There are three basic ways in which letter forms can be altered and remain in a harmonious relationship. For the purposes of comparison, one letter has been used to illustrate the following variations:

(1) The skeleton of the letter remains constant, but the weight is either reduced or increased. Note the variation that occurs as the letter weight changes from light to extra-bold. The medium-weight letter is generally the standard from which the others were derived. (Fig. 123)

(2) The skeleton of the letter is varied in a vertical manner. An increase in height results in a proportionate decrease in weight, and the letter becomes condensed. Do not confuse this variation with the normal size-change that occurs when the standard letter is enlarged or reduced in its original form. The latter is only a change in the physical size of the letter, and no variation has taken place. (Fig. 124)

(3) The skeleton of the letter is varied in a lateral or horizontal manner. The letter is reduced in height, resulting in an extended letter of heavier weight. (Fig. 125)

When varying a letter form, always be aware that the variation must be proportionately consistent throughout the alphabet if the resulting words and sentences are to be well designed. The variation of a letter form is a tricky endeavor that can easily have unfortunate results if all controlling factors are not carefully considered. The beginning letterer should not concern himself with these problems; it is better to experiment in this direction after considerable experience, and after a mastery of standard forms has been achieved. A large number of letter variations can ultimately be obtained, resulting in what might be termed a "letter family." (Fig. 126)

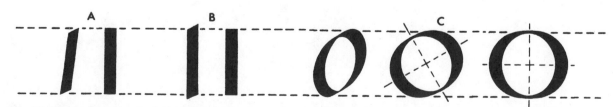

Fig. 122 (A) The tendency for the hand to tilt verticals; (B) The tendency for the hand to extend verticals; (C) The tendency for the hand to compress circles.

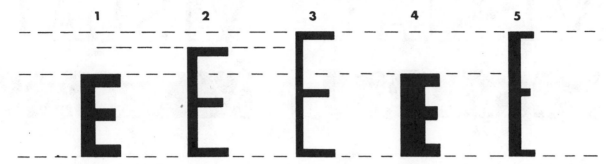

Fig. 123 The effects of weight changes upon a basic, unchanging skeleton form: (1) lightweight; (2) medium weight (standard); (3) light-weight with vertical stem doubled in weight; (4) medium weight with thickened stem; (5) medium weight with stem doubled; (6) heavy-weight. Note: not all of these forms remain aesthetically good.

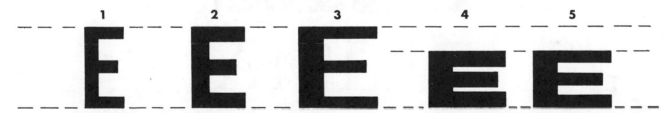

Fig. 124 The effects of varying the letter skeleton vertically: (1) The standard medium letter weight; (2,3) vertical extensions of (1) causing a proportionate decrease in letter weights distributed throughout the entire letter; (4) example No. 5 from Fig. 123; (5) the extension of this letter, creating a bad letter form.

Fig. 125 The effects of varying the letter skeleton in a lateral direction: (1) the standard medium letter; (2) even-weight increase with extension of the letter; (3) further lateral extension to No. 2, causing weight increase to the stem and weight decrease to the arms of the letter; (4) compression of the basic letter skeleton causing a heavy, condensed letter; (5) decrease in arm weights to lighten the visual appearance and increase readability.

Fig. 126 A family of letters. All the letters shown belong to the Futura type family, ranging from light-face through ultra-bold, display, and italics.

Word Construction

Word construction is one of the most difficult visual problems confronting the letterer. Putting letters together to form word combinations requires sensitive judgment in order to determine the correct amount of space between letters. This is referred to as "letter spacing." The entire process is visual, not mechanical; therefore, letter spacing becomes a question of observation, experience, and aesthetic judgment, rather than a matter of measurement. The letterer must acquire a sense of this spacing through the discipline of practice, analysis, and correction, until the eye becomes accustomed to viewing critically the negative areas in relation to the positive areas. The space occupied by the letter forms the positive

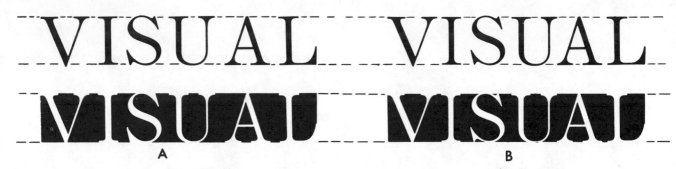

Fig. 127 (A) Letter spacing by mechanical means. An equal division of space has been allowed between each letter as if spacer bars of equal size were inserted. (B) Letter spacing by visual means. When adjustments for color and balance between positive and negative areas are made by the eye, the spacing between letters becomes asymmetric.

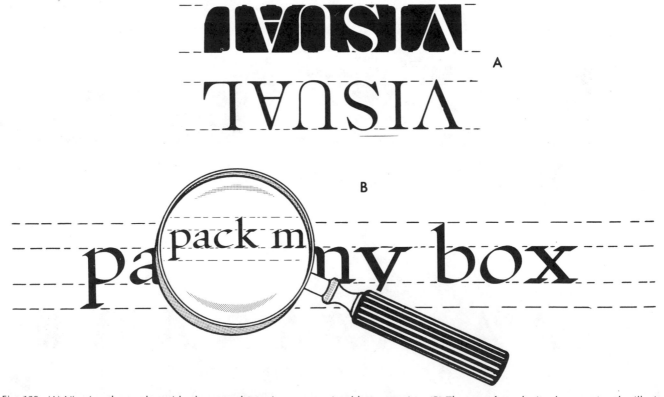

Fig. 128 (A) Viewing the work upside-down to determine proper visual letter spacing. (B) The use of a reducing lens to give the illusion of distance while remaining in close proximity to the work.

area, while the space between two or more letters forms the negative area. In Figure 127, one word is shown spaced by both mechanical and visual methods. The negative and positive areas must visually balance one another for the word to be readable and aesthetically correct. This balance is asymmetrical, since both areas will rarely be equal in size.

Letter Spacing

As letter spacing affects the readability of a word, it becomes a very important consideration. Proper spacing is dependent upon the nature of the letters involved, so it would be foolish to suggest that there exists an easy method of solving the problem. The letters may be tall and thin, short and heavy, extended, or condensed; the letters involved may be angular, vertical, or curvilinear. The extreme number of variations which exists precludes the possibility of applying any single rule. Illustrated in Figure 128 are several fairly reliable ways of visually checking a word:

(1) View the completed rough draft of the rendering upside-down, critically analyzing the negative areas. In this position, the word cannot be read easily and the eye becomes more attuned to the design of the letter forms, causing inconsistencies of spacing to become apparent. Squinting the eye may also help to bring spacing problems into more immediate focus.

(2) A reducing glass will usually focus attention on a problem of poor letter spacing. This lens gives the illusion of great distance when it is only a few inches above the work. The clarity of the image is excellent, making this tool a very effective aid for general design work. Reducing lenses may be purchased for a relatively nominal sum at any good art supply store.

(3) Position a piece of tracing paper over the work and black in the negative areas, leaving the positive areas white. Under the conditions of a reversed pattern, inconsistencies of spacing will generally become apparent.

Legibility and Color

Legibility is very important if the letters are to satisfy their function. Capitals must be rendered in an even line, and the ascenders and descenders of the minuscule letters must not be extended above the cap line or below the drop line. Ragged and uneven lines of lettering, and extreme contrasts in height and weight, result in words and sentences difficult for the eye to comprehend. The easiest words to read are those composed of capital and minuscule letters from an alphabetic style familiar to the reader. The capital-minuscule combination offers a pleasing variety of contours for the eye, and a familiar letter style allows the reader to be conscious of the letters only as symbols of communication. Readability is

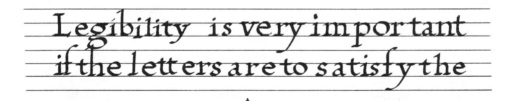

Fig. 129 (A) An example of two lines of lettering exhibiting some of the most glaring errors of letter and word spacing, color, line-up, line spacing, and letter construction. (B) A more sensitively rendered line of lettering showing attention given to the factors of legibility and aesthetics.

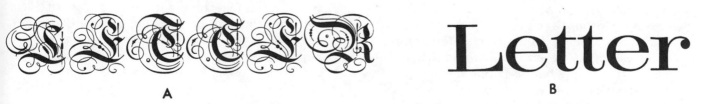

Fig. 130 (A) The word "LETTER" rendered in initial letters intended only for paragraph headings. The result is unfamiliar to the reader and therefore illegible. (B) The word "Letter" rendered in a clear, familiar form. The result is legible and highly readable.

AIOST
SOWER

Fig. 131 Full-size practice examples for visual letter spacing. Consistent analysis and correction will show quick positive results.

not stalled due to a lack of comprehension of the letters. For the same reasons, letters composed of thick-and-thin weights are easier to read than letters of even weight. It is not that even-weight letters are unreadable; they are very readable and are useful letters in a great many situations, but they do not function as well as thick-and-thin letters in large masses of small copy.

The "color" of a line of lettering is an important factor in establishing legibility. The color of a line or page refers not to a particular hue, but to the balance set up through the proper relationship of letter weights and spacing requirements. The color of a line should appear even and harmonious, with no single part of a line having undue emphasis, unless such emphasis is important to the meaning. The necessity for an emphatic statement within the line should be carefully considered by the letterer. Words exhibiting incorrect letter spacing and uneven weights will create lines having inferior color quality and faulty balance. Lines of lettering rendered in this manner will produce a page having poor aesthetic quality and readability.

Listed below is a series of letter combinations and words that present difficult spacing problems. The first combination of letters and the first word are illustrated in Figure 131. Follow the same practice pattern previously set up, rendering the others in the list, with the model alphabets as reference. The capital and minuscule forms should be rendered separately. Do not attempt to combine them at this time. Several practice sheets probably will be necessary before satisfactory letter spacing is achieved. *Do not rush.* Take time and analyze a word each time it is rendered, determining the corrections to be made on the next rendering. Keep the strokes sharp and correct, and remember to maintain the pencil at a constant angle of contact.

AIOST	BANJO
EFHILT	MANDATE
ANMK	ROMAN
COGQ	BOTCH
SOWER	JAGUAR

Sentence Structure

Sentence structure is not difficult, providing the steps to this point have been successfully mastered. The major problem is the determination of the proper amount of space that should be left between words. A general rule that can be applied is: "Words should not be spaced so far apart that they lose the sentence structure, nor so close together that they have a tendency to run together visually." In a sentence consisting of capital letters, the rule may be adhered to by leaving a space equal to the width of the capital *E* between words. An exception to this spacing formula occurs between words beginning or ending with letters constructed with oblique strokes. In such situations, a visual judgment must be made according to the letter combination found at the word break. In a sentence consisting of minuscule letters or capital-minuscule combinations, the rule may be adhered to by leaving a space equal to the width of the minuscule *e*. However, if there are two or more words consisting of capitals in a sentence, use capital word spacing *between* the words, but not immediately preceding and following them.

Line Spacing

Sentence structure implies the use of more than one line of lettering. Though there is no specific rule that can be applied to determine the proper spacing between lines, a space between lines equal to one-third the height of the capital letter will generally result in good, readable sentences. It may be practical to leave more or less space between lines of capitals, depending upon design requirements. It is permissible, for special design effects, to allow no space at all, but very careful consideration must be given to the selection of the letter style. In order to suit various design situations, and to create the proper tension that must exist between the letter height and weight and the total design of the page, line spacing must be flexible. Because of this flexibility, the letterer must exercise self-control to prevent aesthetic abuse. Between lines of minuscule letters, it is usually necessary to leave only enough space for the descenders of the upper line to clear the ascenders of the lower line.

Practice for word and line spacing should follow the same pattern already established. Listed below are two sentences containing the 26 letters of the

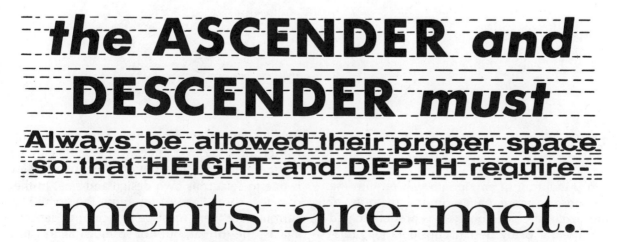

Figs. 132-133 These figures illustrate the problems of line spacing, capitals, minuscules, and the combination of both.

alphabet in different combinations. Render each at least ten times, using all capitals, all minuscules, and the capital-minuscule combination. The greater part of the practice should be done with combined alphabets in order to spotlight the varying spacing problems that will result. Experiment with line spacing to discover the amount of variation possible without destroying the aesthetic appearance of the page.

THE QUICK RED FOX JUMPED OVER THE LAZY BROWN DOG.

The Quick Red Fox Jumped Over The Lazy Brown Dog.

PACK MY BOX WITH FIVE DOZEN LIQUOR JUGS.

Pack My Box With Five Dozen Liquor Jugs.

PACK MY BOX
pack my box
Pack My Box

Fig. 134 Word spacing and sentence structure problems for practice.

Page Layout

A lettered inscription of any length will require the layout of one or more pages. In the majority of cases, the size of the page or sheet is predetermined by an art director or by design considerations relative to a total project. The letterer, therefore, will usually determine the letter style and height that will create a desired effect within a specific size. If there are no specific requirements, then the letterer is free to select his own design and size. In the case of a few short lines of lettering, the "white space" surrounding them must be sufficient to set them off against the format, but not so much as to cause the lines to "float" in the center of this area, nor so little

A
soul is an
expensive
thing to
maintain

A

A
soul is an
expensive
thing to
maintain

B

A
soul is an
expensive
thing to
maintain

C

Fig. 135 Page layout: (A) Too much space allowed for margins so that the lettered inscription seems to float and become lost within the format; (B) Too little space allowed for margins — the inscription appears to run off the format; (C) Correct amount of margin allows the inscription to maintain maximum emphasis with proper balance and readability within the format.

Fig. 136 A typical page layout allowing reasonable margins. Any combination of shapes and elements is possible providing the factors of balance and emphasis are correctly judged according to the desired format.

that the lines visually seem cramped. This is another example of visual determination that will be mastered with experience and observation. (Fig. 136)

The steps in planning a 14 in. by 17 in. page are as follows:

(1) Determine the appropriate margins that will properly display the lines of lettering. With this size page, it would be correct to allow 2½ in. for each side margin, 2 to 2½ in. for the top margin, and 3½ to 4 in. for the bottom margin. This will provide a pleasing proportion between the lettered inscription and the total page.

(2) Establish the style and size of the lettering. The style is chosen for its suitability for a particular job. The size of the lettering will be determined by the area left to contain the inscription. A sample line of lettering in the desired size will determine the number of words possible in one line. By dividing this number into the total number of words contained in the inscription, one can find the total number of lines needed. The number of lines possible on one page will then determine the number of pages necessary. If, at the chosen size, the inscription will require more than one page and only one page is allowable, the size of the letters will have to be reduced to allow the message to fit on the required page. When figuring the number of lines, it is usually wise to allow an extra line, since the word count is only an approximation.

(3) When the letter size and number of lines have been determined, measure for the guide lines and rule them lightly in pencil. Use either a commercially manufactured or homemade line spacer. The line spacer allows one to rule a variety of guide-line spaces having a harmonious relationship. Leave extra space for paragraph divisions and, if two columns are used instead of one, leave a suitable "gutter" between them. Always bear in mind the effect these spaces will have on the design of the total page.

(4) Lightly sketch in rough skeletons of the chosen style to determine quickly the "fit" of the words on the page. Any necessary changes should be made during the process of lettering, as there is no point in trying to make skeletons fit.

(5) Letter the inscription in the desired manner.

Serif Construction

Serif endings are common to all Roman-style letters. Their primary function is to provide a finish to the letter strokes, though they often serve also as decoration. Serif endings apparently began with Roman stone-inscription letters. After the stone had been prepared, the sign-writer lettered the inscription with a flat, chisel-edge brush. The brush strokes required to form each letter created a natural serif ending. When the stonecutter applied his art to the inscription, he often corrected or modified the original brush form according to his taste or technical requirements. A bonus of the serif endings in Roman letters was the elimination of the optical illusion of a narrowed cut as it approached its extremities. The serifs also added grace and balance for a well-designed letter.

The basic style of serif — pointed, round, or

Fig. 137 A variety of serif endings created with the pen and brush for calligraphy.

Fig. 138 A variety of serif endings created through carefully built-up construction.

square — must be kept uniform throughout a particular alphabet. The basic form of serif used with vertical and oblique strokes will be consistent for all strokes of this type, and serifs used with curved strokes will be consistent for all curves. There are many varieties of serifs used for both calligraphic and built-up letter forms. Some of these are illustrated in Figure 138.

Numerals

Our numeral system is descended by evolution from Arabic rather than Roman sources. The Romans used combinations of letters to act as a numeral system; for example, I = one, V = five, X = ten, C = 100, etc. The Arabs seem to have derived their numeral system from India, and the Arabs, in turn, introduced it to Western Europe during their European conquests and territorial occupation. There are two kinds of Arabic numerals in use today: (1) ranging numerals, the familiar even-height numbers, are used with capitals and are aligned between the cap line and base line; and (2) non-ranging numerals, an early form of numbers dating back to the first printed type styles, are for use with minuscules or capitals and occupy the same number of spaces as do the minuscules. The 1, 2, and 0 are the same as body letters, aligning between the waist and base lines. The 3, 4, 5, 7, and 9 are descending numbers, and align between the waist and drop lines. The 6 and the 8 are ascending numbers and align between the base and cap lines. Both numeral forms are illustrated as models for use with the alphabets used in this chapter. (Figs. 140-141)

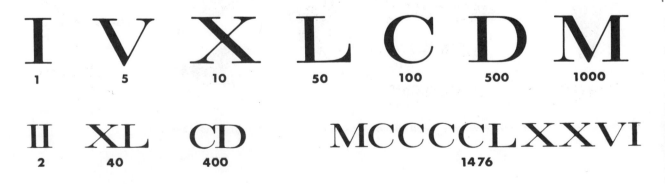

Fig. 139 The basic Roman numerals, together with some sample numeral combinations.

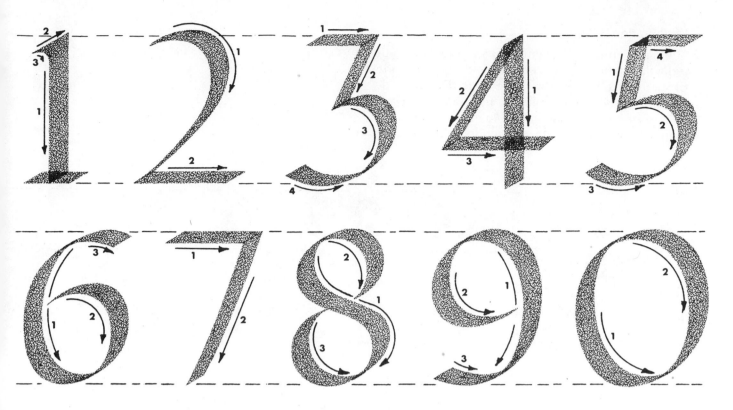

Fig. 140 The ranging Arabic numerals designed for use with the model alphabets. Note: two guide lines are necessary for construction, as with the capital letters. These numerals are usually used with capital letters.

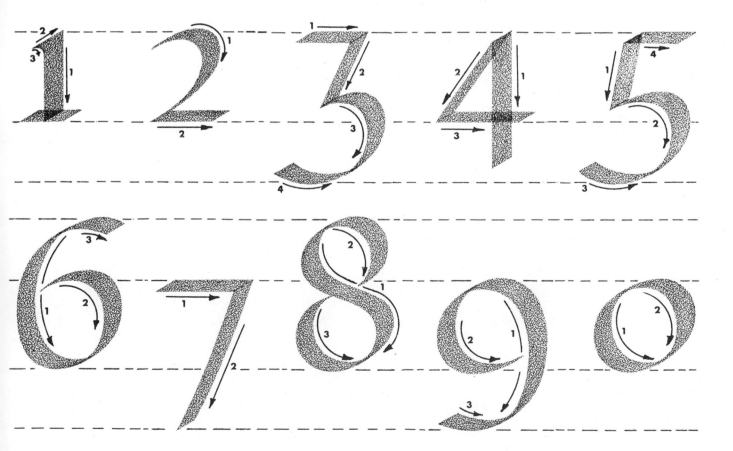

Fig. 141 The non-ranging Arabic numerals designed for use with the model letters. These numerals require four guide lines for construction, as with the minuscule letters. They are usually used with the minuscule form or the capital-minuscule combination.

Punctuation

The major forms of punctuation are often left to the individual letterer to devise. While the proper forms of some are obvious, others are more difficult to determine without some guide. Illustrated in Figure 142 are the basic punctuation marks, rendered in a manner compatible with the model alphabets.

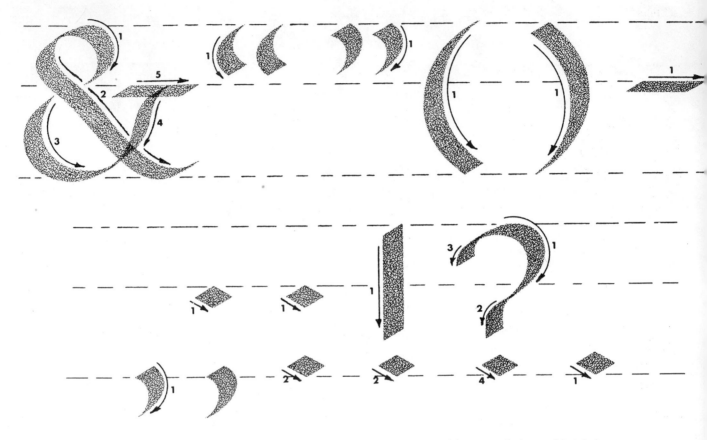

Fig. 142 The most common and most used punctuation marks, designed for use with the model alphabets.

A SENSE OF FREEDOM

The primary concern of Chapter 7 was the acquisition of a discipline that would enable the individual to understand the aesthetic and kinaesthetic problems encountered in rendering and combining the basic letter forms. In order to achieve this, it was necessary to exercise rigid control of the hand movements, thus suppressing certain natural directional tendencies. These natural tendencies of the hand are the essence of the expression of "freedom," a quality that imparts individuality to written letters. This quality may now be explored using the pen and the brush as tools. Extensive practice with these writing instruments will provide experience in their manipulation, and will also furnish a means for the expression of "controlled freedom."

The Pen

The pen should present little difficulty because of its similarity to the pencil. A few important differences, however, should be pointed out. The pen is designed primarily to use ink, though thin watercolor may be used if the situation demands it. The ink is held in a well, positioned just behind the writing edge, from which it flows by capillary action, along a fine cut in the pen edge, onto the writing surface. The imperceptible pressure created by touching the writing edge of the pen to the paper is sufficient to start the ink flowing. A very uniform lightness of touch must be developed by the individual if best results are to be expected. Do not, under any circumstances, bear down so heavily as to cause the edge to spread. This will often create the following problems: (1) blotting of the ink, (2) a stoppage of the ink flow by the breaking of capillary action, and (3) probable destruction of the pen edge. Repeated abuse will spring the edge and render the pen of no further use as a writing instrument. Keep the pen in motion while it is in contact with the paper. The ink at the edge will dry rapidly if normal flow is stopped for too long. Experience will soon indicate how long a working pen can remain idle between

strokes or letters, and continue to be reliable. If it is necessary to leave the work for any extended period of time, clean and dry the pen thoroughly. Cleanliness of equipment is extremely important. The pen should be cleaned regularly throughout the course of a piece of work, and *always* upon the termination of its use. A dirty pen will clog easily, causing blotting and interrupting the ink flow.

Setting Up

The pen requires a different set-up than the pencil, if ideal results are to be expected. A pen is designed to be used in a horizontal position, the flow of ink being most efficient in this position. In order for the pen to approximate a horizontal attitude, the drawing board must be at a 45-to-50-degree angle with its base. This does not mean that the pen will function only at this board elevation, but at a lower angle working comfort may suffer and errors, undoubtedly, will be more prevalent. A forward and more upright position of the pen causes greater ink pressure at the edge of the nib, resulting in an increased ink flow. (Fig. 143)

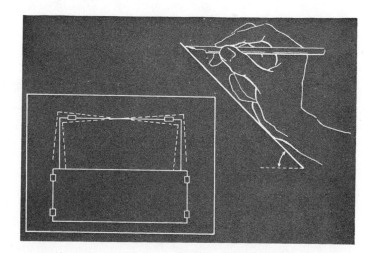

Fig. 143 Setting up the drawing board and writing material for lettering with the broad- or chisel-edged pen.

It is important that the letterer be able to move the paper. Imagine the problems of cramping, and the pen angle that would be necessary, if the paper were in a fixed position. It is better to keep the pen in approximately the same position, thereby maintaining the proper angle. The paper, though movable, must be held firmly in position while lettering. This can be accomplished by affixing a small piece of pressure-sensitive tape along the top edge of each sheet. Turn one end of the tape over to form a pull-tab for easy removal. The lower portion of the sheet may be held down by the hand or a tongue depressor. It would be advisable also to use a sheet of paper to cover the lower portion of the work in order to prevent smudging of guide lines. The normal position of the paper is vertical, though a slight cant to left or right may prove easier for some individuals. This cant is especially advantageous for the left-handed letterer. A scratch sheet of the same writing material should always be available for the purpose of testing ink and paper compatibility and ink flow.

Types of Pens

There are three types of pens: (1) reed, (2) quill, and (3) metal. The first two varieties must be manufactured by the letterer from suitable materials, while the third is mass produced and can be purchased from most art suppliers in a variety of styles and widths.

Reed pens. Good pens can be made from the common swamp reed (*Phragmites communis*) found growing along the ocean shores and in low swampy areas. Select only the largest stems ($^3/_8$ to $^1/_2$ in. thick), using the strongest portion found near the base of the plant. Cut sections about 8 to 10 in. long and let them dry for a few days. Prepare them by following the illustrated step-by-step instructions.

There are three advantages in the use of the reed pen: (1) The reed "glides" over the paper surface. Of the three types, it is the most compatible with the paper. (2) The reed can be made in a great variety of widths, many of which are not manufactured in metal pens. (3) The reed can be made to suit individual needs. This is especially important for the left-handed letterer, who will find it difficult to purchase metal pens designed for his use.

Quill pens. Quill pens are made from bird feathers — the best for pen-making are those of the goose. When properly dried and cut, the quill is excellent for making smaller letters, writing script, etc. If desired, a fairly fine point can be produced and maintained. This type of pen is flexible and more delicate than the reed, so care must be exercised in controlling pressure. Illustrated are step-by-step instructions for its manufacture.

Fig. 144 The construction of the reed pen. Select a length of reed that has been cut off between the joints and is about 8 in. long. Using a sharp pen knife or "X-acto" knife, make a cut about ¾ in. from the end (1). Then make a cut about half this distance (2). Make these cuts by shaving the reed rather than by making single cuts. Next, carefully press the blade against the center of the cut end and make a split about ½ in. back. Trim each side if necessary to even them up (6). Then cut the bevel according to the minimum or maximum shown in (7) by placing the end flat against a hard surface and cutting at the selected angle. In order for the pen to hold ink, a well must be fashioned. Secure an old watch spring and break off a piece about 1½ in. long, breaking it against its natural curve. Then anneal half the piece by applying heat, and fashion it according to detail (8), being careful to make the front arc as shown. If this is too shallow or too deep, the ink will not flow properly. The final step is cutting the skew. The right-handed letterer will prefer to cut it straight across, while the left-handed letterer will probably prefer a slight angle, either to the right or left, at 5 to 10 degrees. The bevel will have to be recut to the desired angle.

Fig. 145 The construction of a quill pen. Select a good sturdy goose quill and cut off the end of the feathered part leaving about 8 or 9 in. Strip the barbs off and make the cut shown in (1) with a sharp knife. Cut off the end (2), paying close attention to the angle of the cut. Now, with the knife, make a very short cut (1/16 in.) in the end and lengthen it by lifting upward with the end of a small brush handle. Hold a finger firmly on the back of the quill to prevent the split from running back more than ¼ in. Be sure to clean out the quill first if good results are expected (3). Next, pare down each side to form a point and cut off this point about halfway back (4,5,6). Add the skew (if necessary) and the bevel. Then prepare a well in the same manner as for a reed pen. As an alternative method for making a well, a piece of tin or similar metal may be used as long as it is pliable enough to make the necessary bends.

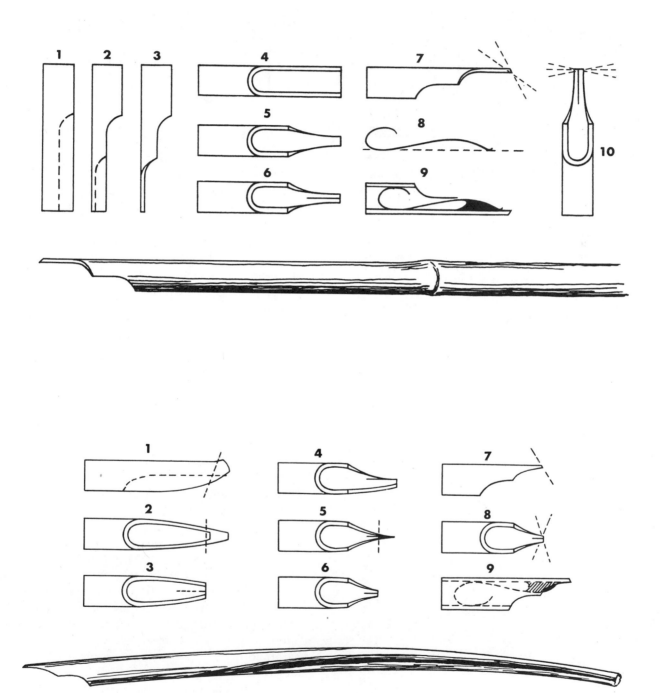

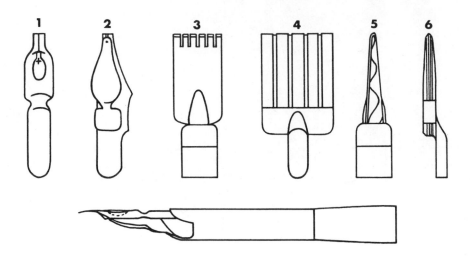

Fig. 146 Illustrated are some of the more common types of steel pens available through most sources: (1) The Mitchell roundhand pen; (2) The Speedball lettering pen, style "C"; (3) The Coits pen; (4) The Speedball Steel Brush; (5,6) Side views of the Coits pen and the Steel Brush; (7) The well-holder supplied by Mitchell for their pens.

Metal pens. Of the three kinds of pens, these are the most readily available. An entire set, consisting of widths from #6 to #0, including holder and well, is inexpensive. There are various types, examples of which are illustrated below. One disadvantage is that the steel edge is not as compatible with paper as the reed and quill edges. The sharp edges can catch the fibers and cause splattering or blotting. However, metal pens are available in larger widths than reeds, an advantage when larger letters are desired.

Exercises

The accompanying illustrations have been provided as models from which to work. While the model alphabet and examples are italic and cursive in form, for the purpose of "freeing" the hand, the roman form learned previously should not be neglected. Use the roman style to get the "feel" of the pen and to become familiar with the methods of working with this tool. When this has been accomplished, practice the italic letter, working gradually in confident stages toward freer letter variations. Do not be afraid, at this point, to experiment with the letters to achieve the goal of "controlled freedom." This means that one should be aware of the requirements for a pleasing aesthetic form, while creating letters of individual grace and flow. Scrutinize these new forms closely to determine their validity and trueness. As a test of the ability to exercise control of the letter form, select one or more of the classic written examples provided in Chapter 4 and render them as faithfully as possible in their original context.

ABCDEFG

HIJKLLMN

OPQRSTU

VVWXYZ

abcdefghijklmnop

qrstuvwxyz st ct

ge

Fig. 147 A freely written form of the chancery cursive to be used
as a model for tracing and study.

Classic Guitar

TO US A CHILD IS GIVEN

Introducing

Foreword

This Certifies that

SEASON'S GREETINGS

Will it build GOODWILL and
BETTER FRIENDSHIPS?

ABCDEFGHIJKLMN
OPQRSTUVWXYZ

Fig. 148 Examples of calligraphic pen work and a complete pen-written alphabet based on the Roman uncial designed by Anita Anderson.

Fig. 149 Examples of lettering rendered with the broad pen: (1) A book jacket published by Alfred A. Knopf; Artist: George Salter; (2) A book jacket published by Alfred A. Knopf; Artist: Golda Fishbein; (3) A handwritten page from *The Descendants of Alpha Beta* by Thomas D. Greenley. (All works are shown half-size.)

The Brush

Brushes that are used for lettering are square-edged, like the chisel-edge pencil or pen, rather than the pointed type used for watercolor painting. The best brushes are made with red sable hair and are quite expensive. Less expensive brushes employ black sable, weasel, or squirrel hair; the latter is usually incorrectly termed "camel hair." Real camel hair is too coarse in texture and is not used in the manufacture of brushes. There are two types of lettering brushes primarily in use: the round-ferruled and flat-ferruled brushes, the latter being preferred for calligraphic rendering. The brush is manipulated in a manner similar to the pen, with two important differences: (1) The brush is a very flexible writing instrument; it requires a great deal of experience to handle it properly and to produce good letter forms; and (2) The brush should be held in a different manner and is generally used with paint rather than ink.

Methods of Use

For the best results, a brush should be held vertically by the ferrule (the circlet that holds the hairs in place) and allowed to glide across the writing surface. To produce a good flow of color, the hairs of the brush should be well "charged" with a tempera or watercolor paint up to about two-thirds the distance of the ferrule. The proper amount must be determined by experimentation, for the brush must be neither too dry nor too loaded. The only exceptions to this rule occur when one wishes, for design considerations, to render a letter in a "drybrush" or "flooded" technique. Never allow the ferrule to become choked with paint, as this will, in time, deteriorate the fine hairs of the brush and render an expensive tool worthless. Cleanliness is also very important in the maintenance of equipment. The brush should be cleaned of excess paint frequently during its use and then thoroughly rinsed with water and washed with common soap after use. Figure 150 illustrates the two usual types of lettering brushes.

There are, however, limitations to brush letters that will soon become evident. First, it is not possible to change the direction of the brush without having lifted it from the writing surface. Any attempt to change direction in the same manner as with a pencil or pen will result in a spoiled stroke and a ruined letter. Second, the critical control that must be exercised over the pressure applied to the brush, unlike the pencil or pen, requires a continual awareness of the correct pressure necessary for creating a desired stroke. In terms of commercial brush-lettering, it is almost impossible to letter copy that will fit into a planned area and still exhibit good spacing and an even line color. Lettering problems of this sort invariably require that the artist write the individual words a number of times, cutting apart the best examples and respacing or replacing individual letters or phrases. The letterer must then work over the entire inscription, touching up the letters to make them lighter or heavier until the desired effect is achieved.

These limitations notwithstanding, brush-lettering is a product of the individual characteristics of the person wielding the brush, and thus is capable of expressing a wide range of freedom and style. Too much retouching will destroy or seriously reduce this freedom. The letterer must be capable of judging when to stop — when the lines of lettering are readable and express the called-for styling. Brush-lettering should not be attempted with students until the discipline of making good letters has become firmly implanted, for the limitations and peculiar characteristics of the brush can easily result in the formation of bad letters and, worse, misconceptions of what constitutes a good letter form. Once erroneous and misleading ideas are established, it is difficult to correct them.

Experiment with the brush by executing the basic strokes found in Chapter 7, and follow the same procedures as for the pencil, but with complete regard for the above limitations. Proceed from these strokes to the rendering of roman and italic forms. Next, try matching some of the examples provided following this text, or develop an individual style based on handwriting or other source materials. The discipline required to master the brush is most worthwhile, for brush-lettering is in great commercial demand.

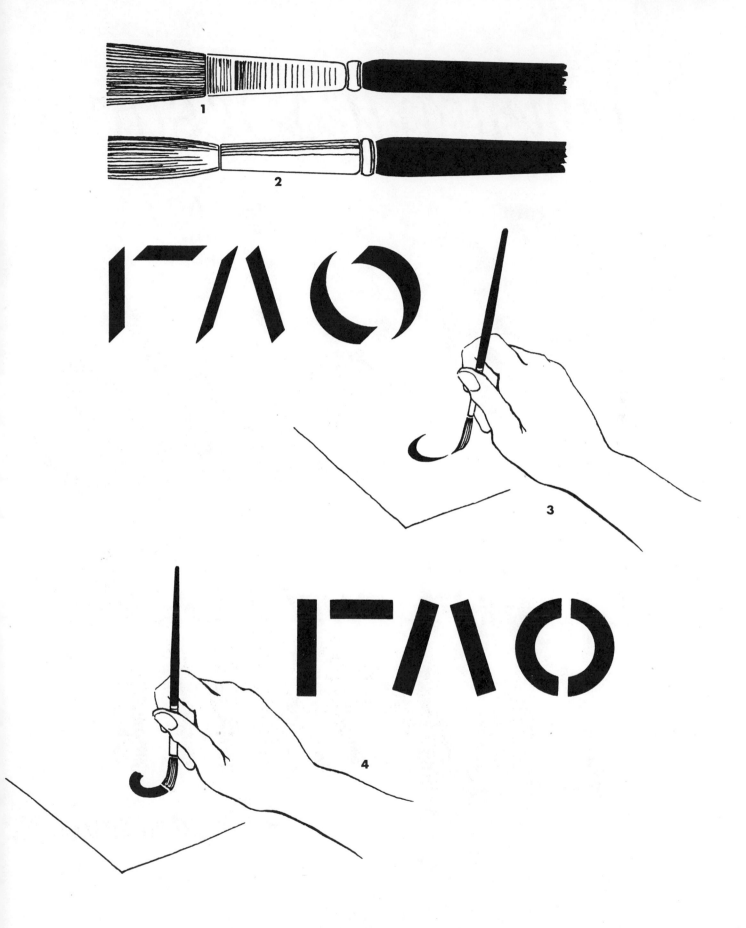

Fig. 150 The types of lettering brushes, the method of manipulating them, and the strokes that each will create with some help from the artist.

Elementary Design

1

Mirada

2

3

A

THE
LAST
OF
THE
JUST

4

and TODAY

5

WINTER

6

Representatives

7

Fig. 151 Some examples of lettering produced through the manipulation of the brush: (1) Artist: Thomas D. Greenley; (2) Los Angeles Art Center, College of Design; Artist: Gloria Klissner; (3) Artist: Anita Anderson; (4) Courtesy of Atheneum Publishers; Artist: George Salter.

THE BUILT-UP LETTER FORM

An important function of the lettering artist today is the ability to produce letter forms that are difficult or impossible to render with ordinary writing instruments. This ability may be utilized for renditions of existing type-set and pen-written forms, or for the creation of new letter styles. They must be drawn or constructed with a variety of tools: compasses, ruling pens, and other drafting instruments — as well as pencils, pens, and brushes. Letter forms that are made in this manner are called "built-up," while written letters are referred to as "calligraphic."

Exercising Control

Chapters 7 and 8 focused attention on calligraphic letters, in order to develop and sharpen the letterer's awareness of the subtle and sensitive relationships existing within letters, thus establishing a rapport with them. The built-up letter presents a complete change of pace from the written form. The former, by definition, cannot be dependent upon the nature of a single tool to create the quality of its strokes. Lettering strokes, whether made formally or informally, essentially are lines having two edges, each of which contributes toward the final appearance of those strokes. The properly used, chisel-edge tool produces both of these edges simultaneously and in correct relationship, according to the nature of the stroke. The letterer exercises control over the skeleton form, and the writing instrument produces the desired letter. The making of a built-up letter requires that the letterer have control over both the skeleton and the resultant letter. He must determine the relationship of the stroke edges, as well as those relationships existing between the strokes, a kinaesthetic extension of a mental image. The ability to do this can only be the result of much experience with the analysis and execution of written forms. It represents an advanced form of expressive freedom, a synthesis of design and drawing requiring a comprehensive knowledge of the functional and aesthetic qualities that are the essence of a letter. The letterer not possessing this knowledge should not attempt to assert himself in this direction, for good letter forms cannot logically result.

The Techniques of Construction

The tools used for making a built-up letter are pointed, rather than flat-edged, and are varied. For the purposes of describing the techniques involved, the letter A, found in the step-by-step illustrations used later in this chapter, will serve as an example. A 2H drawing pencil should be used for drawing the letter, a pen or pointed brush for inking-in, and mechanical dividers for checking correct letter weights.

The Outline Letter

Assuming that the letter is to be made larger than the actual sample, rule guide lines on a sheet of tracing paper to establish the desired height. Next, observe and analyze the original letter. Compare its height with the width; compare the weights of its various parts; check the relationship between the parts and the counters; observe the structure of the serifs. This visual comparison will tend to form a mental image of the letter.

Lightly sketch the skeleton of the A between the guide lines. Then proceed to sketch the letter in outline form, still very lightly, while correcting the weights visually. Check back with the original to determine if the height-to-weight relationship of the new letter is convincingly in proportion. If it appears to be in proper proportion in all respects, proceed to draw carefully the letter shape with a light, sharp line, paying close attention to these lines as being edges of a shape. Erase all fuzzy or multiple lines from sketching, and replace them with a single, clear

line. Use the mechanical dividers to check whether stroke weights are constant, according to their quality, and make any necessary corrections. Turn the sheet in any direction that is most convenient to achieve a good line, and make sure the pencil is always sharp. A mechanical pencil with insertable lead is convenient and timesaving. The lead can be lengthened instantly and is easily sharpened on a sand block.

When the *A* has been completed in outline form, place a second piece of tracing paper over it and proceed to black in the letter carefully to produce a solid. This is the final check for weight, color, and form in comparison with the original. This is particularly necessary for checking letter spacing, line weights, and overall color when constructing a line of lettering. It is recommended that the first exercises involving words should include letter combinations that manifest a variety of stroke sequences, in both capital and minuscule forms. Two combinations that might be use are: A O S R T and

a b g o h. Mechanical aids to construction should be avoided, except in the case of letters that are precise and mechanical in appearance. Letters of this type are designed with these qualities in mind and are best rendered by using drafting procedures. Early development of the ability to render *any* letter in a freehand manner is essential for the lettering artist who wishes to be creative and inventive. Remember, the final results can only be as good as the original constructions. (Fig. 152)

Fig. 152 The construction of the outline letter. (1) Touch up the initial construction with a precise line; (2) black in the letter on a tracing sheet upside-down to check color and letter weight; (3) check the dimensions with a mechanical divider to ensure that all letter weights are consistent for each relative part.

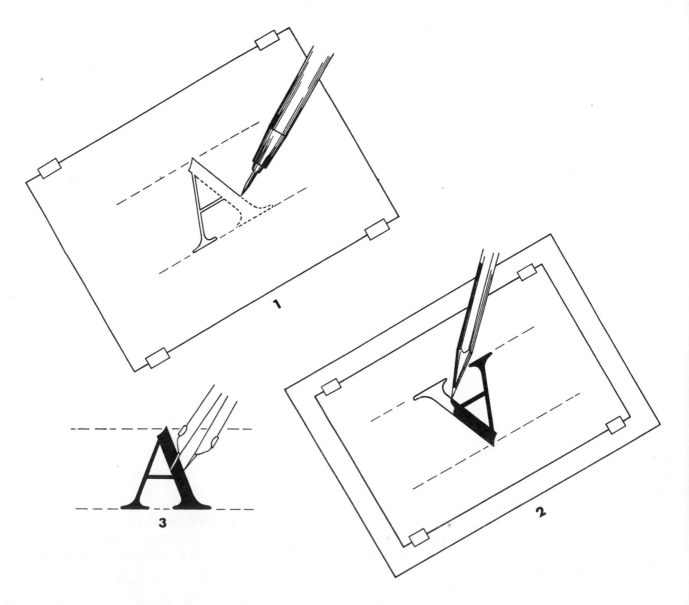

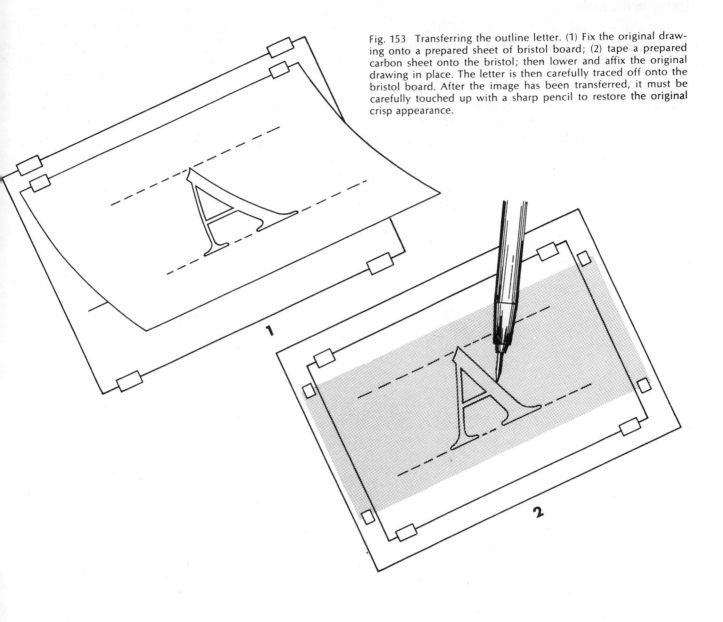

Fig. 153 Transferring the outline letter. (1) Fix the original drawing onto a prepared sheet of bristol board; (2) tape a prepared carbon sheet onto the bristol; then lower and affix the original drawing in place. The letter is then carefully traced off onto the bristol board. After the image has been transferred, it must be carefully touched up with a sharp pencil to restore the original crisp appearance.

Transferring the Letter

The finished outline structure must now be transferred onto a sheet of bristol board (a hard, white drawing paper) or similar material, for the final ink or paint rendering. This requires making a transfer sheet; use a light blue pastel or 6B drawing pencil and rub it onto one side of a sheet of tracing paper with the finger or a piece of tissue. Blow off any excess chalk or carbon and wash hands thoroughly with soap and water. Next, rule very light guide lines on the bristol to correspond with those on the outline image; then tape this image in position on the bristol right-side-up. After flipping the image

sheet back, carefully place the transfer sheet on the board, tape it in position, and lower the image back into place. Using a hard pencil (4H), carefully trace over the lines of the letter image, turning the work frequently so that the lines are always in full view. When every line has been traced, carefully remove both the image and the transfer sheet and check the resulting letter. Remove the excess chalk by lightly dabbing a soft, kneaded eraser over the image. Do not, under any circumstances, rub the image with the eraser, as this may remove it entirely. Then lightly touch up the lines of the transferred image with a sharp drawing pencil so that they are clear and distinct. The letter is now ready to be inked-in.

Inking-In the Letter

There are two methods that may be used for filling in the outline letter to achieve a finished solid form. The first of these employs a pointed pen to outline carefully the letter in ink; the balance of the letter is filled in with a flat- or round-ended pen or brush. The second method employs a pointed brush; the inking process involves working from the middle of the letter strokes outward to a careful meeting with the edges. While both these methods are good, the latter is preferable, as it allows best for any necessary minute corrections regarding letter weights, curves, etc. The description of the inking process uses this second method.

Use a good-quality, pointed watercolor brush (#3) and place an island of ink in the center portions of the heavy weights of the letter, avoiding contact

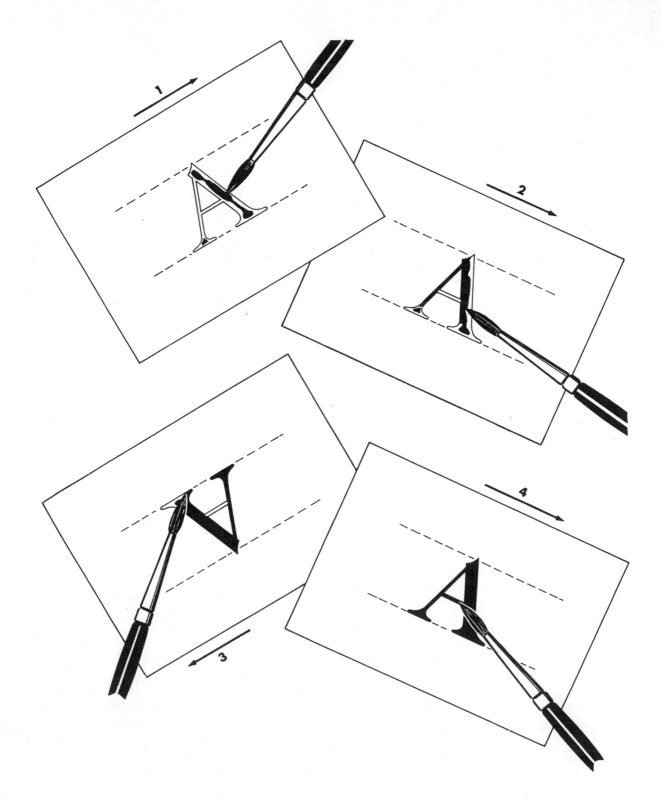

with the edge lines. Work outward from this color mass and fill in to the line, being very careful that the tip of the brush does not exceed it and deposit ink outside the extremities of the letter. Ink the serifs next, establishing the outermost straight edges and filling in up to the parent stroke, but not approaching the curved portions of the serifs. Render these next, using a series of short, connected strokes until the desired curve is completed. It is possible, after some experience, to complete many curved edges with a precisely controlled brush stroke. Complete the crossbar connections to finish the letter. Turn the work frequently in all phases of inking so that the lines are always in view and the work is always in a convenient position. Whenever curved strokes are being inked, pay the most attention to the thin parts; there is often an unconscious tendency to increase their weights. (Fig. 154)

Corrections

Even the most careful letterers probably will make inking errors. Some of these can be corrected with simple erasure, but most of them must be corrected by the use of an opaque white paint, such as "Permo-white." White paint should be applied to as small an area as possible to avoid being noticeable. The letterer should never allow corrective measures of this sort to replace excellence of skill.

The Trajan Inscriptional Capitals

One of the most valuable experiences a student of lettering may have is that obtained from the study and execution of Trajan Roman capitals. They are the finest examples of Roman letters extant in terms of design, beauty, and function. They are letters of slender grace, possessing an incredible softness created through the many intricate and subtle relationships inherent in their composition. The letterer who is able to perceive, understand, and faithfully render these relationships will be capable of the same performance with any letter form. Moreover, one will then possess the ability to conceive and execute new letter styles, with the assurance of creating good and true letters.

Fig. 154 Inking-in the completed letter drawing. (1) Place islands of ink in the centers of all major stroke areas; (2) ink from the center to the inside and outside edges of the strokes. Turn the work constantly so that the line being inked to is always in unobstructed view; (3) turn the work and ink in the serif parts; (4) complete the crossbar and touch up any small errors.

The Trajan capitals present the greatest challenge to the letterer's ability. The curvatures are so sensitive; the counters and serifs are so subtle; and the balances are so delicate that the utmost concentration and skill are required to achieve true, accurate renditions. In addition, these letters must be drawn freehand, as the application of any mechanical implements will disturb the relationships and destroy their aesthetic appearance. The following plates and their accompanying analytical statements are provided to help the individual derive, through study, a greater sensitivity, a richer knowledge of the intrinsic qualities of letter design, and a more fertile imagination.

The inscription from which these letters have been taken is located at the base of the Trajan Column, found in the Forum of Trajan in Rome, Italy. This column was erected in 112 A.D. to commemorate Emperor Trajan's participation in the Dacian Wars, fought between the years 101 and 106. The inscription was incised between December 10 of the year 112 and the following December 9, and measures 4 ft. 5¾ in. in height and 10 ft. in length. The bottom edge of the marble inscriptional slab is 10½ ft. from ground level, and is located directly over the entrance to Trajan's sepulchral chamber, which serves as a pedestal for the column. Figure 43, in Chapter 3, is a photographic illustration of the entire inscription.

The Trajan Letter Plates

The letters rendered for these plates are as authentic as is possible. They have been constructed from close study of the original inscription, along with reference to facsimiles of rubbings made by Edward Catich during the years 1935 to 1939. The letters H, J, K, U, W, Y, and Z, are not found in the inscription and have been devised with painstaking attention to the manner in which the existing letters must have been constructed. In every case, verification has been sought for each part of these missing letters. They are offered not as absolutes, but as possibly acceptable forms in harmony with the existing originals. An analysis has been provided with each letter to point out the primary relationships and subtle variations that might otherwise escape notice. A system of measurement in units has been established to make it practical to render the letters in various sizes, as well as to provide a means of location and comparison of letter parts. (Nomenclature of letter parts appears in Chapter 6, Figure 111.) The number of units remains the same; only the numerical value of the units need be changed, to any fraction or number divisible by four, in order to render the letters in another size while keeping the relationship the same.

147

Fig. 155 The Trajan letter *A*.

The *A* is 19 units wide from serif to serif, and 18½ units high. It is a pointed letter and rises slightly above the cap line for optical correction. The outer and inner edges of the oblique strokes tend to "bend" inward to a very slight degree. The maximum inward movement occurs at the center of the crossbar. Note that the differences in serif structures, similar to those of the *M* and *X,* and included in this version of the *U,* are in keeping with the aesthetics of the Trajan form. The left-hand serif is constructed in the manner common to this style, and is varied only to the extent necessary for it to function with an oblique stroke. The right-hand serif has been designed in a unique manner and is apparently a result of the artist's desire to create a graceful finishing stroke, as well as a foot upon which to rest the letter weight. The right oblique stem is 2 units thick at its center and the left oblique is 1¼ units thick. The inside juncture of the oblique strokes, therefore, is 14¼ units above the base line. The crossbar is slightly greater than ¾ units in thickness; its center is located 7¾ units above the base line. The angle formed at the apex of the outer edges of the oblique stems is 42 degrees; the point of the angle is located ½ unit to the left of the center line.

The *B* is 12¼ units wide, from the serif tips to the widest extension of the lower lobe of the bow, and 18 units high. This is a very beautiful letter form. Note the subtle relationships of the strokes forming the bow, the extension of the lower lobe and the delicate balance provided by the counters. The *B* "grows" from both the top and the bottom of the stem to form the lobes, the juncture of which is unique. The weight of the center stroke has been pared down, providing a balance with the lobes, while allowing the eye to follow either lobe to a logical merger with the stem. The height of this bar at its center is 9½ units above the base line. The top of the bow presents an edge having a slightly curved depression, while its bottom bends slightly below the base line in the outward and upward growth toward the center of the letter. This corrects the optical illusion present in curvilinear forms. Note the slightly upward direction of the center stroke, as well as the counters of the *B.* They are very sensitive negative shapes formed by the relationship of the lobes with the stem. Their shapes must be maintained if the rendered letter is to retain the aesthetic quality and balance of the original. The edges of the lobes forming the bow create an angle of 58 degrees at their juncture.

Fig. 156 The Trajan letter *B*.

The C is 15 units wide and 18 units high. Note the flattening which occurs at the bottom of the letter and the heavier weight of the stroke compared to the top of the letter. This bottom weight is slightly more than 1 unit in thickness, while the weight at the top of the stroke is slightly more than 3/4 unit. The serifs have been treated in two different manners. The top serif employs the usual ogee turning slightly inward, while the base serif employs a convex curve for stability. The C is the first of the curvilinear letters and sets the style of serifs used for all letters requiring similar endings, whether curved or vertical. This is a very stable letter, particularly since the top portion of it "hangs out" beyond the base. This is a critical point to observe when rendering this letter. A straight line connecting the tips of both serifs to complete the counter will make the outer angle obvious. Note the downward and upward angles of the top and bottom serifs, and the similarity of the top C serif to the right-hand serif of the A.

Fig. 157 The Trajan letter C.

The D is 17³/4 units wide and 18¹/4 units high. This letter grows from the base of the stem and curves upward in a graceful arc to the top of the stem. The D is treated in a manner similar to the B at the base, though a longer and more sweeping curve is necessary due to the greater width of the D. Note the thickening of the inside bottom of the stem at the point where it develops into the lower portion of the lobe. The maximum thickness of the lobe occurs along a level line 11¹/4 units above the base line. The counter of this letter has the same importance as those of the B, and must be faithfully maintained if the letter is to be properly balanced. The maximum width of the counter is located along the lower edge, 2 units below the horizontal center line. The thin weights of the D are slightly greater than 3/4 unit, gradually thickening to a heavy weight of 2 units.

Fig. 158 The Trajan letter D.

Fig. 159 The Trajan letter *E*.

The *E,* from serif tip to serif tip, at its base, is 10½ units wide, and the height is 18¼ units. The base of this letter is its widest point, the serif ending on the lower arm curving upward and outward, similar to the base serif of the C. The upper and middle arm serifs are reminiscent of the upper serif of the C. These two arms are of approximately equal weight, both about 1 unit thick, while the base arm is slightly heavier and slants very slightly below the base line at a point one-half the length of its bottom edge, measuring from the left-hand serif tip. It is important not to accentuate this slant too much. The middle arm is ½ unit shorter than the upper arm, while the lower arm is the longest of all by about ½ unit. The upper edge of the middle arm is slightly more than 10 units from the base line. This letter has great visual stability. Pay particular attention to the shape of the area at which the lower arm grows from the stem.

The *F* is slightly narrower than the *E.* This is because of the slight extension of the base serif on this letter. The *F,* therefore, is 10 units wide and 18¼ units high. This letter is identical to the structure of the *E* in all respects except that it has no lower arm. The letter balances on the base serif of the stem. The length of the middle arm is 5¾ units, compared to 5½ for the arm of the *E.*

Fig. 160 The Trajan letter *F*.

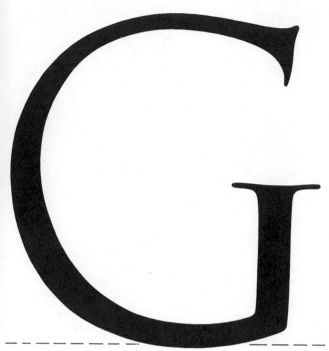

Fig. 161 The Trajan letter G.

The G is 17½ units wide, from the farthest extension of the curve to the farthest tip of the serif ending of the upright, and 18½ units high. This letter extends slightly above the cap line and drops below the base line for optical correction. The upright of the G rises vertically from the bottom portion of the curve to a height of 8¾ units at the top edge of the serif ending. The bottom of the curve is heavier than the top portion, as in the letter C. The G and the C are related letters, and both constructions are derived from those of the letter O. The top portion of the G is almost identical to the letter C.

The H is 18 units wide from serif tip to serif tip, and 18 units high. This letter, though part of the alphabet at the time, is not found in the inscription because it was not needed. It was necessary to devise this letter in a form compatible with the others. The H basically is composed of two stems and a crossbar. Its width is a full square, because the Trajan letters normally appear wider than the accepted skeleton widths. When drawn narrower than a square, the visual appearance is less than satisfactory. The crossbar is located slightly above center and the top and bottom edges of this bar widen very slightly just prior to their mergers with the two upright stems. The center of the crossbar is located on a horizontal line 9½ units above the base line.

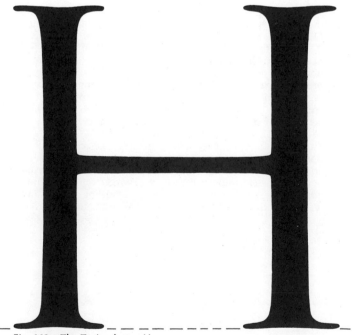

Fig. 162 The Trajan letter H.

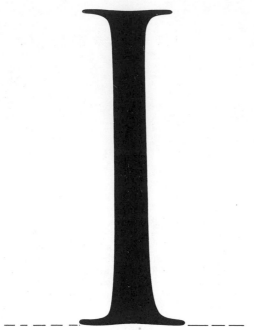

Fig. 163 The Trajan letter *I*.

The *I* is a key letter in the alphabet. It establishes the basic height of the letters, the weight of the heavy portions of the letters, and the basic serif structure found in the majority of the letters. The height of the *I* is 18 units, though this will vary with some of the other letters for the reasons expressed in the opening part of this chapter. The weight of the letter is 2 units, establishing a ratio of 1:9 for weight/height relationship. This 1:9 ratio exists only at the center of the stem stroke, due to the concavity of the edges. The stem becomes imperceptibly wider toward its termination at both serif endings. This concavity of the edges is extremely important to the soft and graceful quality that sets these letters apart. The slightest over-accentuation of this feature will destroy the aesthetic quality and result in a bad, misshapen letter. The actual width of the letter *I*, including serifs, is 5¼ units.

The *J* is 5¼ units wide and 24 units high, 9 of which fall below the base line to form the "tail" of the letter. This letter and the *Q* are the only ones that definitely drop below the base line. It is an extension of the *I*, and represents that letter's consonant sound. The *J* was not part of the Roman alphabet and does not appear in the inscription. The design of the letter was approached simply and from the viewpoint that the main function it would have had in Roman times would have been to appear distinct from the parent letter *I*. This distinction is achieved by extending the *I* stem downward, ending in a "tail" structure. This tail ending was taken from that of the letter *R*, the best letter for comparison in this respect. The farthest downward extension should be 6 units, ideally, though this could be greater, depending on the situation. The maximum bend of this extension is 4 units, measured from the right-hand edge of the stem where it meets the base line. With more or less bend, the letter does not seem as aesthetically correct.

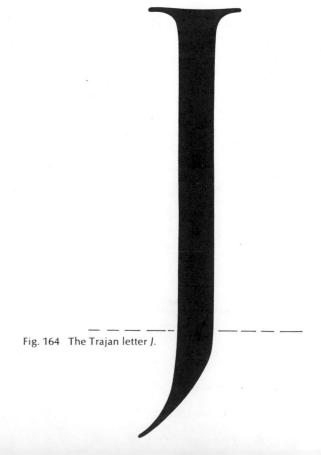

Fig. 164 The Trajan letter *J*.

The *K* is 18 units wide at its base, 14³/₄ units wide at its top from serif tip to serif tip, and 18 units high. This letter is not found in the inscription, though it was a part of the Roman alphabet. It is composed of a stem, a projecting oblique arm, and a tail. The thickness of the stem and the tail is 2 units, while the weight of the arm is one-half this thickness. The left-hand edges of the arm and tail meet the stem at its center point, the angle thus formed being 90 degrees. The tail is similar to that of the *R*, and acts as an ending and balancing stroke. This tail rests exactly on the base line and does not fall below.

Fig. 165 The Trajan letter *K*.

The *L* is 11 units wide from serif to serif at its base, and 18 units high. The base of the *L* is handled in much the same manner as the *E*, except that it is longer. The major difference lies in the fact that the top edge of the *L* arm is concave, while the same edge of the lower arm of the *E* is almost a level horizontal. As with the E, pay particular attention to the area at which the arm grows from the stem of the letter.

Fig. 166 The Trajan letter *L*.

Fig. 167 The Trajan letter M.

The M, from serif to serif, is 23 units wide and 18½ units high. This is a pointed letter, the points of which exceed the cap and base lines for optical correction. The stems angle away from the perpendicular, the inside edges of the stems and oblique strokes forming an angle of 30 degrees. The angle formed at the juncture of the inside edges of the obliques is 52 degrees. Note particularly the weight differences of the stems and the obliques. As a result of these weight differences, the inside angles are formed at different heights above the base line. The left-hand angle is 12 units high, while the right-hand angle is 13 units high. Note also the slight inward curvature of the edge of the left-hand oblique. This is known as an *entasis,* and is a critical point to observe and maintain when rendering this letter. The right-hand serif is handled in the same manner as that of the A.

The N is 19¼ units wide and 18½ units high. It is also a pointed letter; the points must exceed the cap and base lines slightly. The angles formed by the junctures of the inside edges of the stems and the oblique are both 44 degrees. The bottom edge of the oblique exhibits the same *entasis* observed on the letter M. Measured along the oblique, the *entasis* begins 12 units from the inside juncture with the left-hand stem. This relationship must be maintained. Note that the right-hand stem has a slight inward bend toward the serif ending. This helps to create the letter's "soft" feel, and over-accentuation of the bend will destroy the aesthetic quality; it should be barely perceptible.

Fig. 168 The Trajan letter N.

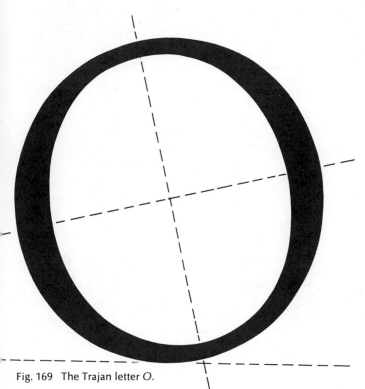

Fig. 169 The Trajan letter O.

The O is the other key letter in the alphabet. It determines the basic relationships for all curvilinear forms, and is 17¼ units wide and 18¼ units high. This letter is narrower than a full square, contrary to the basic skeleton structures. It slightly exceeds the cap and base lines for optical correction. The vertical axis of the O tilts to the left, to create an angle of 77 degrees with the base line. The horizontal axis bisects this at an angle of 90 degrees. The shape of the counter is very important and must be maintained.

The P is 11½ units wide and 18 units high. It is composed of a stem and a lobe. This lobe is the principal characteristic of the letter P. It grows from the top portion of the stem and arcs gracefully in a wide curve back toward the stem in a manner similar to the B, except that it does not reconnect. The bottom edge of the unconnected lobe tip is 8 units above the base line, and the distance between this tip and the stem is 1 unit. The lobe tip is 1 unit below the level center line of the letter, though it appears optically centered. As in the B and the D, the counter is very important and must be maintained in a rendering of the P. The maximum thickness of this stroke is located 1½ units above this point.

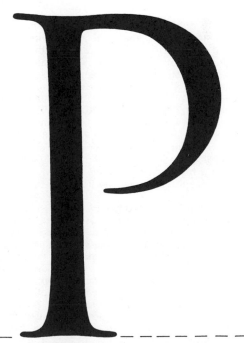

Fig. 170 The Trajan letter P.

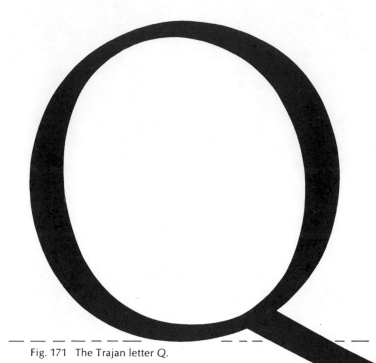

Fig. 171 The Trajan letter Q.

The Q is 33 units wide, including the tail, and 18 units high. This letter is basically an O with a tail attached and is a very beautiful letter form. The bottom edge of the tail begins at a point on the main part of the letter, slightly more than $\frac{1}{2}$ unit above the base line and to the right of the vertical axis. The length of the tail is flexible, depending on the situation, but a tail that is too long or too short might affect the aesthetic balance of the letter. Consider carefully any extreme alteration of the original. Note that the tail drops below the base line, the maximum depth being $4\frac{1}{4}$ units to the lower edge of the tail. This maximum depth occurs at a point 13 units from the beginning of the tail, measuring straight along the base line. The tail projects from the lower part of the main letter body at an angle of 28 degrees. The upper edge of the tail is straight until it meets with the base line, at which point the edge curves in a slowly decreasing angle until it begins its return to the base line. The tip of the tail is located $2\frac{1}{2}$ units below the base line and 21 units from the beginning point of its lower edge, measured straight along the base line.

The R is $18\frac{1}{2}$ units wide and 18 units high. This letter is composed of a stem, a lobe, and a tail. The counter is constructed like that of the D, except for the fact that the bottom of the counter turns upward in a subtle, shallow curve to a juncture with the stem. Note the bottom edge of the crossbar stroke, essentially a straight line with an almost imperceptible dip at its center in comparison with the upward curve of the top edge. The lower edge of this crossbar is $7\frac{1}{2}$ units above the base line at its juncture with the stem. The widest point of the counter is located on the inside edge of the lobe, $12\frac{1}{4}$ units above the base line. The center of the thickest portion of the lobe stroke is located $14\frac{1}{2}$ units above the base line. Note that this counter is higher than it is wide, the lowest point occurring $8\frac{1}{4}$ units above the base line and $3\frac{3}{4}$ units to the right of the stem.

The tail of the R presents another series of subtleties. It comes off the lower section of the lobe at an angle of 48.5 degrees. The edges of the straight part of the tail appear at first glance to be parallel. Actually, the thickness of this part is greater near the bottom than at the top. The maximum widening occurs 8 units from the beginning of the tail, measured along the inside edge. The maximum difference, $\frac{1}{4}$ unit, occurs gradually throughout this distance. The curves of both the inner and outer edges begin at the same distance of 2 units above the base line, though visually this does not seem to be true. The inner edge utilizes a much sharper curve than the outer edge, a fact that might account for the illusion. The tip of the tail falls on the base line $14\frac{1}{2}$ units from the center of the stem, measured along the base line. The tail does not fall below the base line at any time.

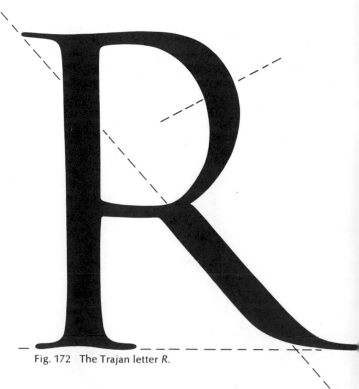

Fig. 172 The Trajan letter R.

Fig. 173 The Trajan letter *S*.

The *S* is 9³/₄ units wide and 18¹/₄ units high. This is perhaps the most intriguing and deceptive letter to render. It is a letter possessed of grace and sensitive flow, and one that requires a high degree of perception to capture its aesthetics. This letter slightly exceeds the cap and base lines for optical correction. The cap and base serifs are reminiscent of those of the *C*. Its body can be considered a curving stem that grows outward in each direction from the central portion, gradually thinning in weight and then becoming slightly heavier at the juncture of the serif endings. Though this letter was probably conceived by means of two tangent circles offset from the perpendicular, this is no longer obvious in the final letter form. The difficulty presented when making a rendering of this letter is the angle of forward cant. This is very unusual in a Roman *S*. This angle has an 83-degree forward cant, and the angle of the oblique section with the base is 43 degrees. The upper counter is slightly smaller in area than the lower one, principally because the bottom curve and base serif are more extended, creating a wider lower counter. This greater negative weight, the verticality of the base serif, and the greater volume of positive letter weight falling below the physical center of the *S*, account for the ability of the balance of the letter to equalize the pull of the cant. There is no illusion of the letter tipping forward.

The *T* is 14³/₄ units wide and 18¹/₄ units high. This letter is composed of a horizontal and a vertical unit. The horizontal can be considered a crossbar topping a stem. The additional ¹/₄ unit is necessary because the upper part of the left-hand serif extends above the cap line. Note that the serifs both turn inward toward the stem at the tips, though both serifs are parallel, at an angle of 79 degrees to the base line. The thickness of the stem is approximately 2 units and that of the crossbar is slightly greater than 1 unit.

Fig. 174 The Trajan letter *T*.

The *U* is 18½ units wide from serif to serif, and 18 units high. This letter was not part of the Roman alphabet and is, consequently, not found in the inscription. The letter has been designed with a foot, in the manner of the uncials, rather than in the style of the *U* form used today, since this seems to be more closely related to the Trajan alphabet. This letter is relatively wide, so the curving portion of the left-hand stem must be constructed in a deep, full manner. The outside edge of this stem begins to curve 5¾ units above the base line. From a perpendicular extension of the outside edge of the left-hand stem, the measurement along the base line to the juncture of the curve is 5 units. The arc continues slightly below the base line and then rises above to join with the right-hand stem 1¾ units above the base line. The base serif of the right-hand stem has been constructed in the same manner as those of the *A* and *M*, for aesthetic appearance. Note that the inside curve begins at a point 6 units above the base, somewhat sooner than the outside edge.

Fig. 175 The Trajan letter *U*.

The *V* is 20¼ units wide and 18¼ units high. This letter is composed of two oblique elements merging at the base. The point of the base drops slightly below the base line for optical correction. The thickness of the left oblique is 2 units, while the right oblique is a scant 1½ units thick. Note that the left oblique exhibits the *entasis* found on the *M* and *N*, while the right oblique bends slightly outward instead of being a straight member. The angle formed by the convergence of the inside edges of the obliques is 45 degrees.

Fig. 176 The Trajan letter *V*.

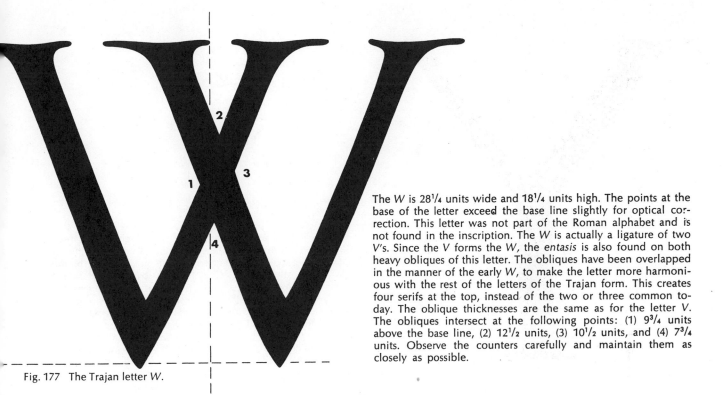

Fig. 177 The Trajan letter W.

The W is 28¼ units wide and 18¼ units high. The points at the base of the letter exceed the base line slightly for optical correction. This letter was not part of the Roman alphabet and is not found in the inscription. The W is actually a ligature of two V's. Since the V forms the W, the *entasis* is also found on both heavy obliques of this letter. The obliques have been overlapped in the manner of the early W, to make the letter more harmonious with the rest of the letters of the Trajan form. This creates four serifs at the top, instead of the two or three common today. The oblique thicknesses are the same as for the letter V. The obliques intersect at the following points: (1) 9¾ units above the base line, (2) 12½ units, (3) 10½ units, and (4) 7¾ units. Observe the counters carefully and maintain them as closely as possible.

The X is 16 units wide and 18 units high. This letter is composed of two oblique elements crossing each other at their approximate midpoints. The points of this juncture, measuring from the base line, are as follows: (1) 8½ units, (2) 10½ units, (3) 9 units, and (4) 7¼ units. The angle formed at point (4) should be 57 degrees. Note that the serif endings of the heavy obliques extend beyond the other serifs. The weight of the heavy obliques is 2 units, and that of the thin members is 1¼ units. A slight widening of the obliques occurs where the serifs are bracketed to the strokes.

Fig. 178 The Trajan letter X.

The Y is 18³/₄ units wide and 18 units high. This letter was a part of the Roman alphabet, but was not needed in the inscriptional message. It has been designed in a manner harmonious with the other letters. This letter is constructed of a partial stem and two oblique arms. The point of convergence of the outside edges of both arms is located on the center line of the stem, 7¹/₂ units above the base line. The angle formed by the convergence of the inside edges is 72 degrees. This juncture is 8 units below the cap line and ¹/₂ unit to the right of the center line of the stem. The thickness of the left arm is 2 units, while that of the right arm is slightly more than 1 unit.

Fig. 179 The Trajan letter Y.

The Z is 18 units wide and 18¹/₂ units high. This letter was a part of the Roman alphabet, but was not needed in the inscription. There are no letters in the inscription that offer clues as to how the Z might have been incised. The letter was, therefore, designed as it probably would have been constructed, with certain basic endings as reference points and a stem angle that offered the greatest balance and aesthetic quality. A slight *entasis* has been incorporated in the stem to enhance the softness so evident in these letters. The arms thicken slightly as the serif is approached and the serifs have been angled for increased stability. Note that the upper tip of the cap serif extends above the cap line, while the lower edge of the bottom arm drops below the base line in a gentle, sweeping curve. The upper edge of the latter stroke is slightly concave, rising upward into the serif ending to create a greater thickness at this point with the lower edge. The general angle of the oblique stem with the base is 55 degrees, though the *entasis* changes this slightly as the stem swings toward the left.

Fig. 180 The Trajan letter Z.

160

Built-Up Letter Exercises

The letter plates illustrated on the following pages are provided as practice elements; they offer a wide exposure to the variety of problems inherent in the rendering of built-up letter forms. These plates have been arranged in the major style classifications of letters.

These basic classifications: Text, Roman, Italic, Script, Square Serif, and Sans Serif, represent a range of weight, balance, and serif changes, as well as numerous style variations found within individual categories.

Text. The two predominant styles are pointed and round letter forms (discussed in Chapter 4). These are Gothics and are compressed letters exhibiting extreme thick/thin characteristics of weight. They are upright forms and have no italic or cursive counterpart.

Roman and Italic. Most roman letters today have italic companion styles. The italic is not simply a "slanted" roman, but a new letter style based upon cursive handwriting (Chapter 5). Roman letters and their italics can be classed into five style variations: (1) old style antique, (2) formal old style, (3) informal old style, (4) transitional, (5) modern. These are characterized principally by changes of weight relationships and very different serif endings.

Scripts. Script letters are characterized as a flowing, connected cursive that usually exhibits a marked forward slant having extreme weight thicks and thins. There are three definite style variations: (1) formal, (2) informal, and (3) vertical. Their stroke formations are somewhat different from roman or italic and must be studied closely in order to gain a proficiency in rendering script. Originally pen-written letters (Chapter 5), scripts are now generally considered to be built-up letters because of the usual necessity of following a prepared layout or conforming to a specific area or space. Much can be learned about the nature of these letters, however, by writing them with a flexible, pointed pen.

Square Serif and Sans Serif. These letter styles are often considered mechanically constructed forms, though in practice it is usually necessary to apply a certain amount of freehand discipline. To reproduce the subtle weight variations incorporated in minuscule letters, in particular, care must be taken to eliminate heavy-color areas. These areas occur regularly wherever a curvilinear stroke junctures with a straight or oblique stem. The mechanical implements applied are those used for drafting procedures; the T square, triangle, ruling pen, compass, mechanical and proportional dividers, protractors, and straightedge. The major differences between these two styles are the heavy-slab serifs common to square serif, and the total absence of serifs on the sans-serif forms.

ABCDEFGHIJKLMNOPQRSTU
VWXYZ abcdefghijklmnopqrstuvw
xyz 1234567890

Fig. 181 Old English.

ABCDEFGHIJKLMNOPQRS
TUVWXYZ abcdefghijklmnopqrstuvw
xyz 1234567890

Fig. 182 Goudy Text.

ABCDEFGHIJKLMNOPQRSTUVWX
YZ abcdefghijklmnopqrstuvwxyz 123
4567890

Fig. 183 Bodoni Roman.

ABCDEFGHIJKLMNOPQRSTUVWX
YZ abcdefghijklmnopqrstuvwxyz 123
4567890

Fig. 184 Bodoni Italic.

ABCDEFGHIJKLMNOPQRST
UVWXYZ abcdefghijklmnopqrs
tuvwxyz 1234567890

ig. 185 Baskerville Roman.

ABCDEFGHIJKLMNOPQRST
UVWXYZ abcdefghijklmnopqrst
uvwxyz 1234567890

ig. 186 Century Expanded Italic.

ABCDEFGHIJKLMNOPQRSTUV
WXYZ abcdefghijklmnopqrstuvw
xyz 1234567890

ig. 187 Caslon Roman Bold.

ABCDEFGHIJKLMNOPQR
STUVWXYZ abcdefghijkl
mnopqrstuvwxyz 1234567
890

ig. 188 Craw Modern Roman.

ABCDEFGHIJKLMNOPQRSTUVWX
YZ abcdefghijklmnopqrstuvwxyz 123
4567890

ig. 189 Century Nova Italic.

ABCDEFGHIJKLMNOPQRSTU
VWXYZ 1234567890

Fig. 190 Neuland Inline Roman.

ABCDEFGHIJKLMNOPQRSTUVWX
YZ abcdefghijklmnopqrstuvwxyx
1234567890

Fig. 191 Franklin Gothic Roman.

ABCDEFGHIJKLMNOPQRSTUVWX
YZ abcdefghijklmnopqrstuvwxyz
1234567890

Fig. 192 Franklin Gothic Italic.

ABCDEFGHIJKLMNOPQ
RSTUVWXYZ 123456 7
890

Fig. 193 Microgramma Roman.

ABCDEFGHIJKLMNOPQRS
TUVWXYZ abcdefghijklmn
opqrstuvwxyz 1234567890

Fig. 194 Standard Medium Roman.

164

ABCDEFGHIJKLMNOPQRSTUVWX
YZ abcdefghijklmnopqrstuvwxyz 12
34567890

Fig. 195 Venus Medium Italic.

ABCDEFGHIJKLMNOPQRSTU
VWXYZ abcdefghijklmnopqrstu
vwxyz 1234567890

Fig. 196 Craw Clarendon Roman.

ABCDEFGHIJK
LMNOPQRSTUV
WXYZ abcdefghij
klmnopqrstuvwx
yz 1234567890

Fig. 197 Egyptian Expanded Roman.

ABCDEFGHIJKLMNOPQRSTUVW
XYZ abcdefghijklmnopqrstuvwxyz
1234567890

Fig. 198 Stymie Bold Roman.

ABCDEFGHIJKLMNOP2RS
TUVWXYZ abcdefghijklmnopqrs
tuvwxyz 1234567890

Fig. 199 Commercial Script.

ABCDEFGHIJKLMNOPQRSTUVWXYZ abcdefghij
klmnopqrstuvwxyz 1234567890

Fig. 200 Dom Casual.

ABCDEFGHIJKLMNOPQRST
UVWXYZ abcdefghijklmnopqrstuvwxyz 1234
567890

Fig. 201 Legend.

ABCDEFGHIJKLMNOPQRSTUVWX
YZ abcdefghijklmnopqrstuvwxyz 12
34567890

Fig. 202 Lydian Roman.

ABCDEFGHIJKLMNOPQRSTUV
WXYZ abcdefghijklmnopqrstuvwxyz 123
4567890

Fig. 203 Lydian Cursive.

ABCDEFGHIJKLMNOPQRSTUV
WXYZ abcdefghijklmnopqrstuv
wxyz 1234567890

Fig. 204 Mistral.

1

2

THE LIFE OF FRANCESCO GUICCIARDINI

3

4

5 PIGEON FEATHERS

6

7

8

9

Eden in Jeopardy

Fig. 205 Examples of built-up lettering and the use of letters in combination: (1) Corporate symbol of Folta & Schaffer Advertising, Greenfield, Mass., courtesy of Folta and Schaffer Advertising; (2) Courtesy of Doubleday & Co., Inc.; Artist: Milton Glaser; (3) Courtesy of Alfred A. Knopf; Artist: Golda Fishbein; (4) Courtesy of Gilbert M. Garte & Assoc.; Artwork: Folta & Schaffer Adv.; (5) Courtesy of Alfred A. Knopf; Artist: S. Neil Fujita; (6) Courtesy of Alfred A. Knopf; Artist: S. Neil Fujita; (7) Courtesy of The Franklin County Public Hospital, Greenfield, Mass., Artwork: Folta & Schaffer Adv.; (8) Personal hallmark of the Author; (9) Courtesy of Alfred A Knopf; Artist: Anita Karl.

167

Fig. 206 Examples of corporate symbols showing a highly imaginative and fresh use of letter forms and shapes. Designed by J. Malcolm Grear, Head, Department of Graphic Design, Rhode Island School of Design, Providence, R.I. Courtesy of Malcolm Grear Designers, Inc. (1) Merrimack Valley Textile Museum; (2) Bay State Abrasive Products; (3) Mount Attitash Ski Area; (4) Arkwright-Interlaken; (5) Research and Design.

THE RENAISSANCE SPIRIT IN TYPE ¹

VENEZIA

²Pageantries

Drawing ³

⁴ McDONNELL DOUGLAS

VOLUME II OF THE

DIARIES & LETTERS OF ⁵

1939-1945

Fig. 207 Examples of built-up lettering: (1) A composition from an originally designed and constructed alphabet by Anita Anderson; (2) Courtesy of Los Angeles Art Center, College of Design; Artist: James Brech; (3) Courtesy of Thomas D. Greenley; Artist: Thomas D. Greenley; (4) Courtesy of Los Angeles Art Center, College of Design; Artist: Wayne Carmona; (5) Courtesy of Atheneum Publishers; Artist: Jeanyee Wong.

ABCDEFGHIJ KLMNOPQRS TUVWXYZ& 1234567890$

abcdefghijklmn opqrstuvwxyz

Fig. 208 Times New Roman

ABCDEFGHIJ
KLMNOPQRS
TUVWXYZ&
1234567890$

abcdefghijklmno
pqrstuvwxyz

Fig. 209 Times New Roman Italic

ABCDEFGH
IJKLMNOP
QRSTUVW
XYZ& 12345
67890$

Fig. 210 Caslon 540

abcde
fghijklmno
pqrstuvwxyz

ABCDEFGHIJ
KLMNOPQR
STUVWXYZ&
1234567890$

abcdefghijklmnopq
rstuvwxyz

Fig. 211 Caslon 540 Italic

173

ABCDEFGHIJKLM
NOPQRSTUV
WXYZ&
1234567890$
abcdefghijklmnopqrs
tuvwxyz

Fig. 212a Weiss Roman

ABCDEFGHIJKLMN
OPQRSTUVWXYZ
1234567890$&

Fig. 212b Weiss Initials #1

ABCDEFGHIJK
LMNOPQRST
UVWXYZ&
1234567890$

abcdefghijkl
mnopqrst
uvwxyz

Fig. 213 Franklin Gothic

ABCDEFGHIJ
KLMNOPQR
STUVWXYZ
1234567890

abcdefghijkl
mnopqrstuv
wxyz&$

Fig. 214 Spartan Black

ABCDEFGHIJK
LMNOPQRSTU
VWXYZ&
1234567890O$

abcdefghijkl
mnopqrstuv
wxyz

Fig. 215 Helvetica Medium

ABCDEF
GHIJKLM
NOPQR
STUVW
XYZ&
1234567890$

Fig. 216 Venus Extrabold Extended

ABCDEFG
HIJKLMN
OPQRSTU
VWXYZ&$
1234567890

abcdefghij
klmnopqrs
tuvwxyz

Fig. 217 Fortuna Extrabold

ABCDEFGHIJ KLMNOPQRS TUVWXYZ& 1234567890$

abcdefghijklmno pqrstuvwxyz

Fig. 218 Times New Roman Bold

ABCDEFGHI
JKLMNOPQR
STUVWXYZ
1234567890$

abcdefghijkl
mnopqrstuv
wxyz&

Fig. 219 Cooper Black Italic

ABCDEFGHIJK
LMNOPQRSTU
VWXYZ

Fig. 220a Berling Caps

ABCDEFGHIJ
KLMNOPQRS
TUVWXYZ
1234567890&

Fig. 220b Univers 65

ABCDEFGHIJKLMNO
PQRSTUVWXYZ

Fig. 221a Zipper

ABCDEFGHIJKLMN
OPQRSTUVWXYZ

Fig. 221b Tip-top

abcdefghijklm
nopqrstuvwxyz

Fig. 221c American Uncial

ABCDEFGH
IJKLMNO
PQRSTUV
WXYZ&

Fig. 222a Lombardic Caps

ABCDEFGHI
JKLMNOP
QRSTUV
WXYZ&

Fig. 222b Goudy Text

184

ABCDEFGHIJKLMNO
PQRSTUVWXYZ@
1234567890$

Fig. 223a Solemnis Caps

ABCDEFGHIJKLMNOP
QRSTUVWXYZ&
1234567890$

abcdefghijklmnopqrstuv
wxyz

Fig. 223b Post Roman Medium

Suggested Project Material

1. Using bristol board or illustration board and pencil, pen-and-ink, or paint, create an original abstract design composed of six varieties of unfamiliar characters, such as oriental, asiatic, arabic, runes, or ancient alphabets. Size need not exceed 9 x 12 in.

2. As a companion piece, try the same project as #1 above, using six different letters and sizes of Roman Capitals.

3. Select an advertising or story headline from a magazine source and duplicate it either *twice* the size or *one-half* the size through construction and rendering in ink or paint.

4. Select one or more of the Trajan Capitals in this book and construct and render each in ink three to four times the original size. Use illustration board of sufficient size to allow ample margins. The truly adventurous might attempt to render a complete word.

5. Create an example of descriptive lettering. Select an English word, such as "apple," which conveys an immediate picture of the object for which the word stands. Using only the letters of the word, modified and changed in any way that does not destroy the readability of the individual letters, create the shape of the object. Some additional line illustration may be used, such as the stem and leaves atop the apple, in order to heighten the illusionary effect. Color can be used to excellent advantage in this project. Size is optional according to need.

6. Create a logotype, or corporate design symbol, using letters only. Select an existing company or corporation and design or redesign a symbol that will represent the selected business. Some initial research is desirable in order to learn as much as possible about the chosen company. Work large (4 to 6 in.). All final renderings should be in black ink on illustration or bristol board.

7. Select a decorative initial from lettering sources and carefully contract and render the initial in an enlarged size (two to four times the original). One method of enlargement is to rule thin, light grid lines, equally spaced, in each direction on the original. The same grid lines are then drawn on tracing paper and spaced according to the required enlargement (i.e., 1/16 in. on original equals 1/4 in. spacing for quadruple size).

8. Select the title from a book or record album and reproduce it in a freehand technique, using the original only as reference material.

9. Create an imaginative and highly graphic design utilizing one to five lower-case alphabetic letters repeated a number of times and in a variety of sizes to form a pleasing and aesthetic visual image. The letters may be placed in any attitude or position, overlap, or create transparencies. Color may be used to great advantage in this project, as well as values of gray, white upon black, or color backgrounds.

BIBLIOGRAPHY

BANDI, HANS-GEORG, et al. *The Art of the Stone Age.* New York: Crown Publishers, Inc., 1961.

BENSON, JOHN HOWARD. *The First Writing Book — Arrighi's 'Operina.'* New Haven: Yale University Press, 1955.

BENSON, JOHN HOWARD, and CAREY, ARTHUR GRAHAM. *The Elements of Lettering.* Newport: John Stevens, 1940.

BICKHAM, GEORGE. *The Universal Penman.* New York: Dover Publications, 1941 (facsimile of 1743 edition).

CASSON, LIONEL and THE EDITORS OF TIME-LIFE BOOKS. *Ancient Eygpt.* New York: Time Inc., 1965.

CATICH, EDWARD M. *The Trajan Inscription in Rome.* Davenport: St. Ambrose College (Catfish Press), 1961.

CERAM, C. W. *Gods, Graves, and Scholars.* New York: Alfred A. Knopf, 1959.

———. *The March of Archaeology.* New York: Alfred A. Knopf, 1958.

CLEATOR, P. E. *Lost Languages.* New York: The John Day Co., 1961.

CLODD, EDWARD. *The Story of the Alphabet.* New York: D. Appleton-Century Co., 1938.

DAVIDSON, MARSHALL B. (ed.). *The Horizon Book of Lost Worlds.* New York: American Heritage Publishing Co., Inc., 1962.

DOBLHOFER, ERNST. *Voices in Stone.* New York: The Viking Press, 1961.

DOEDE, WERNER. *Schön Schreiben, Eine Kunst.* Munich: Druck von Klein & Volbert, 1957.

DÜRER, ALBRECHT. *Of the Just Shaping of Letters.* New York: Dover Publications, 1965 (reprint of 1925 edition).

ETIEMBLE. *The Orion Book of the Written Word.* New York: Orion Press, 1961.

GREENLEY, THOMAS D. *The Descendants of Alpha Beta.* Amityville, New York: The Scriptorium, 1964.

Horizon Book of the Renaissance. New York: American Heritage Publishing Co., Inc., 1961.

HORNUNG, CLARENCE P. *Handbook of Early Advertising Art.* Vol. II. New York: Dover Publications, 1956.

JOHNSTON, EDWARD. *Writing and Illuminating and Lettering.* London: Pitman Publishing Corp., 1962.

McMURTRIE, DOUGLAS C. *The Golden Book.* New York: Pascal Covici, Publisher, Inc., 1934.

MASON, WILLIAM A. *A History of the Art of Writing.* New York: The Macmillan Co., 1928.

NESBITT, ALEXANDER (ed.). *Decorative Alphabets and Initials.* New York: Dover Publications, 1959.

NESBITT, ALEXANDER. *The History and Technique of Lettering.* New York: Dover Publications, 1957.

PIGGOTT, STUART (ed.). *The Dawn of Civilization.* London: Thames and Hudson, Ltd., 1961.

THOMPSON, EDWARD MAUNDE. *An Introduction to Greek and Latin Palaeography.* Oxford: Clarendon Press, 1912.

THOMPSON, TOMMY. *The Script Letter.* New York: Studio Publications, 1939.

Three Classics of Italian Calligraphy. New York: Dover Publications, 1953.

ULLMAN, B. L. *Ancient Writing and Its Influence.* New York: Longmans, Green & Co., 1932.